America 1585

America 1585

The Complete Drawings of John White

by Paul Hulton

The University of North Carolina Press and

British Museum Publications

© 1984 The University of North Carolina Press

Photographic Acknowledgements

Colour plates 1–75 and frontispiece © The Trustees of
the British Museum

Colour plate 76 © The British Library Board

Figures 1–33 © The British Library Board

Figures 34–106 © The Trustees of the British Museum

Printed and bound by New Interlitho S.P.A., Milan, Italy.

Set in Galliard by the University of North Carolina Press

Library of Congress Cataloging in Publication Data

White, John, fl. 1577–1593.

 America 1585.

 Bibliography: p.

 Includes index.

 1. White, John, fl. 1577–1593. 2. North Carolina in
art. 3. Virginia in art. I. Hulton, P. H. (Paul Hope)
II. Title.

NC242.W53A4 1984 759.2 84-3707

ISBN 0-8078-1605-1

British Library Cataloguing in Publication Data

Hulton, Paul

 America 1585.

 1. White, John, *fl. 1577–1593*

 I. Title II. White, John, *fl. 1577–1593*

 759.2 ND1942.W5

ISBN 0-7141-0798-0

To Nancy

Contents

Publishers' Acknowledgement

The publishers gratefully acknowledge the support of America's Four Hundredth Anniversary Committee of the North Carolina Department of Cultural Resources in the publication of this volume.

Acknowledgements

I wish to record the help and consideration I have received from the staff of British Museum Publications, in particular Celia Clear and Johanna Awdry of the editorial staff, and Jenny Ashby who read the manuscript of this book with salutary efficiency. I owe a special debt of gratitude to Professor David B. Quinn who read the introductory text and made a number of invaluable suggestions and corrections. I would like most of all to express my appreciation of the way my wife has adjusted to posthumous pressure from John White on her time (in typing), energy and patience which surprisingly has not smothered her interest in him; but this can only be part of the reason why this book is dedicated to her.

P. H.

Foreword

Almost exactly four hundred years ago an English artist was making the first drawings of part of the New World, later to be included in the states of North Carolina and Virginia, its people and natural life and the shape of its coasts and river estuaries. Some of the watercolours which resulted from these drawings have by a strange quirk of fate survived when so much else connected with White's efforts failed or was lost: the colony of which he was the official artist; the second colony which he took out to Roanoke Island and governed briefly and which he failed to reinforce, then to locate, and which became the Lost Colony of legend.

Yet White's images of Sir Walter Raleigh's 'new found land' still live and vividly and optimistically express his commitment to settlement in this part of North America, however resigned he later became to his failures. Most surprisingly, facsimiles of his watercolours were published for the first time only twenty years ago. They were printed from models which were elaborately prepared, in part photographic, in part hand copied, with an element of handwork included in the reproductions themselves. The present reproductions, reproduced entirely from photographic transparencies, should therefore be more faithful to White's originals.

The aim of this book is to make fine reproductions of White's drawings widely available, so doing justice to an artist whose work outside the American field, apart from his 'Picts' and a few other Oriental and costume studies, is unknown. The accompanying text seeks to explain the drawings and the conditions which produced them, as well as to make clear what little is known about their author who was designated 'Iohn White of London Gentleman' and 'Gouernour of the Cittie of Ralegh'.

Paul Hulton

America 1585

1 The English Discovery of the New World

Many artists before John White sailed to the New World with voyages of discovery but he alone left the first convincing record to have survived of the people and the natural life of the lands he explored. The work of other explorer-artists has either been lost or has survived only in fragments or in a few prints reproducing lost drawings. A decade before White's record was made, for example, a team of artists under Francisco Hernandez in Mexico produced a great quantity of drawings for Philip II of Spain, but the fifteen volumes of their work were destroyed by fire in the Escorial in 1671. Their quality may have rivalled White's, though it is difficult to judge accurately from the selection of woodcut reproductions published in the earlier seventeenth century.

The English were slow to explore and settle the New World. Though they had made an early and brilliant start under the Cabots before 1510, when a considerable part of the American coastline was discovered,[1] their lead had faded. Apart from their share in the development of the Newfoundland cod fishery and Martin Frobisher's three voyages, 1576–8, to discover a north-west passage to the Indies, they had before 1580 fallen behind the Spaniards, the Portuguese and the French. But the growing confidence of Elizabethan seamen and their rising ambition to control the sea-lanes to the west of their island began by the 1580s to focus their attention on plans to establish an English foothold on the North American continent. Their motives were various: to exploit the vast but ill-understood resources of the New World; to establish a Protestant commonwealth to counterbalance the hispanic Catholic empire already established there; to bring the savage inhabitants of America to a knowledge of the true religion, as they saw it; to set up a base sufficiently concealed for safety but sufficiently close to the Spanish possessions to allow destructive blows against their shipping. For Sir Walter Raleigh too there was a genuinely patriotic motive. In John Hooker's words these things were to be done 'for the honour of the prince and the benefit of the commonwealth'.

Raleigh was the prime mover in these first colonial ventures by the English, the series of expeditions, 1584–90, generally known as the Roanoke voyages, since the island of Roanoke within the Carolina Outer Banks was the sole English base from 1585 throughout.[2] Raleigh had inherited his interest in North American colonization from his half-brother, Sir Humphrey Gilbert, who in 1578 had obtained a patent from Queen Elizabeth to exploit land in North America. Well thought out as were his plans to settle in the southern part of the area later called New England, and to control the Newfoundland fishery, they came to nothing in practice with the notable exception of his annexation of Newfoundland in 1583. In the same year Gilbert died at sea. In view of White's position as expedition artist it is interesting to note that instructions to Gilbert's artist, one Thomas Bavin, otherwise unknown, have survived. They must have been very like White's own instructions which are lost, but the extent of Bavin's duties is discussed later (see p. 9).

Raleigh's position as promoter of the enterprise relied on material support from gentlemen at Court as well as from the Queen. He formed a syndicate of courtiers, mainly from Devon and Cornwall, but seems to have based his hopes more on the possibilities of capturing Spanish shipping and merchandise than on the resources the syndicate might be able to provide. The Queen's contribution was cautious rather than whole-hearted, consisting of a licence to explore and settle in North America granted on 25 March 1584, the loan of a ship on the voyage of 1585 and the right to name the land to be explored Virginia in her honour. She also knighted Raleigh on 5 January 1585.

English ambitions to expand in North America tended to grow as relations with Spain deteriorated. Just as the menace of Catholic Spain was felt to be embodied at home in the person of Mary, Queen of Scots, so the Spanish possessions in North America were seen ever more clearly to pose the strongest threat to English maritime expansion. The first major publication in favour of English colonization appeared in 1582 (about two years before Spanish intervention was seriously feared) with the younger Hakluyt's *Divers voyages touching the discoverie of America*. This propagandist tract was prompted

1 D.B. Quinn, 'The argument for the English discovery of America between 1480 and 1494', *Geographical Journal*, CXXVII (1961), pp. 277–85; J.A. Williamson, ed. *The Cabot voyages and Bristol discovery under Henry VII* (Cambridge, Hakluyt Soc., 1962).

2 See D.B. Quinn, ed. *The Roanoke voyages 1584–1590*, 2 vols (London, Hakluyt Soc., 1955). This collection of documents is essential reading for those wishing to discover more of the background to these voyages.

mainly by Sir Humphrey Gilbert's plans. Both the elder and younger Hakluyt were concerned with promotional literature, firstly in support of Gilbert then of Raleigh.

The first material result of Raleigh's planning was the reconnoitring expedition of 1584 in which, as we shall see later (see p. 8), John White may well have taken part. Two ships commanded by Philip Amadas and Arthur Barlowe set sail on 27 April and reached the south-east coast of North America, by way of Puerto Rico, in early July. No ship's journal of this voyage has survived and, tantalizingly, Barlowe's lucid account gives only the sparsest details of the geographical extent of the exploration, but much more of ethnographical interest concerning the aboriginal culture of the Carolina Algonquians with whom the English now made contact for the first time. The expedition's pilot was a Portuguese, Simon Fernandez, who is likely to have known these coasts from previous service with the Spaniards. It was he who finally decided to enter the inlet and harbour called Port Ferdinando in the Carolina Outer Banks (close to the present Oregon Inlet) which the English made their base. One ship may have gone on later to enter Chesapeake Bay.

The difficulties they experienced in these shallow but exposed waters were not fully taken to heart and they were to run into similar dangers the following year. But they made a successful reconnaissance as a result of which the Island of Roanoke, which lies just to the north of their base, was probably considered as the likely future base of operations. The site was far from ideal; there was no satisfactory deep water harbour available; and the situation was too exposed not only to the weather but also to possible Spanish reconnaissance. The entrance to Chesapeake Bay would have provided a more suitable site in both respects but was considered less secure from Indian attack – perhaps the question which weighed most at the time with the would-be colonists. And the Island of Roanoke was certainly well placed for exploring Pamlico and Albemarle Sounds and the rivers which run into them. The English formally took possession of Roanoke Island and adjacent lands (though the precise extent of the area was never made public). They traded with and established good relations with the Indians on whom they had to rely to a considerable extent for information about the interior and its inhabitants, clearly of the greatest importance if they were to obtain the co-operation of the Indians in their efforts to establish a colony. That they created a relationship of some trust in

the short time that they stayed in the area may be gauged from the fact that they returned home with two Indians, Manteo and Wanchese, who, we must suppose, came voluntarily.

The expedition returned to England in September. Raleigh and his associates were now supplied with much vital information about this area of North America which they hoped to settle: its topography, with a probable base of operations; its inhabitants and something of their language; and with some idea of its natural resources. On such a basis planning for the attempt of 1585 could go ahead.

At this point the part being played by another member of the colonizing circle becomes clearer. The contribution of Thomas Harriot, scientist and mathematician, to the planning and execution of the 1585 venture was outstanding and greater perhaps than that of any other individual. It was he who had supplied Amadas and Barlowe with navigational instructions for the 1584 voyage which were in some respects in advance of their time.[3] It was he who doubtless interrogated the two Indians at length, acquiring some knowledge of their language and of Indian society and obtaining from them essential information on the resources of Raleigh's Virginia. As the scientist of the 1585 expedition he was, as in 1584, not only responsible for the navigational instructions but was in a position personally to supervise their effective execution at sea. His part with John White in mapping the new lands, classifying and describing their natural life and, most important of all, carefully portraying the life and customs of the Indians, will be discussed later (see chapter 5).

The promoters were now engaged in raising money, enrolling volunteers and organizing the logistics of the voyage. These activities were accompanied by the appearance of documents written in support of the new colonizing effort. The younger Richard Hakluyt had begun writing in 1584 what later became known as *The discourse of western planting*, of which the only copy to survive is in manuscript in the New York Public Library. It lays stress on the commercial advantages that would accrue to the realm from settling the recently discovered lands.

3 British Library, Department of Manuscripts, Add. MS 6788, ff. 468–92, discussed by E.G.R. Taylor in 'Hariot's instructions for Raleigh's voyage to Guiana, 1595', *Journal of the Institute of Navigation*, V, p. 345. Printed in full in D.B. Quinn, *New American World*, III (1979), with plate at end of volume.

This tract was intended not for the public but for the Queen as a detailed case for colonization and copies were made for one or two major associates of Raleigh. The enterprise, it maintained, was of such potential that it should not be left to private financing alone but demanded the involvement of the state. Richard Hakluyt the elder's 'Inducements to the liking of the voyage intended towards Virginia . . .' was on the other hand written as propaganda for wide circulation in manuscript. It was perhaps even printed though it now only exists in the published version of 1602. Other documents in support of the venture were also in circulation. In addition the younger Hakluyt had already collected published and unpublished material, both English and foreign, on voyages of exploration which he put at the disposal of the promoters. These later became famous as the monumental collection which he published in a substantial volume in 1589 under the title, *The principall navigations, voiages and discoveries of the English nation.*

The success of the reconnaissance voyage and the over-optimistic reports on chances of settlement produced a certain euphoria among the organizers. Plans for the 1585 expedition were consequently on a large scale. A squadron of seven ships under command of Sir Richard Grenville in the *Tiger* (the Queen's ship) was fitted out with a complement of six hundred men. Raleigh supervised the operation but was to remain in England contrary to the later popular belief that he sailed with Grenville. In fact he never set foot in his Virginia. The fleet set sail from Plymouth on 9 April but was quickly dispersed on the voyage across the Atlantic. The *Tiger* reached Puerto Rico alone in May. Grenville spent several weeks in these waters taking on supplies, building a pinnace, collecting plants, seizing salt from the Spaniards (but also trading with them, here and in Hispaniola). John White made drawings of these activities (see plates 3, 4) many of which were recorded in the *Tiger's* journal.[4] In the meantime the *Elizabeth* had joined the *Tiger* and the two ships reached Wococon Island in the Carolina Outer Banks on 26 June. There was a period of exploration in Pamlico Sound before they sailed north to Port Ferdinando where they made contact with two other vessels of the fleet, the *Lion* and a flyboat. Finally Ralph Lane took control as governor of the colony of

108 men on Roanoke Island where they built a fort and houses for the settlers nearby. (The fort, as Fort Raleigh, has long been excavated and work is actively proceeding to discover the exact location of the settlement.) The *Tiger* left on her return voyage on 25 August.

The colonists were a mixed lot, soldiers in the main as was Ralph Lane, but there were also a few gentlemen (attracted by offers of land), merchants and specialists, among them John White artist, Thomas Harriot scientist and surveyor, and Joachim Ganz metallurgist. From the earliest days it was clear that the colonists could not survive entirely independent of the Indians. They traded with them for basic necessities which they could not grow or obtain themselves. Their demands for corn later alienated the Indians with whom their relations had at first been friendly. Finally, suspicious of a plot against them, they hatched a counterplot which resulted in the killing in June 1586 of the Roanoke chief, Wingina (who had now changed his name to Pemisapan). Though this relieved what had become a virtual blockade of the English in Roanoke Island, the colonists remained short of food.

Ralph Lane's account of the colony[5] is incomplete but it is clear that the colonists explored and mapped the area in the vicinity of the island, in particular the Chowan and Roanoke rivers. As with all Europeans attempting to colonize the American mainland the lure of precious metals was something of an obsession. The Spaniards had struck gold. The French and English always believed in its existence somewhat inland of their areas of settlement. Lane wrote that 'the discovery of a good mine, by the goodness of God, or a passage to the Southsea [the Pacific], or some way to it, and nothing else can bring this country . . . to be inhabited by our nation.' In this instance a mine was thought to be located along the upper reaches of the Roanoke River, which accounts for the more complete exploration of that river in the spring of 1586. Lane also intended to send a party overland to explore the mouth of the Chesapeake with a view to discovering a safe deep water harbour not available in the vicinity of Roanoke Island. He had already sent Harriot, White and others by sea round Cape Henry to spend the winter with the Chesapeake Indians somewhere near the southern shores of Chesapeake Bay.

The killing of Wingina, though removing some of the

4 Richard Hakluyt, *The principall navigations, voiages and discoveries of the English nation* (London, 1589), pp. 773–6; 2nd edn III (1600), pp. 251–3; Quinn, *Roanoke voyages*, pp. 178–93.

5 Hakluyt, *Principall navigations* (1589), pp. 737–47; 2nd edn III (1600), pp. 255–64; Quinn, *Roanoke Voyages*, pp. 255–94.

Indian pressure on the English presence, nevertheless forced the colonists to realise that henceforth they must rely on their own resources to survive. This they did, though meagrely. Lane had decided to disperse his men since the supplies he had expected to arrive with Grenville by Easter had not materialized. Some he sent to Cape Hatteras, some to Port Ferdinando, not only to ease the food problems but also to look out for the arrival of English ships. A relief squadron under Bernard Drake and Amyas Preston had been ready to put to sea but had been diverted by the Queen to Newfoundland to attack Spanish and Portuguese shipping, in answer to a Spanish embargo on English shipping.

The arrival on 9 June of Sir Francis Drake's fleet, following its attack on Santo Domingo and Cartagena early in 1586, was entirely unexpected. Drake's intention was to discover how the colony fared and to give what assistance was needed. He generously offered either to provide reinforcements of men and supplies (he was rather short of food), a ship, a pinnace and some boats or, if need be, to return the colonists to England. Lane had planned to explore the Chesapeake Bay area further and Drake's offer would have enabled him to do this with enough supplies in hand for the return journey to England. He had given up hope of reinforcements from home although Grenville's and Raleigh's supply ships were now well on their way. The hurricane which blew up on 13 June, and which lasted three days, wrecked several small vessels, driving other larger ships out to sea, and sapped the colonists' will to explore further, thereby deciding the issue. Lane opted to return home with Drake.

So the first concerted attempt to plant a colony on North American soil came to an abrupt end. Drake set sail on 19 June and reached Portsmouth on 28 July. The colonizing effort had received a setback but the promoters did not count it as a failure. A considerable store of experience had been gained which they intended to follow up. The failure of Sir Richard Grenville, when he finally arrived, to establish an effective colony discouraged Raleigh. The result was that the role of two of the key figures changed. Raleigh chose to shift the responsibility for organizing and executing the new effort to a company headed by John White who with Thomas Harriot remained optimistic of success. The subsequent history of the attempt to restore the foothold lost in 1586 becomes closely identified with White's personal history which will be examined in the following pages.

2 The Story of John White

A Question of Identity

Who was John White? There are no documents to illuminate his family background or early career and no certain mention of the artist before 11 July 1585 when he is named as one of a party who left Wococon Island in the Carolina Outer Banks to row across Pamlico Sound with Sir Richard Grenville to explore the Indian villages of the mainland.[1] In fact so shadowy is John White the artist that until comparatively recently he and John White, governor of the 1587 colony, were often thought of (surprisingly, in view of contemporary evidence) as two different people.

Though it is true that none of the drawings are signed and that there is no evidence of authorship to be found on the sheets themselves, it is certain that a John White drew them. Their first engraver and publisher, Theodor de Bry, printed on the title-page to the Indian engravings illustrating Thomas Harriot's *A briefe and true report of the new found land of Virginia* (1590) these words: 'Diligentlye collected and draowne by Ihon White who was sent thiter speciallye and for the same purpose by the said Sir Walter Ralegh the year abouesaid 1585'. The engravings follow closely the Indian figures of the surviving originals but often show extra background details or back views of some of the figures so that it is clear that the engraver must have been using different versions of the drawings, now lost.

That John White the artist was identical with governor White is plain from the remarks of a famous contemporary, John Gerard, who writes in his *Herball*, 'Master *White* an excellent painter who carried very many people into Virginia . . . there to inhabite'. White himself supplies supporting evidence which will be mentioned later.

The question of White's origin is more problematic. To us it seems strange that someone who made a reputation both as artist and as governor of the second colony of 1587 should be so difficult to identify. It might be thought that these achievements would have brought a measure of fame to his family. This was in fact less likely in Elizabethan or Jacobean England than in later times, for in general it can be said that an artist did not then enjoy any enhanced status. This is made clear by Nicholas Hilliard, the famous miniaturist and White's contemporary, who claimed a special status for limners, i.e. minia-

ture-painters. In his *Arte of limning* he writes that this kind of painting should be practised by 'none but gentlemen', so attempting to make a distinction between limning and other kinds of painting which he presumably equates with the work of artisans. As for the office of governor, the appointment of White was strictly practical and based on his experience, not on his social standing. But in order to enhance his status he was granted a coat of arms and designated 'Iohn White of London Gent*leman*'. It was a kind of promotion in the social scale, for his family background was almost certainly modest.

One obvious difficulty in the search for his family is that there are too many John Whites even among the comparatively meagre records that survive from the sixteenth century and no indication to distinguish the artist from among them. We are left to make deductions from what we know of White after his first appearance on the historical scene in 1585 and to look at the scanty indirect evidence available before then in the light of that knowledge.

He was probably born in the decade 1540–50, for by 1588 he was already a grandfather. His surviving journals and letters of the later 1580s and early 1590s make no mention of his wife who may be presumed to have died before he became involved in Raleigh's ventures. He had at least one child, Eleanor, and one grandchild, her daughter Virginia. Eleanor married Ananias Dare, bricklayer and tiler, good reason for supposing that White's own family was of modest stock.

Surprisingly, the quarterings in his arms do not provide the clues to his family connections that might be supposed. The Whites of Truro in Cornwall had the same arms and provided a John White who was a member of the Haberdashers' Company, but he died in 1584. That White had a nephew, another John White (with a twin brother, Robert), who could be the artist. Though of the same generation there is nothing definite to show that he is our man although a Cornish origin would not be at all unlikely, for so many of those involved in Raleigh's colonial ventures were from Devon and Cornwall. Yet another John White was an 'engineer' in Ireland, 1567–8, whose knowledge of fortifications might possibly be reflected in our artist's drawings of the English entrenchments on Puerto Rico (plate 4).

That White had professional training as a limner is, from his work, virtually certain. Apprenticeship with

1 Quinn, *Roanoke voyages*, p. 190.

a London master would have been the traditional way of acquiring his not inconsiderable skills. That master would normally have been a member of the Painter-Stainers' Company, a guild which included those who practised all the painterly crafts. Though the early records of this company have been largely destroyed, a John White is recorded as a member in 1580, without further information.[2] This is the one piece of documentary evidence that we can confidently link with our subject. Membership of such a company would have precluded his attendance at a university. Yet it is clear from his journals and letters that he was a man of some education who wrote with feeling and a certain style, a quality evident too in his fine italic hand.

Why did Raleigh and the promoters and organizers of the 1585 voyage choose White to record the life and shape of the new lands they observed in passage or intended to settle? The possibility is that he was able to show them examples of this very kind of work. It is likely that about eight years previously he had portrayed with the same eye for detail observable in his portraits of the Carolina Algonquian Indians the three Baffin Island Eskimos – a man, and a woman with her baby (plates 63, 64) – brought back to Bristol by Martin Frobisher from his second voyage to the north-west in 1577. That he was actually with Frobisher on that voyage may be deduced with some degree of conviction from an early copy of a lost John White drawing representing a scene in Arctic waters (figure 43). It portrays a boatload of Englishmen firing at Eskimos who are replying with bows and arrows from a cliff top, and other Eskimos paddling kayaks among the ice-floes. It would have been impossible for anyone to reconstruct this Arctic scene with its Eskimo clothing, tents and kayaks in such convincing detail if he had not himself witnessed it and recorded it on the spot. As the drawing is a copy, the original would have been still more convincing. It almost certainly portrays a skirmish at Frobisher Inlet on Baffin Island. But it could be argued that the original White drawing might itself have been a copy as are his Indians of Florida (from Jacques Le Moyne de Morgues, plates 61, 62), but this would suppose the existence of another English artist, of at least White's calibre, of which there is no evidence whatever. These and other Eskimo drawings, now lost in the original, would have provided the kind of material to per-

suade the promoters of the Roanoke venture that White was the right choice, one who was already experienced and skilled in recording North American exploration.

White's experience of the New World before 1585 was probably not confined to the Frobisher expedition of 1577. There is indirect evidence that he had sailed with Amadas and Barlowe in 1584. He is not mentioned as a member of that expedition any more than he was listed among Lane's colonists on the expedition of 1585. In a letter of 1593 White looked back to five 'American' voyages. Four are documented and unless the Frobisher voyage counted as the first, which is perhaps unlikely, this must have been the expedition of 1584. If so, White would already have gained valuable experience of the Outer Banks and the adjacent mainland, its native inhabitants and its natural life. Whether or not he had official duties as graphic recorder he would surely have spent much time making drawings of what he observed.

Another influence which widened his knowledge of the American Indian and must have stimulated his artistic outlook came through his acquaintance with the French Huguenot artist, Jacques Le Moyne de Morgues.[3] A generation older than White, Le Moyne had settled in Blackfriars, London, sometime early in the 1580s 'for religion'. His career to some extent paralleled White's, for he too had been the artist of a colonizing expedition, that of René de Laudonnière to Florida, 1563–5. He too portrayed Indians (the Timucua), their daily life and tribal warfare, and mapped their lands. His Indian drawings, of which only one original has survived, were also engraved by Theodor de Bry, and printed as illustrations to the artist's own account of the colony. This volume, published in 1591, formed the second part of De Bry's great series *America* of which Thomas Harriot's *Briefe and true report* was the first. White is likely to have met Le Moyne before the former became involved in the Roanoke ventures and was certainly familiar with his work. Elements of Le Moyne's map of Florida appear on White's general map of southeastern North America (plate 59). Two Timucua Indians, a man and a woman, are found among White's portraits of Algonquian Indians, undoubtedly drawn by White, but not from the life, as none of the English colonists set foot in Florida. The presentation of these Florida Indians is very similar to the way in which White displays his

2 W.A.D. Englefield, *The history of the Painter-Stainers' Company of London*, (1923), p. 53n.

3 See Paul Hulton, *The work of Jacques Le Moyne de Morgues, a Huguenot artist in France, Florida and England* (London, 1977).

Indians of 'Virginia', but the details of clothing and colouring are altogether distinct. The explanation must be that White copied the work of Le Moyne. A Timucuan headdress also appears, inappropriately, on an idol in one of De Bry's 'Virginia' plates (figure 25), and there are many other examples of interchange of material and ideas between the two artists as well as of some confusion (or substitution?) by the engraver or publisher.

By 1585 White would have acquired a deep interest, and probably some experience, in depicting unfamiliar racial types of the New World, and developed a keen eye for ethnological detail. His ability to portray zoological and botanical life was to be proved in many ways equally effective.

The Artist at Work in Raleigh's 'Virginia'

When White was recruited as official artist of the 1585 expedition he would have been given a precise set of instructions as to his duties. Though these have been lost, those given to Thomas Bavin, Gilbert's artist, have survived.[4] They were compiled for one of the expeditions of 1582 and though intended for southern New England (as this area was to become) were concerned with the same Atlantic route and a not too distant extension of the same part of the eastern coast of North America which White was to record. In Bavin's instructions are notes for an 'observer' entirely suited to Harriot just as Bavin's own instructions could have been modelled for White. More explicitly Bavin was to 'drawe to lief one of each kinde of thing that is strange to us in England . . . all strange birdes beastes fishes plantes hearbes Trees and fruictes . . . also the figures & shapes of men and woemen in their apparell as also their manner of wepons in every place as you shall finde them differing'. The artist and his observer were to be attended by others carrying their equipment to allow them to continue with their work without interruption. They were to make 'cardes' (maps) 'garnished' with conventional signs for Indian villages, variations of vegetation, location of springs, shoals, shellfish, etc. and showing co-ordinates, depth of rivers and inlets, and elevations, all these to be entered too in the journal which was to be kept by the observer. Nothing could have fitted more precisely the activities of

White and Harriot on this expedition, White's eye and hand to record every detail, Harriot's intellect to identify, describe and put in order the things discovered. They worked as a team and the quality of the final result as seen, in much reduced form, in the De Bry edition of Harriot's *Briefe and true report* testifies to the effectiveness of their effort.[5]

In May 1585, when Grenville's flagship, the *Tiger*, entered West Indian waters, White and Harriot set to work. A Spanish source tells of Englishmen on Puerto Rico taking away banana plants and making drawings of fruits and trees and must surely refer to White and Harriot.[6] There are in fact two drawings of the banana (plates 13, 14), and others of the mammee apple (plate 12) and pineapple (plate 11), drawn here or on Hispaniola. That some of Grenville's activities on and off Puerto Rico were recorded by White as well as by the writer of the *Tiger's* journal is likely proof that White was on board Grenville's ship (though the *Elizabeth* joined the *Tiger* about a week after she had reached the area). The drawing of the fortified encampment on Puerto Rico (plate 3) has special interest as something of a composite. White is not only recording events but has brought together several fauna into the drawing which even on a very small scale are generally recognizable if not always fully identifiable: land crabs, a heron, a grebe and a duck. We can be sure that each of these was based on an individual study of which only that of the land crab (plate 5) has survived. There are a number of other West Indian fauna which White and Harriot observed in or near the area, and which in many cases – such as the fishes, reptiles, crabs and insects – they must have captured. They would have collected plants too, not only to draw them but with the probable intention of trying to grow them in the new colony.

The activities of the would-be colonists were no doubt considered to be of less interest as subjects for the record than the unfamiliar human and natural life they encountered. There are only two drawings of scenes involving the colonists – those of Puerto Rico (plates 3, 4). They include intriguing glimpses of the English at work: Sir Richard Grenville on horseback at Guayanilla Bay, men hauling in timber for the building of a pinnace (shown

4 British Library, Department of Manuscripts, Add. MS 38823, ff. 1–8.

5 For a recent facsimile of the 1590 edition of *A briefe and true report* see that of Dover Publications, Inc. (New York, 1972).

6 Museo Naval, Madrid, relation of Hernando de Altamirano. See Quinn, *Roanoke voyages*, p. 742.

Sketch-map of Raleigh's Virginia (original in possession of Public Record Office, London, MPG 584).

partly completed), a barge crossing a river with barrels of fresh water, and the *Tiger* lying offshore; and in the other drawing, entrenchments on a foreshore (in plan not unlike the excavated Fort Raleigh on Roanoke Island), a Spanish (prize) frigate offshore, and English soldiers and Spanish prisoners removing Spanish salt for English use.

After Grenville left Hispaniola on course for the Carolina Banks, White and Harriot were concerned in drawing, naming and describing mainly oceanic birds and fishes, many of them found in the Florida Channel. The fish portraits in general are of a high quality (plates 20–31), while the fine drawing of a flamingo (plate 15) can perhaps be associated with their passage through the Bahamas. The route would now have been by way of the Gulf Stream towards Cape Hatteras for the landing on Wococon Island (covering the present Ocracoke and possibly part of Portsmouth Island).

Soon afterwards White and Harriot were with Grenville crossing Pamlico Sound to explore the mainland. White made a drawing of the village of Pomeiooc (just north of Wysocking Bay, plate 32) on 12 July, and of the unenclosed village of Secoton and a number of its inhabitants (plates 36–41), shown by him on the west side of the Pamlico River estuary, on 15 July. After their return to Wococon Island White's and Harriot's activities become merged with those of the other colonists and are not documented. But it is likely that they were with Amadas when he explored Albemarle Sound and spent several weeks during August with the Indians in the tribal area of Weapemeoc further to the north. Equally they would have been members of the later expedition sent by Lane to explore the area along the southern shore of Chesapeake Bay. They apparently set out by sea, sometime in the autumn, along the coast, rounded Cape Henry and penetrated the Elizabeth River as far at least as the 'city' of Skicóac, the main centre of the Chesapeake Indians. Somewhere in the region the Englishmen, led by a colonel, set up camp. Though there is evidence of considerable surveying activity *en route* (e.g. White's indications of shoals in Currituck Sound), we do not know where the camp was, for Lane, perhaps for reasons of security, has left no account of the expedition.

This area, now part of Virginia, was the northern limit of the colonists' survey. Lane was impressed by the fertility of the land and was interested particularly in locating a suitable harbour for possible future use and in learning more about the powerful group of Indian tribes known later as the Powhatan Confederacy. The expedition was away several months and may perhaps have returned in February 1586.

Whether or not White had any previous training in survey work and map making is not known but his versatility suggests that, if not, he would have been a quick learner. Their work, which Professor Quinn has called 'the most thorough topographical survey of an extensive tract of North America during the sixteenth century', resulted finally in White's manuscript map of Raleigh's Virginia (plate 60) and the somewhat different map engraved from another version of the same in the De Bry volume (figure 5). It began with a much more primitive map, a pilot's sketch (see p. 10), which cannot be proved to be White's work but is possibly his.[7] This was the result of the boat journeys in Pamlico and Albemarle Sounds made by the explorers between July and late September. It was constructed from elementary surveys requiring no more than compass bearings and estimated distances, and though very roughly executed yet shows some professional touches. It is a proper map, not a bird's-eye view, containing a good deal of information about the botanical and zoological character of this part of the coast given in glosses written over the areas concerned, together with symbols for palisaded and open Indian villages (Pomeiooc and Secoton), and shoals and an indication of water depth. As an ecological document it comes close to what was required of Bavin. The writing on the map is probably not Harriot's and no cursive writing by White exists with which to compare it. However, its basic italic character is not at odds with his formal italic found throughout the original drawings. The map is connected with, and is in some sense preparatory to, the engraved map in the De Bry volume, 'The arriual of the Englishemen in Virginia' (figure 6). That too is 'garnished' with symbols for different types of trees, fish-weirs, crops, shallows and Indian canoes as well as with the more pictorial English ships and pinnace.

7 London, Public Record Office, M.P.G. 584. See Quinn, *Roanoke voyages*, pp. 215–17; W.P. Cumming, *The southeast in early maps* (1958), pl. 10, and 'Our earliest known map', *The State*, XXV, no. 17 (11 Jan. 1958), pp. 10–11, 22.

In White's manuscript map of 'Virginia' this ecological information has been completely suppressed, except for the Indian canoes, leaving only the coastal outlines, some English ships, the compass rose and a scale of leagues. The engraved version in De Bry (figure 5) is however 'garnished' with symbols indicating mountains, varieties of trees, Indian villages (undifferentiated) and with Indian figures, and has the scale of leagues as well as the compass rose. It also covers more of the area inland. Both maps set a new standard of accuracy unapproached in any previous larger-scale maps of any part of North America. This can only have been achieved by constructing the manuscript map from field sheets (now lost) drawn from a survey employing astronomical observations and a uniform scale. These sheets would have been fitted together by means of accurate registration and adjustment. It is difficult not to see Harriot taking control of such a survey with White's able and willing assistance.

Bavin's observer, it will be remembered, was to keep a journal in which all his observations are noted. In the same way Harriot compiled a chronicle from which he intended eventually to publish an illustrated account of the colony. In this his information on the Indians and the natural products of the country would have been methodically arranged together with copies of White's drawings. His *Briefe and true report* gives various clues about the way they went to work. Under the heading 'Of Foule' he writes, 'we haue taken, eaten, & haue the pictures as they were there drawne with the names of the inhabitants of seuerall strange sorts of water foule eight, and seuenteene kinds more of land foul, although we haue seene and eaten of many more, which for want of leasure there for the purpose coulde not be pictured. . . .' It is clear that though White made many drawings of birds he did not have the time to draw all they found. Harriot makes a similar reference to the naming and drawing of fish. It must have been the same for all the natural history subjects and it is certain that both men were kept extremely busy. Four centuries later, even after so much of White's original material has been lost, we can still judge how wide their field of work must have been, not only from Harriot's *Briefe and true report*, but also from the large number of birds and fishes (the mammals and most of the botanical material have disappeared) found in the so-called Sloane copies (figures 34–106). There can be no doubt that both men collected and drew (or intended to draw) every living creature and

plant they came across and gave each its name (usually Indian) and description, seeking to discover its economic value whether for clothing, food, medicine, housing or trade.

And what of 'the figures & shapes of men and woemen in their apparell' required of Bavin? We know that Harriot's main responsibility was to gather information about the Indians and it is not surprising that the chief value of his *Briefe and true report* lies in what he and White have to tell us of their way of life, Harriot in his text and notes to the plates, White in the illustrations themselves. Between them they provide a remarkable insight, if a somewhat narrow one, into the lifestyle of the Indian tribes they contacted – their rituals, food, houses, clothing, agriculture and something of their religion. Harriot's method is analytical and White matches it by the precision of his drawings. Just as their maps set a new standard of topographical accuracy, White's drawings of Indians and Harriot's notes achieve a new level of ethnological recording. What documentary and archaeological evidence there is tends to support their accuracy to the extent that where there is no such evidence we can expect their written and visual information to be soundly based. One small example of White's accuracy of observation, but which De Bry could not accept as it was outside his experience, and which therefore he modified in his engraving, is the way his Indians squat to eat in the drawing 'theire sitting at meate' (plate 41). This posture was changed in the engraving (figure 20), where the man and woman are seated on the ground with their legs stretched out before them in European fashion.

White must have made many hundreds of field sketches, initially, no doubt, two versions of each subject, one for Harriot's chronicle, one for his own file. For more than a year, until the arrival of Drake's fleet in June 1586, they were fully occupied with the graphic survey, carried out often in great haste and difficult conditions. By June 1586 White could have completed the bulk of his work. Afterwards he would have few opportunities to make new drawings and would have concentrated on producing more finished watercolours for presentation or possible publication.

In Lane's account of the departure of the colonists from Roanoke Island on 18 July he writes, 'and so hee [Drake] sending immediately his pinnaces vnto our Island for the fetching away of fewe that there were left with our baggage, the weather was so boysterous, and

the pinnaces so often on ground, that the most of all wee had, with all our Cardes, Bookes and writings, were by the Saylers cast over boord. . . .'[8] This can only mean that a part, perhaps a large one, of White's pictorial record, the charts and maps, Harriot's journals and any specimens they may have collected, were lost. It is clear from the material that survives that some was brought home or sent back to England beforehand. Whatever the actual extent of the loss the comprehensiveness of their record must have been destroyed at that moment. Of what survived or was sent home earlier, the Indian section was perhaps the most complete.

During the voyage, or just before, White is likely to have come in contact with Drake's artist, Baptista Boazio, who made drawings of the Spanish bases attacked by Drake and of natural history subjects.[9] A number of Boazio's town plans were published with a general map in 1588, in Walter Bigges, *Expeditio Francisci Draki*, and can be seen to include insets of reptiles and fishes engraved after John White – an iguana, an alligator or crocodile, a trigger-fish, a flying-fish and a dolphin or dorado. These must be the earliest known engravings of his work, preceding by two years De Bry's more famous plates. It seems that White allowed Boazio to make use of some of his material rather in the way that White himself used some of the Indian drawings of Jacques Le Moyne.

Lane's colonists reached Portsmouth at the end of July. If White had managed to bring away some of his drawings, we must imagine him spending much of his time during the five weeks of the voyage making finished watercolours from his preliminary sketches and perhaps designing some of his composite works such as the 'Village of Secoton' (plate 36) and the 'Indians fishing' (plate 43). After the arrival home his energies were to be directed to a different end, the organizing of a new expedition and the establishment of a permanent settlement of men, women and children.

Governor and After

From working artist and assistant to Thomas Harriot White in a short time became the central figure of the

8 See Quinn, *Roanoke voyages*, p. 293.
9 See Mary F. Keeler, ed. *Sir Francis Drake's West Indian voyage 1585–6* (London, Hakluyt Soc., 1981).

new venture. After the setbacks of the previous expedition Raleigh had to contend with some adverse publicity. The Roanoke colony was not in fact dead, as Grenville reached Roanoke shortly after the colonists had left and placed a holding party on the island. Limiting his own commitments Raleigh chose now to place the responsibility of organizing the new expedition on White's company. He clearly had the highest opinion of White's ability and dedication and of the latter there can be no doubt.

White chose as his associates men he knew in London and the west of England who could be expected to invest in the new venture in the expectation of profit. The would-be colonists were encouraged to bring out their families so that the colony would be self-perpetuating. As a minimum incentive every volunteer was promised 500 acres of land. This time the site envisaged was Chesapeake Bay as instructions from Raleigh confirm.

The latter part of 1586 was spent in recruiting settlers and the early part of 1587 in fitting out the ships in the Thames. On 7 January 'Iohn White of London Gentleman' was named governor of the 'Cittie of Raleigh in Virginia' and he and his twelve assistants were incorporated by Raleigh who, though retaining ultimate responsibility, allowed the company considerable independence. But we know very little about the organization of the expedition.[10] Besides the activities in London preparations were also being made in North Devon and the Isle of Wight but were evidently not carried through. The final tally of potential settlers was smaller than intended and clearly did not represent an ideal balance: eighty-four men, seventeen women and eleven children. The intention had been for 150 settlers. One of White's assistants was Ananias Dare, husband of his daughter Eleanor, who was also among the would-be colonists. White's squadron consisted only of three vessels, the *Lion*, a ship of about 120 tons, a fly-boat and a sea-going pinnace, the last two unnamed.

For the history of the expedition we have to rely solely on White's narrative.[11] They finally sailed not from the Thames but from Portsmouth on 26 April, probably because a proportion of the settlers came from that part of the country. White makes it clear that from early on in the voyage he had serious differences of opinion with Simon Fernandez, the master of the *Lion*. The main rea-

son may well have been that White, unusually for an English sea captain, turned his face against privateering, probably wishing to protect his settlers from the delays and dangers in fighting Spanish vessels whereas Fernandez was eager to continue the tradition. It is abundantly clear too that White had little control over Fernandez and would perhaps have exaggerated his personal malice to cover a certain ineffectiveness in himself. The fly-boat became separated from the *Lion* and he blames Fernandez for this, and at other stages of the voyage Fernandez is shown to be at fault, yet he is clearly being allowed his own way against White's better judgment. The voyage was slower than that of 1585 but took much the same route. They called at Santa Cruz (St Croix of the US Virgin Islands) where all the colonists were put ashore and had some unpleasant experiences with poisonous fruit and bad water, but managed to capture five turtles (probably loggerheads; plate 55), which must have provided heaven-sent variety in an otherwise monotonous diet.

Animosity between White and Fernandez seems to have come to a head when they reached Hatarask, in the Outer Banks, near Roanoke Island, on 23 July. Raleigh's instructions were first of all to make contact with the men left at Roanoke the previous year. As White was preparing to leave for the island in the pinnace, the sailors on board the *Lion* presented him with an ultimatum that he should land the colonists on the island and not take them on to Chesapeake Bay as Raleigh had instructed, giving the flimsy excuse that it was now too late to continue the voyage. We do not know enough to explain what was virtually a mutiny. Quite possibly Fernandez intended to be revenged on White for refusing to attack Spanish ships and settlements and in this he would have the support of his crew. On the other hand, and this is less likely, Fernandez could have been genuinely apprehensive of the hostility of the Chesapeake Bay Indians which he had observed between 1561 and 1566, when he served on Spanish expeditions to the area. Whatever the reason White had no alternative but to give way. Roanoke Island was after all familiar and offered accommodation, even if in need of repair, and was a suitable base for privateering raids on Spanish shipping. And to settlers and sailors alike the idea of immediate release from the rigours of a long sea voyage must have provided instant attractions.

The colonists were landed, the houses of the 1585 colo-

10 Quinn, *Roanoke voyages*, pp. 508–9.
11 *Ibid.*, pp. 515–38.

nists repaired and others built, and the search for Grenville's men made, though without success. It seems that they had been driven away by hostile Indians but where they were or what fate had befallen them was never fully discovered. Of more ultimate importance were White's attempts to re-establish friendly relations with the Indians of the neighbouring island of Croatoan and his reliance on Manteo, who was soon christened and invested Lord of Roanoke and Dasemunkepeuc. There were misunderstandings between others of the surrounding tribes and the settlers but Manteo remained loyal. George Howe, one of the assistants, was killed by Indians who had belonged to Wingina's tribe and who were believed to be responsible for driving out Grenville's men from Roanoke Island. White was obliged to send out a raiding party to Dasemunkepeuc, the centre of disaffection, to avenge Howe's death, but Wingina's men had fled the village. The fact that a friendly Indian from Croatoan was shot dead in error compounded the misunderstandings, though Manteo blamed the incident on the Croatoan men for failing to make their identity known. White's efforts to re-establish friendly relations with the other surrounding villages, Pomeiooc (plate 32), Aquascogoc and Secoton (plate 36), came to nothing.

In the middle of his lengthy preoccupation with Indian affairs, White records two more cheerful events: the arrival of the fly-boat on 25 July (so that the full complement of settlers was now ashore) and the birth of a daughter to Eleanor Dare on 18 August, christened Virginia in honour of the Queen and her new colony. But these events could not disguise White's precarious authority in the running of the colony. The question of future supplies now preoccupied the settlers and it was decided that two assistants should return to England to expedite the despatch of provisions. None volunteered and finally White was approached by the whole community. He refused at first, feeling that an early return home might be seen by his enemies as an act of desertion. He was finally persuaded to go but asked for safeguards for the protection of the belongings he left behind and a written testimonial stating that he was leaving by general request of the settlers. These he obtained. He boarded the fly-boat which with the *Lion* sailed on 27 August.

Both vessels kept together until they reached the Azores on 17 September, but then the *Lion* went in search of prizes and left the smaller ship to make a stormy passage and limp into Smerwick in the west of Ireland on 16

October. Her condition was so poor that White had to tranship to the *Monkey* in order to reach Southampton, where he arrived on 8 November.

Raleigh received White two weeks later and heard his story with sympathy, promising immediate preparations to despatch a pinnace with the more urgent supplies, to be followed by a larger expedition commanded by Sir Richard Grenville. We do not know whether he intended Grenville to carry out this plan to establish the City of Raleigh on Chesapeake Bay or merely to reinforce the colony as it existed on Roanoke Island. In the event, no reinforcements of any kind got away. There was a stay of shipping in English ports on 9 October because of the threat of the Spanish Armada. When it seemed Grenville's ship might be allowed to sail, as an exception, it was stopped by order of the Privy Council on 31 March 1588.[12] All hope of relief was not quite lost, as Grenville was permitted by Drake to make use of any small vessels the latter did not require. So it was that the *Brave*, a bark of 30 tons, and the *Roe*, a pinnace of 25 tons, left Bideford on 22 April carrying a few more colonists of both sexes and supplies of biscuit, meal and vegetables. Captain Facy of the *Brave* turned to prize-taking and then in his turn was attacked *en route* for Madeira by two French ships. There was a bloody fight and the *Brave* was left partly crippled and defenceless with its supplies looted. Its pilot Pedro Diaz was taken off and the vessel was fortunate to be able to reach Bideford on 22 May, as shortly afterwards did the *Roe* which had also abandoned the voyage. White was wounded with several others, but others had been killed and the responsibility rested solely with Facy.[13]

Raleigh and Grenville were so completely involved in the Armada campaign and its aftermath, after White's return, that nothing was done to relieve the colony that year or early in 1589. But White persevered in recruiting financial support for the company by associating more merchants with it. He sought to make it more effective by some reorganization of the assistants. A new agreement was made between the company, the merchants and Raleigh in March 1589 giving evidence of a lively interest in the venture in spite of all the difficulties of the moment. All the same it is not easy for us, without knowing more of the facts, to understand why it was not possible

12 *Ibid.*, pp. 560–61.
13 For White's brief account of the abortive voyage, see *ibid.*, pp. 562–9.

for a supply ship to sail before March 1590. Then at last White boarded the *Hopewell* at Plymouth. This ship belonged to the London merchant John Watts who awaited a licence for this and other ships of his to sail as privateers for the West Indies. William Sanderson, one of the group of merchants willing to underwrite White's company, came to an agreement with Watts that if a licence was forthcoming, his ship, the *Moonlight*, should join the others. White and Sanderson both claimed to have been instrumental in obtaining, with Raleigh's help, authority to sail on condition that the ship called at the colony before returning.

White sailed on 20 March and the *Hopewell* was joined by the *Moonlight* and other smaller ships at a prearranged rendezvous off Hispaniola on 2 July. Again we have only White's account of the voyage.[14] The *Hopewell* helped to capture a highly profitable Spanish prize, the *Buen Jesús*, but the English vessels were scattered and it was not until the middle of August that the *Hopewell* and the *Moonlight* anchored off Port Ferdinando in stormy weather. The following day they were misled by smoke seen rising from the Banks into believing that it signified the presence and position of the colonists, but that proved not to be so. On 17 August Captain Spicer of the *Moonlight* and six others were drowned as they attempted to get ashore when their boat capsized in heavy seas. Though the sailors were by now naturally reluctant to continue to Roanoke Island and search for the colonists in such appalling weather, White persuaded them to carry on. When their boat reached the north end of the island at nightfall they saw the light of a fire which again raised their hopes so that, in White's words, 'we let fall our Grapnell neere the shore, & sounded with a trumpet a Call, & afterwards many familiar English tunes of Songs, and called them friendly; but we had no answer.' At daybreak they went ashore and discovered that the fire came from grass and rotten trees. A little to the north-west of the site of the fort they found a tree topping a ridge carved in 'faire Romane letters CRO'. They also saw that the settlers' houses had been removed and the site enclosed by a strong palisade. On a post at the entrance they found CROATOAN carved in 'fayre Capitall letters', indicating to White that the colonists had moved to Croatoan, the island of Manteo's friendly tribe. As no cross had been added to the word he understood, by a previous arrange-

ment, that at least they had not left under duress. They appeared in fact to have left in good order, as no personal possessions or small arms were visible. Later the sailors found a number of chests which had been buried in a ditch on the site of the old fort and which the Indians had dug up and ransacked, including three belonging to White, who records 'about the place [were] many of my things spoyled and broken, and my bookes torne from the covers, the frames of some of my pictures and Mappes rotten and spoyled with rayne, and my armour almost eaten through with rust' – conclusive evidence that John White governor and John White artist were one person.

It was decided after another night of storm to go to Croatoan in search of the settlers and, being without a pinnace, to work the ship down the coast and come in as close as possible to the island. But as they were getting under way the *Hopewell* lost her anchor. The weather grew ever worse and, with food short and fresh water left behind and only one anchor and cable now available, they dare not risk the ship further in such dangerous waters. It was then decided that they should winter in the West Indies and resume the search in the spring. The *Moonlight*, short-handed and in a leaky condition, set course for England. After two days sailing south the *Hopewell* was blown off course and far out to sea towards the Azores. By the time they reached these islands, the plan to winter in the West Indies had to be abandoned. The *Hopewell* with White arrived in Plymouth on 24 October.

From the time White failed to continue the search for the colonists in Croatoan the mystery of the Lost Colony may be said to have begun. Though he certainly continued to believe that they were still alive there, or elsewhere in the region, he does not appear afterwards to have attempted to supply them. Perhaps this can be explained by the realisation that, had he found evidence that the colony had been destroyed, Raleigh's patent of 1584 would have lapsed, but it remained in force so long as the colonists were thought to be alive.

The last we hear directly of White is from the letter he wrote to Richard Hakluyt from Ireland on 4 February 1593 from 'my house at Newtown in Kylmore', Co. Cork.[15] These concluding lines say much about White and might almost be taken as an epitaph on himself and his colony:

14 For White's final narrative of the 1590 voyage, and the search for the lost colony, see *ibid.*, pp. 598–622.

15 *Ibid.*, pp. 712–16.

Thus may you plainely perceiue the successe of my fift & last voiage to Virginia, which was no lesse vnfortunately ended then frowardly begun, and as lucklesse to many, as sinister to my selfe. But I would to God it had bene as prosperous to all, as noysome to the planters; & as ioyfull to me, as discomfortable to them. Yet seeing it is not my first crossed voyage, I remaine contented. And wanting my wishes, I leaue off from prosecuting that whereunto I would to God my wealth were answerable to my will. Thus committing the reliefe of my discomfortable company the planters in Virginia, to the merciful help of the Almighty, whom I most humbly beseech to help and comfort them, according to his most holy will & their good desire.

Indirect evidence on White after this can only barely be said to exist. It is just possible that he took part in a voyage with Martin Pring in command of a reconnaissance ship in 1601 to search once again for the lost colonists and was once more frustrated by its crew, but there is no proof of this. Again there is no telling which John White is referred to when Brigit White, sister of John White, was in May 1606 appointed administratrix of the estate of her brother 'late of parts beyond the seas',[16] but this could just mark the end of John White artist and governor of the City of Raleigh in Virginia.

16 Somerset House, PCC Administrations Act Book, 1606, p. 38.

3 John White's Publisher, Theodor de Bry

The De Bry four-language edition of Harriot's *Briefe and true report . . . of Virginia* (1590) was by any reckoning a remarkable feat of publication: Latin, English, French and German versions were produced within days.[1] Thus Harriot's *Virginia* with White's illustrations was able to make its maximum European impact. That its impact was considerable says much for White's ability to create those 'true pictures' and for De Bry's expertise in engraving and publishing them. Moreover this volume took pride of place as the first in De Bry's series *America* where the illustrated histories of many of the great European voyages of exploration to the New World were later to be found.

Theodor de Bry, a native of Liège in Flanders, had set up his printing house as a Protestant refugee in Frankfurt-am-Main. He was naturally sympathetic to the idea of publishing the efforts of Protestant nations and minorities to plant colonies on American soil where Catholics under Spanish and Portuguese flags were already establishing themselves. His first intention was to publish Jacques Le Moyne's illustrated account of Laudonnière's ill-fated Huguenot colony in Florida, 1564–5, as the first part of his *America* for, as he observed in his foreword to the *Virginia* plates, the account of Florida 'should bee first sett foorthe because yt was discouured by the Frencheman longe befor the discouerye of Virginia'. It seems likely that he first came to know Le Moyne through the Sidney family (Lady Mary Sidney was a patron of Le Moyne's) for he came to England in 1587, commissioned to engrave Thomas Lant's drawings of Sir Philip Sidney's funeral which had taken place in February of the previous year. However, it is likely that he heard of Harriot's and White's work and was then persuaded by Richard Hakluyt to publish it first. No doubt White's patron Raleigh (he was also Le Moyne's) was readier with financial support to promote the *Virginia* volume, as the colony at that time was still a live issue and the memory of the year's stay in 'Virginia' still fresh. This pressure on De Bry was no doubt part of the explanation of Le Moyne's reluctance to part with his work to De Bry in 1587 though he and De Bry seem to have come to an understanding about its publication. De Bry himself says in a short notice in his *Florida*, which followed the *Virginia* in 1591, that he acquired Le Moyne's drawings after the latter's death in 1587 from his widow, but he was mistaken and must have meant 1588, the actual year of Le Moyne's death, when De Bry made a second visit to England.

It is doubtful whether De Bry acquired any of White's work on his first visit – White would at that time have been on his third American voyage – but by the end of his second visit he must have been in possession of a good many drawings of both White and Le Moyne. Unquestionably there was an exchange of ideas between the two artists. White also made direct copies of Le Moyne's work (plates 61, 62) and both made drawings of Picts of which De Bry may have availed himself. Perhaps then it is not surprising that there was some confusion in the use of this material by De Bry and his fellow engravers. We cannot be sure whether similarities in background details in both the *Virginia* and the *Florida* volumes were because they were composed in this way or whether the engraver drew on the work of both artists for small details where he may have thought that discrimination between them was unnecessary. More probably De Bry kept closely to the original drawing in hand, unless he had a strong reason for making some minor variation, so that any confusion was likely to have been unconscious. But it is certainly difficult to explain the appearance of a Timucuan headdress, exactly as seen in Le Moyne's *Florida* illustrations, on the idol in De Bry's *Virginia* (figure 25).

There is a greater confusion in the section of Picts and Ancient Britons which follows the Indian plates in the same volume. De Bry says that he had these figures from the artist who drew the Indians, that is to say John White, and that he wanted to include them to show that the ancestors of the British were once as savage as the inhabitants of 'Virginia'.[2] De Bry was no doubt as interested in comparative ethnography as the artists themselves. The exercise was fashionable and other contemporaries of White and Le Moyne made the same sort of historical reconstructions. But in this instance John White's figures (plates 65–69) are not faithfully reproduced: some are approximations, one does not appear among the engravings, and there is one engraving (figure 31) for which there is no original among White's drawings. These inconsistencies are puzzling since the Indian engravings, by contrast, correspond very closely in essential detail with White's drawings, all of which

1 See the facsimile of the English version of the De Bry edition issued by Dover Publications, Inc. (New York, 1972).

2 See the title-page to the section of 'The Pictes', *ibid.*

are in fact reproduced even though De Bry was working from different versions with added landscapes and other additional detail. But new light was thrown on the problem by the appearance some years ago in the art market of a miniature painting which corresponded almost exactly with the engraving just mentioned, for which no original White drawing exists, the young daughter of the Picts.[3] Even so the style was not White's. Could it be a contemporary copy of the De Bry engraving? But there was one essential difference between them: the engraving shows rather stylized floral patterns covering the girl's naked body, whereas the miniature shows her painted with a variety of well-observed flowers executed with such skill and understanding, and with such miniature charm, that they could only have come from the brush of Jacques Le Moyne. It therefore seems certain that De Bry was working from this painting or a replica of it. The discrepancies between the White drawings of Picts and Ancient Britons and the De Bry plates can now be explained by supposing that Le Moyne was the creator of all the originals of this section. De Bry may well have taken away drawings of Picts by both artists in 1588 and, without realising his error, attributed Le Moyne's figures to White. Perhaps other originals of these plates will come to light to reinforce – or explode – this theory.

But the primary purpose of De Bry's *Virginia* is given in the dedication to Raleigh which follows the main title-page in the English version. It is written in awkward misspelt English but the aim is clear enough. He can find no better way of expressing his goodwill than to cut in copper to the best of his ability the 'Figures which doe leuelye represent the forme and maner of the Inhabitants of the same countrye. . . . Addinge vnto euery figure a brief declaration of the same . . . that euerye man cold the better vnderstand. . . ?' He then goes on to say that the figures would commend themselves better if Harriot's 'rapport' of 'Virginia' were to be reprinted with them. For the English version of the edition Harriot's captions to the plates were translated from the original Latin by Richard Hakluyt. The 'True pictures' of Indians form a separate section preceding the Picts and Ancient Britons and following the text of Harriot's *Report*. Each section has its own title-page. It is an appropriately elaborate and handsome publication. De Bry includes

3 Now in the collection of Yale Center for British Art, New Haven, Conn. and reproduced in Paul Hulton, *Jacques Le Moyne de Morgues*, pl. 7.

in the Indian section twenty-three plates. It was clearly White's intention to supply De Bry with 'local colour' by way of landscape backgrounds and to add relevant detail to the basic figures (the only ones that have survived), usually back views as well as front views and more incidental objects, for example the pouch and tobacco pipe in the foreground of the man and woman eating (figure 20), the rattle along with the English doll held by the young girl of Pomeiooc (figure 12) and the diversity of crops seen in the view of the village of Secoton (figure 24).

There are also four plates for which the originals have not survived: the large-scale map entitled 'The arriual of the Englishemen in Virginia', showing Roanoke Island and the adjacent coast and Outer Banks (figure 6); making a canoe (figure 16); the idol Kiwasa (figure 25); and the markings tattooed on the backs of Indian chiefs (figure 27). As a result of these new elements and additions the De Bry plates give us greater insight into the culture of these South-eastern Algonquians than do the drawings themselves. It is as if the light by which we observe them is brighter and our range of vision somewhat wider.

De Bry, who engraved most of the plates, and Gysbert van Veen, who signed three, were highly professional craftsmen. That they attempted accurately to reproduce the material they were given is not in doubt. Where we can compare the engravings with the originals, not it must be stressed again the versions actually used by them, we can see how faithfully they reproduced their models. Their ability to draw the human figure was in fact rather better than White's so that they, not always consciously perhaps, tended sometimes to idealize and to Europeanize the Indian figure and features. They would often make the female Indian face accord more than did White's drawings with European ideas of beauty and attractiveness, introducing Mannerist stylistic characteristics then in fashion more markedly than White himself. But there is at least the one example (plate 41) of a posture which De Bry considered so strange that he deliberately modified it. But this kind of modification is exceptional. The others are rather trivial departures from White's record which merely serve to emphasize how closely De Bry generally kept to his models.

The De Bry plates were boldly and skilfully worked and printed to a high professional standard. Though the *Virginia* volume was followed by many others in the

America series it is doubtful whether any of them made the same visual impact as these clear and scientifically presented images of the South-eastern Algonquians. Not until the nineteenth century was any Indian tribe so accurately observed and so convincingly portrayed. De Bry must take most of the credit for making an interested readership throughout Europe simultaneously aware of this achievement. His success can be measured by the great number of White–De Bry derivatives which have been used to illustrate accounts of the American Indian which often have nothing to do with the South-eastern Algonquians of 1585, or in other ways such as designs for ballet or for the decoration of ceramics.

4 The History and Publication of John White's Drawings

The many hundreds of preliminary drawings or field-sketches which John White must have made on the voyage to the Outer Banks and in the Roanoke Colony between April 1585 and June 1586, not to mention those he may have made on the reconnaissance expedition of 1584, constitute the primary collection. This was personal to White and kept in his own portfolios. It would have consisted of rapid outline drawings in black lead or the point of the brush, with colour notes or added watercolour washes, but sufficiently definitive to allow him at some later date to produce satisfactory finished versions. We can only guess at his system of working. He may have found it necessary at the end of each day to add colour to his outlines or he may have reinforced them immediately with washes of colour. Such drawings we can presume from Harriot's *Briefe and true report* covered most of the visual aspects of Indian life including studies of many individual Indians, as well as a wide range of animal and plant life, together with charts and sketch-maps. It is an accident of history that no studies survive of mammals and that there are few plants among the drawings. It is more doubtful whether White would have considered it necessary, or could have spared the time, to make any record of the life of the colonists themselves, even though he did record incidents involving the English in the West Indies on the outward voyage. Perhaps the first of the finished drawings to be made would have been for Thomas Harriot so that he could begin to compile the 'chronicle' which they intended to publish.

It is clear that the surviving drawings relate to only a very small part of the primary collection of which, as we have seen, an unknown but perhaps large proportion was lost at sea as the colonists were leaving Roanoke Island. From that moment, as circumstances allowed, White would have produced his finished watercolours. Of these only sixty-three American subjects (including the profiles of the islands of Dominica and Santa Cruz, plate 2, which may not be White's work) have survived and these, with the exception of four insect studies, all belong to one set. This was evidently made within a short period of time, for all the drawings are executed on the same kind of paper and in a consistent style. These 'fair copies' were carefully drawn, coloured and inscribed as if for presentation. The title-page (plate 1), written we believe in White's own hand, the same which appears on many of the drawings, gives no clue to au-

thorship nor to the person for whom they were made. Any evidence there may have been disappeared when the sheets were rebound in 1865 and the old binding discarded. The set could have been intended for one of several eminent people involved in the colonizing venture – Raleigh, Grenville, Walsingham, or even the Queen herself – but if so, we would expect a dedication to be included, but nothing of the kind was referred to when the volume of drawings in its original binding appeared in Thomas Payne's catalogue of 1788.

Besides the drawings connected with the Roanoke venture the set also contains studies of a man and a woman of Florida after Jacques Le Moyne, two Eskimo drawings – of the man and of the woman and her baby brought back to England from Frobisher's voyage of 1577 – five figures of Picts and Ancient Britons, five Middle-eastern and Oriental costume studies and two drawings of Old World birds. All are drawn in the same careful way though the Oriental studies are much less convincing than the Indian or Eskimo figures and give every sign of having been derived from some earlier costume book. Though it may seem strange that White included such diverse drawings in one set, particularly if it was intended for presentation to someone in or closely connected with the colonizing circle, this is very much in line with the work of other contemporaries, reflecting the increasing interest then shown in comparative ethnology, when races of the Old and New World and of the ancient historical past had become subjects of intense curiosity and speculation.

The drawings cannot be precisely dated but must be close in time to the lost set of drawings used by Theodor de Bry, to which, to judge from the engravings, they corresponded closely in their main details. Since they were less elaborate than those De Bry used, it is likely that they were made before rather than after them. Thus, if De Bry returned from his second visit to London in 1588 with his set of White's drawings, it is probable that the surviving set had been completed by then.

The four original insect studies surviving from outside the set belonged to Thomas Penny, the Elizabethan entomologist, whose manuscript on insects, 'Insectorum . . . Theatrum,'[1] was edited by Thomas Moffet but not pub-

1 British Library, Department of Manuscripts, Sloane MS 4014. See also Paul Hulton and David Beers Quinn, *The American drawings of John White, 1577–1590* (London, 1964), I, pp. 24, 48–9, 71–2, 134–5.

lished until 1634. The drawings are all pasted into the manuscript and one, the swallow-tail butterfly, has Penny's inscription saying that he had it from White. This is the only time White's name (the note is in Latin and White is referred to as 'Candidus') appears on any of the drawings and is another piece of evidence of White's authorship of the main set, since the drawing duplicates the butterfly there (plate 58), and in fact is rather less well drawn. The same is true of the other three which are likewise duplicates. Penny appears to have received them direct from White.

No other original drawings by White are known but other people must have possessed versions of his drawings. John Gerard, author of the *Herball*, as we have seen, evidently knew White and illustrates his entry on the milkweed with a woodcut from a somewhat simplified version of the drawing in our set (plate 50). He also says that he discussed with White the root from which sarsaparilla was obtained.[2] It is likely that White was able to show him or give him a drawing of the plant.

The so-called Sloane copies (figures 34–106) cannot compare with White's original drawings in quality or definition but, because they contain a considerable number of subjects not found in the original set, increase our knowledge of White's achievements to a marked degree. They were discovered by Dr Hans Sloane, the collector and founder of the British Museum, *c*. 1706–7, in the hands of White's descendants. Because of his familiarity with the De Bry plates, he immediately connected them with these drawings which he not unnaturally believed to be the originals of the engravings. In 1709, in some excitement, even several years after his discovery, he wrote to the Abbé Bignon an account of his find. He says that he had thought of the De Bry plates as so unusual and fine that he believed that the engraver had embellished them with his own inventions, but that when he saw the drawings he realised his error, for he was now looking at the originals. Moreover, he also found birds and fishes and other subjects not reproduced by De Bry. As the owners were unwilling to sell the drawings, he had had them all copied by a competent artist. He added that the volume was somewhat damaged by being used as a copybook by children.[3]

There is little doubt that the volume Sloane described to his learned correspondent is the same one that was later in his own collection. The words he inscribed on the flyleaf echoed those he wrote to the Abbé Bignon: 'The original draughts of ye habits, towns / customs Etc found in Groenland, Virginia, / Guiana Etc by Mr John White who was a Painter / Etc accompanied Sr Walter Ralegh in his voyag. See the preface to the first part of America of Theodore de Bry or / the description of Virginia where some of these / draughts are curiously cutt by the Graver'. The White family provenance too can be confirmed by another inscription in a seventeenth-century and semi-literate hand: ' . . . this Lent to my soon whit 11 Aprell 1673', i.e. lent to my son White. A woman in the seventeenth century, if remarried or a widow, might refer to her son by her former husband's name. If so the White family owned the volume in 1673. The conclusion is likely that a member of the family, perhaps a son or a grandson of White, made copies from his primary collection but there could be more than one copyist involved as their quality varies considerably.

The Sloane copies, as they came to be called, were already in existence early in the seventeenth century. We know this because, among the illustrations used by Edward Topsell, the writer on natural history, in his manuscript, 'The Fowles of Heauen or History of Birdes' (Huntington Library), which he worked on between 1608 and 1614, are a number of 'Virginia' birds which are clearly derived from White through the Sloane copies. One, the towhee, was stated by Topsell to have come from Richard Hakluyt.[4] The other derivatives presumably come from the same source. So Hakluyt was in possession of drawings apparently by the White copyist well before 1614.

Twenty-seven of the Sloane copies are of items found in the set of originals – Indian, Eskimo and natural history subjects – but two other Eskimo drawings are new, the seascape with Englishmen in a skirmish with Eskimos (figure 43), mentioned above, and the back view of the Eskimo man (figure 41). This is executed in the same way as in the De Bry plates, which show Indian figures viewed from the back as well as the front, which the original drawings do not show. In addition, there are forty-four drawings of birds, fish and reptiles, observed in the area of the Roanoke colony, copied from originals now lost as well as drawings of Tupinamba Indians of

2 John Gerard, *Herball* (1597), pp. 709–10.
3 Quinn, *Roanoke voyages*, p. 395.

4 See Edward Topsell, *The fowles of heauen or history of birdes*, Thomas P. Harrison and F. David Hoeniger, eds (Austin, University of Texas Press, 1972), p. 139.

Brazil which White clearly took from an earlier printed source, and several costume studies again from earlier published or manuscript sources. The 'Duca de Genoa' has '1575' inscribed against the caption which, if it refers to the year when White made the original drawing, is the earliest date to be associated with his work. Quite apart from the items mentioned which all seem to be derived from White himself, there are fifty-seven pages of flower drawings, in a distinct hand, which seem to be copies of a Dutch florilegium, *c.* 1600. So the Sloane copies reflect, as do the original drawings, though to a more marked degree, the diverse range of material undertaken by White who built up his 'theatre of races' at second or third hand where he could not observe and record himself. It is interesting to note that where the copies repeat the subject-matter of the originals, variations and additions are frequently noticeable, evidence that the copyist was using White's primary collection rather than one of the finished sets.

Before his death Hans Sloane had made White's work, as transcribed by one or more early copyists, known to a number of people. He first of all made his own copies of these copies available to students and scholars and later, when he acquired the drawings, allowed others access to the volume. One of those who studied them with special interest was the pioneer naturalist in southern North America, Edward Catesby. He copied no fewer than seven items direct from the Sloane volume, turning them into illustrations for his famous work, *The natural history of Carolina, Florida and the Bahama Islands* (1731–43), making acknowledgement in only one instance, for the swallow-tail butterfly, not to White but to the manuscript of Sir Walter Raleigh, that is to the Sloane copy. So a number of White's drawings were published for the first time by one who visited some of the same areas of the New World but nearly 150 years later, not as the work of the artist who first drew them but as that of his eighteenth-century successor.

The volume of copies came by Sloane's Will, with the rest of his collection, to the British Museum in 1753. He had been instrumental in arousing considerable interest in the content of the drawings rather than in their author and the part he played in the first attempt to found an English colony on American soil. There is no evidence after Sloane's death that this interest was maintained and it was more than a century before it was renewed.

White's original drawings were lost or hidden from sight but the set which now survives made a brief reappearance thirty-five years later. In 1788 it was described without specific provenance in the sale catalogue of a London bookseller, Thomas Payne the elder. The entry, no. 284, repeats the words of the autograph title and gives details in italics, *75 drawings coloured in the original binding. Folio – fourteen guineas.* From the title of Payne's catalogue it seems that the drawings belonged to the library of a 'nobleman'. The item was noted by Edmund Malone, the dramatic critic and agent of James Caulfeild, first earl of Charlemont. Malone wrote to him on 12 March bringing the item to his notice and Charlemont replied by return agreeing to the purchase. The drawings remained in his Dublin library for nearly eighty years and during that time there is no evidence that they attracted the attention of any interested scholar, but they were at least carefully preserved. In 1865 the third earl, James Molyneux, no doubt realising that he had in his possession a unique collection of drawings of a growing interest and value to a wider public, sent them for sale to the rooms of Sotheby, Wilkinson and Hodge. Here they came near to destruction, for a fire broke out in an adjoining warehouse and came so close as to scorch the edges of the sheets of drawings before it was brought under control. They were then seriously threatened by water and the saturated volume lay with other books under pressure for three weeks before it was salvaged and placed in the sale of 11 August. The sale catalogue highlighted for the first time the artistic and scientific interest of the drawings: 'A most interesting and highly important collection of co[n]temporary drawings, beautifully executed in colours heightened with gold and silver. The delineations of the natural history show that Mr White must have been a first-rate naturalist.' They were bought by Henry Stevens of Vermont, the bibliographer of *Americana*, for £125. Like Sloane his curiosity about them was quickened by his familiarity with the De Bry engravings.

A new chapter in White studies had begun. The climate of opinion had changed since Sloane's day and there was now a new interest, particularly among Americans, in the early history of their country. Stevens was perhaps the first to realise the value of the drawings as historical documents, a realisation which was gradually to involve scholars on both sides of the Atlantic. Having bought them Stevens was faced with the task of refurbishing the drawings. He speaks of the damage caused by fire and water as negligible. From the fire there was

admittedly only charring along the edges of the sheets, which was dealt with simply by trimming them. But the water damage was more substantial than he allowed. The original volume was interleaved with plain sheets which absorbed a considerable amount of the pigment and some black lead, to the extent that if these offsets were the only surviving record of White's work we would still have some idea of the quality, colour and detail of many of the watercolours, though the degree of offsetting varied. We can be sure that the watercolours would originally have given a much stronger and more colourful impression than they do now. The drawings were remounted in one volume, the offsets in another, in full red morocco. Unfortunately, Stevens allowed F. Bedford, the binder, to discard the original binding without making any record of it. It is hard to believe that it contained absolutely nothing to indicate its earlier history or provenance.

To Stevens we owe a considerable debt for securing the drawings physically after their ordeal and by his own researches and enthusiasm reviving interest in the drawings and in White himself, the latter a new element as Sloane was content with what was known of White from De Bry and Hakluyt. He showed the drawings to collectors such as William Smith whom he hoped might be able to throw more light on White, about whom he himself had done some research. He could be traced, he said, 'as late as 1622 and perhaps later', though he does not give his source for the statement. It is doubtful whether he found much that was new about White or he would have referred to it.

Stevens's hope was to sell the drawings to an American collector. He was in close touch with James Lenox, the bibliophile, for whom he frequently found books. As he knew he already possessed De Bry volumes, he expected him to show a special interest in the White originals so closely connected with part I of *America*. Strangely, he failed to stimulate the collector's appetite, either because of some failure in communication or because Lenox was preoccupied at the time, soon after the rebinding of the drawings, with other matters. Dr Palsits, who edited Stevens's *Recollections of James Lenox* (1951), thought that Lenox 'was still in the mood of the Civil War' and not having seen the drawings 'did not realise their purport for his already large De Bry collection'. This seems a barely adequate explanation of his reluctance to buy. Having failed with his own country-

man Stevens turned to a collector of a different kind, Anthony Panizzi, Principal Librarian of the British Museum. Panizzi was interested and believed the Museum would gladly buy the drawings. Stevens made his formal offer on 22 March 1866, the price of the drawings 200 guineas, of the offsets 25 guineas, £236.25 in all. Two days later the Museum Trustees gave their approval of the proposal to purchase. A curious footnote to the transaction was that Stevens, who was so knowledgeable about the drawings, referred to them in his offer as 'duplicates' of the Sloane drawings. He cannot have failed to notice that they are distinct and differ in many small details.

No doubt the chief reason for the acquisition in Panizzi's mind was the existence of a fine copy of the English version of De Bry's *Virginia* in the Grenville Library which contained some of the rarer volumes in the Museum's collection. He placed the drawings and offsets next to the De Bry volume. By now the British Museum contained all the surviving drawings by or after White – the original set in the Library, the Sloane and the Moffet drawings in the Department of Manuscripts. To the modern mind this arrangement seems strangely inappropriate. Whatever pleasure Panizzi took in preserving the drawings and the engravings together, the placing of drawings in a collection of printed material was an inconsistency and probably accounts for the non-appearance of the volume of drawings in the Museum's general catalogue of printed books until 1905 when they were published in the *Supplement* to the catalogue. Again the Department of Manuscripts was not entirely appropriate for the Sloane volume after the setting up in the early nineteenth century of the Department of Prints and Drawings to which it was transferred only in 1893. The later nineteenth-century student, interested in the earliest period of English expansion in North America and knowing his Hakluyt and De Bry, might have studied in the British Museum Library and remained in ignorance of the existence of the original White drawings. It is true that the more specialist reader might have been aware that they were recorded in the catalogue of the Grenville Library, *Bibliotheca Grenvilliana* (1872) as G.6837, just as the Sloane volume appears in the catalogue of Sloane manuscripts as no. 5270. Symptomatic of the widespread ignorance in England of the originals was the entry on John White in the *Dictionary of National Biography* when, as late as 1900 (vol. LXI), Thomas Seccombe treats White simply as a draughtsman on the strength of the Sloane

copies. He clearly did not know of the existence of the originals.

The reappearance of the original drawings was at the time attended with a certain amount of publicity. The London *Times* noticed it and Stevens himself described the drawings and their sale to the British Museum in *Bibliotheca historica* (1870) a few years later.[5] Even before this several American scholars connected with the American Antiquarian Society were interesting themselves in the Sloane copies which, before the emergence of the original drawings, continued to be thought of as White's original work. The earliest of these was the American-born treasurer of the Linnean Society of London, Dr Francis Boot, who made a summary catalogue of the contents of the Sloane volume which he published in *Proceedings of the American Antiquarian Society* in 1860 and in the appendix to volume IV of *Archaeologia Americana* of the same year. Though he had been requested to do this by the American antiquary, E.E. Hale, perhaps the chief reason why he was primarily attracted to the copies was because of the flower drawings bound up with the volume, which may have had nothing to do with John White.

It is interesting to note that this first publication in detail of White's drawings, or copies, was issued with recommendations that they should be reproduced in facsimile – a characteristic example of the enthusiasm shown by Americans for these graphic documents which they believed warranted the expense of accurate reproduction. American insistence on this vital step was to mark the later history of the drawings. Another writer in *Proceedings of the American Antiquarian Society*, Charles Deane, the historian of Maine, reported the acquisition of the set of original drawings by the British Museum, though the first detailed account of them was that of Stevens in *Bibliotheca historica*, already mentioned. It was in fact ten years after this that the first reproductions of any of White's drawings, consisting of some of the Indian figures and the maps, were published by Edward Eggleston in the *Century Magazine* in 1882 and 1883. The same writer was the first to compare the originals with the Sloane material which he could now see were 'early and rather clumsy copies', not the preliminary drawings for the De Bry plates which he originally believed them to be.

Knowledge of the drawings was still confined to pub-

5 Pp. 223–6, item 2487.

lications which for the most part could be considered specialist. Popular publicity for White and his drawings began when the first colour facsimiles were exhibited at the Chicago World's Fair, 1892–3. These were the so-called 'platinum photographic prints' taken from the originals and coloured by hand (Smithsonian Institution, Washington). Process colour reproductions followed in 1903 when two Indian subjects were published by W.H. Holmes in the *Twentieth Annual Report* of the Bureau of American Ethnology for 1898–9. In England publicity came later and was more restrained, but the collotype reproductions in monochrome of four American subjects and two maps, which illustrated the Maclehose edition of Richard Hakluyt's *The principal navigations, voyages, traffiques & discoveries of the English nation* (1903–5), were of excellent quality.

In the meantime, in the British Museum, the transfer of the Sloane drawings to the Department of Prints and Drawings in 1893 heralded the beginning of a new appraisal of the whole of the surviving White collections. This gained sufficient impetus to make the transfer of the original drawings necessary and finally inevitable. It followed in 1906, in time for their inclusion in Laurence Binyon's pioneering *Catalogue of drawings by British artists . . . in the British Museum*, vol. IV (1907). They were placed in the first period of the English section and in fact are the earliest English drawings in the department with the doubtful exception of one by Nicholas Hilliard. Earlier English work in the national collection, both medieval and sixteenth-century, largely found in illuminated manuscripts, belongs to the Department of Manuscripts (now part of the British Library). At last it was possible to study the drawings in the context of a long line of English draughtsmen from White's day to the present. They were considered not only as historical documents but as examples, the earliest we have in modern times, and different in style and technique from their predecessors, of draughtsmanship in watercolour, later to become such a distinctive feature of the English School. For the first time an art historian and connoisseur of English drawings, excited by the implications both historical and artistic of this chance survival of so much original material which could be firmly related to English activities in the New World, 1585–6, was able to study them intensively, measuring, describing and relating them to contemporary published documents. Binyon's enthusiasm was clearly shared by the Keeper of the Department, Sir

Sidney Colvin, who wrote in his preface to the catalogue that it 'contains no more interesting section than that which describes (for the first time fully and accurately) the famous album of drawings connected with the name of the Elizabethan traveller and explorer John White'.

Binyon's evaluation of the drawings and the deductions he made from these and other documents about White's place in Raleigh's enterprises and the significance of his work, have formed the basis, with some reservations, of most subsequent work on White. Over a period of twenty-five years he expanded his theme in British and American periodicals. His final conclusions on the drawings are contained in the *Thirteenth volume of the Walpole Society, 1924–5* (1925), illustrated with nine collotype reproductions in monochrome, one of them the drawing of the skirmish with the Eskimos from the Sloane volume. He was careful not to exaggerate White's artistic ability. 'The paramount interest of these drawings is not artistic: they are documents invaluable for the ethnologist and historian.' Yet in his book, *English watercolours* (1933), he sees White as a founder of the modern school of English watercolour painting. This opinion is discussed below. Certainly White's ability as a draughtsman was of particular interest to Binyon. More than any other he established White's reputation in scholarly circles in both Europe and America. As if to confirm this the city of Frankfurt, where De Bry had first made White's Indians familiar to a European readership three hundred and twenty-five years before, produced in 1925 a special publication in honour of White and his engraver, using five plates which appeared in Binyon's article for the Walpole Society with a frontispiece in colour.

Colour reproduction of White's drawings was now becoming more accurate and the British Museum in 1934 published the first colour postcards of White's Indian subjects which were by far the best reproductions in colour yet produced. White had become a popular name and large numbers of these cards must have been sent across the Atlantic to North Carolina where White first drew their originals. The need now was for facsimiles good enough to allow ethnologists, specialists in the various branches of natural history and other interested researchers to examine the drawings in detail in order that a full evaluation could be made. A number of American scholars, librarians and museum officials were pressing for just such a publication and the British Museum, now fully responsive to the growing interest in the

drawings, started to plan the production of facsimiles in colour of all the American drawings. A.M. Hind, Keeper of Prints and Drawings, initiated the project and issued a prospectus. The process of reproduction chosen was colour collotype, Laurence Binyon was to write the introduction and the studies of the ethnological and scientific aspects of the drawings were to be undertaken by American scholars. Though the prospectus, issued by the Pilgrim Trust, contained two excellent collotypes, of the Indian woman and young girl (plate 33) and of the terrapin (plate 57), and publicity was provided at length by *The Illustrated London News* (3 October 1936), the project foundered for lack of subscribers in the aftermath of the depression. No publisher at that time either in England or America would consider producing such an elaborate book. It is an interesting fact that even before the end of the Second World War, and in the early days of peace, efforts were made in America to revive the plan by successive Librarians of Congress, Archibald MacLeish and Luther Evans. Randolph G. Adams, Director of the William L. Clements Library and active in White studies before the war, was also involved. But their ideas were pre-empted by the appearance of the first general book on John White (and Jacques Le Moyne de Morgues), *The New World* (New York, 1948) by Stefan Lorant. It clearly met a general demand and was widely distributed and read. A second (London) edition was published in 1954. Its success acted as a spur to a more adequate publication.

In the meantime a new catalogue of drawings by British artists to supersede Binyon's was being prepared in which White's drawings and the Sloane copies figured prominently. At about the same time Professor David B. Quinn was bringing to a conclusion his monumental work of editing documents relating to Raleigh's expeditions, *The Roanoke voyages*. These included the White drawings and the De Bry engravings alongside the other manuscript and printed documents, and the content of these graphic records was analysed in precisely the same way.[6] The book was published by the Hakluyt Society in two volumes in 1955. Volume I of the new *Catalogue of British drawings*, in which the White material followed Quinn's arrangement, appeared in 1960.[7] This was the moment to combine the resources available to the editors

6 Pp. 390–464.
7 Edited by Edward Croft-Murray and Paul Hulton. See pp. 26–86.

of these two books in order to produce the kind of publication which so many had attempted to initiate before and after the war. It was necessary to bring together the special knowledge not only of historians and art historians but of ethnologists, zoologists, botanists and map experts. It was equally important to employ the best available processes of colour reproduction and it was essential to involve an American publisher. The University of North Carolina Press was the obvious candidate and Lambert Davis, its Director, who for so long had been interested in such a publication, was able to bring in his organisation as co-publisher with the British Museum. For the facsimile reproductions colour collotype was chosen as the process most likely to provide the precision and authenticity required. In addition a process was employed by which certain colours, difficult to obtain in reproduction in the normal way, such as gold or silver, could be added to each plate by hand through stencils.

The American drawings of John White was published in 1964.[8] In addition to the work of the main editors, a number of specialists in the fields already mentioned contributed chapters and notes. It was an Anglo-American effort of some magnitude and was followed by another which certainly had a more immediate impact. The British Museum, not hitherto a lending institution, despatched all the original drawings and some of the Sloane copies to the United States for exhibition in Raleigh, N.C., Washington DC and New York City.[9] They were seen from 30 January to 5 April 1965 and attracted widespread interest, particularly in North Carolina where it seemed as if the drawings had come home. Since then John White's work has been widely reproduced and his name has become familiar to many in England and America. This recognition would have been even slower to materialise if De Bry had not visited England and White's drawings had not been engraved so early and so eloquently. Key figures such as Sloane and Stevens would not then so easily have been alerted to the significance of the drawings. The process of recognition and reappraisal might be carried still further if for instance other White drawings were to come to light. If that is unlikely it cannot be ruled out as an impossibility.

8 Edited by Hulton and Quinn, in two volumes: I *A catalogue raisonné and a study of the artist*; II *Reproductions of the originals in colour facsimile and of derivatives in monochrome*.

9 Catalogued in *The watercolour drawings of John White* (National Gallery of Art, Washington; North Carolina Museum of Art, Raleigh; Pierpont Morgan Library, New York, 1965).

5 The Meaning and Influence of the Drawings

White's Record of the Carolina Algonquians

Of all White's work the drawings of the Indians have made by far the biggest impact on the public imagination. This is to a large extent the result of De Bry's choosing to engrave only these American subjects, or other versions of them, and no others, apart from maps, long before the drawings were rediscovered. There can be no question that in White's time the appearance and lifestyle of a race of men hitherto unknown in England, discovered as the result of a long and difficult sea voyage, created exceptional interest, as indeed it would today. What the drawings tell us about the tribes which once inhabited the coastlands of what is now North Carolina and the most southerly part of Virginia, is of special value for its unparalleled accuracy. One eminent ethnologist, Dr William C. Sturtevant, who has made a close study of White's Indian record, has gone so far as to say, 'There is no comparable set of illustrations by a single hand dealing with one small culture area anywhere in North America before the days of photography.'[1]

White made his drawings at the most favourable moment when the English were in first contact with the Carolina Algonquians, as these tribes came to be called. They are portrayed as yet unaffected by European influences. Within two or three generations both their culture and distribution had changed to a marked degree. White's images with Harriot's descriptions, backed by later records and archaeological evidence, provide a surprising amount of information about these people, even if it is very far from being a complete picture. They have sometimes been called, more precisely, the Secotan from the name given by White to the area of the mainland south west of Roanoke Island (figure 5). They were distinct from the people encountered by the English farther north in the neighbourhood of the later Jamestown colony, the Powhatan, though closely related in language and culture. Together these two peoples are generally referred to as the South-eastern Algonquians.

As White shows in his larger-scale map (plate 60) the Carolina Algonquians lived in villages scattered along the coast, on islands, on river estuaries, or further upstream on smaller tributaries in the area of the Carolina

Outer Banks. Always they were close to water which they navigated in shallow-draught, dugout canoes which are everywhere in evidence in the landscape background of De Bry's plates. In two instances these are the main focus of interest – the making of a canoe (figure 16) and the fishing scene (figure 17). These coasts were warm and abounding in fish and game. The fertility of the soil impressed the English, as did the variety of crops the Indians grew – maize, sunflowers, pumpkins, beans and 'melden' (Harriot's name for a crop which has been identified as salt-bush, *Atriplex hastata*) for food; tobacco and gourds for ritual and other purposes. Maize was the staple crop supplying an important part of their diet. Three crops were planted in sequence and harvested yearly by late September (plate 36). After this and during the winter the Indians largely moved out of their villages to gather fruit, berries, nuts and roots and to hunt game with bows and arrows and traps, and fish by means of spears and fish-weirs. They also lived on clams, oysters, mussels and other shell-fish. In general these activities outside the villages White would have found more difficult to record, though the fishing scene is one of his finest and most instructive drawings. How they cooked and ate some of the food they grew or caught is seen in three of his more intimate drawings (plates 41, 44, 45).

Their agriculture was simple enough. They would clear and burn the plant cover, build mounds of soil with digging sticks, then plant seed of corn and beans together, protecting the young crops by weeding, but using no fertilizers. 'Inter-cropping', that is planting a number of different crops together, was, according to Harriot, general practice though they could be planted separately as shown in figure 24. Weed invasion and decreasing fertility would probably oblige them to abandon fields after a few years. Land was set aside to be reused when it had regained its fertility. The area affected by permanent villages or towns was thus extensive. If there was not room to expand the potential cultivable area, the village might be moved so that entirely fresh land could be used.

White records with great clarity the two kinds of villages which the Carolina Algonquians inhabited, the open village, of which Secoton is the example (plate 36), and the village enclosed by a palisade typified by Pomeiooc (plate 32). Both kinds would contain at least ten houses which were rectangular and made of bent and tied poles to form rounded roofs covered with matting

1 Hulton and Quinn, *White*, p. 40. William C. Sturtevant's contribution on the Carolina Algonquians is summarised by the present writer.

or bark which also formed the walls. They could be as large as 72 by 36 ft and the occupants slept on benches arranged round the walls which are plainly visible in White's drawings of both villages. In both, too, the houses surrounded, or partly so, open areas where the ceremonies and most of the activities took place. Between a hundred and two hundred people would live in a village, each house probably containing more than a simple family group. We have no drawing of a 'capital' town, such as Chawanoac, which was appreciably larger.

Most instructive of all are the drawings which portray Indian individuals, not only their physical characteristics but a whole range of details of their clothing, body decoration and the ornaments they wore. Records and archaeological finds (the latter only concern imperishable artifacts) may tell us quite a lot about, for example, beads of different kinds, copper gorgets, feathers, tattooing and body paint, but it is quite another thing to see exactly how they were worn or applied. A fairly wide variety of clothing, made generally of deerskin, is shown by White, from the most common garments – the breech-clout which passed between the legs with one end brought over the belt to hang down in front, as worn by Indian men all over eastern North America; and the apron-skirt, consisting of an apron-like flap hanging in front and sometimes behind, and worn generally in south-eastern North America by Indian women, and also by men among the Carolina Algonquians – to the deerskin mantle, worn in winter with the hair on the inside, shown best in the fine portrait of the old man (plate 34); and the rabbit skin cape worn by the priest (plate 42). Most striking of all, providing bright colouring among the brown and greys of the skins, are the ornaments, body painting and tattooing. Tattooing was probably confined to women, while painting was used widely by both sexes. The best known and most elaborate example of this is White's Indian in body paint (plate 48), decorated for war or some ceremonial occasion. Necklaces of pearl, copper, bone or shell beads were worn widely by men and women and were sometimes simulated in paint.

White observed and drew the outward and visible signs of the culture of these people and, in addition to their houses, dress and bodily ornament, recorded some of their hunting and fishing weapons and many other artifacts used in their daily lives. He also drew some of their leading men, or *werowans* (a term used indifferently for chiefs or counsellors), and their wives, with their dis-

tinguishable dress and greater use of copper ornaments, but we are not told by White or Harriot anything precise about their status or whether the political structure of the tribe was hierarchical, or much in general about the social organization of the tribe. We do know that after death the dried bodies of their chiefs were preserved in special houses which, together with a religious image, *kiwasa*, were in the care of a priest (plate 38).

In the same way White portrays two of their 'religious men', the priest (plate 42) and the 'conjuror' or medicine-man (plate 49), but there is no clear indication of their precise functions. Again, they are distinguishable by dress and the conjuror wears a bird with wings outstretched on the side of his head as a badge of office. Harriot's description suggests the use of trance in the performance of his duties. White also drew two of the Indian ceremonies he witnessed, involving singing (plate 40) and dancing (plate 39), both of which certainly had religious implications. Their purpose is debatable though the dance must have been connected with the seasonal cycle. Yet Harriot is deeply interested to discover all he can about their religion and in his *Briefe and true report* gives several pages to the subject, claiming 'special familiarity with some of their priestes'. But 'for want of perfect vtterance in their language' he would undoubtedly have learnt more and that would certainly have been reflected in White's drawings.

The considerable amount of information which White's drawings do give us, at least about the material culture of the Carolina Algonquians, and which has been shown to be remarkably accurate, where it can be checked, provides points of reference of the greatest value for archaeologists working in the region and for ethnologists who have to interpret what they recover.

His Record of the Eskimos (Inuit) of Southern Baffin Island

White's two original Eskimo portraits (plates 63, 64) and the derivatives of these same compositions in the Sloane volume (figures 40–43) are the main part of the remains of a larger body of work executed on Martin Frobisher's second voyage to Baffin Island in 1577 in search of a north-west passage to Asia. They are versions of White's earliest American drawings and show a man, and a woman with her baby, of southern Baffin Island,

belonging to the Central Eskimo group and identified with the Nugumiut tribe.[2] In addition to these portraits is a landscape with Eskimos of the same area. Stylistically, the original drawings are entirely consistent with the other American drawings (and made at the same time though from earlier studies) and reveal the same careful attention to detail. They provide very limited but valuable evidence of the older Thule culture which has long since disappeared from Baffin Island, though it survived later in Southampton Island and today exists only in Greenland and northern Alaska. Though not quite the earliest realistic images of Eskimos to survive they are the most accurate and detailed of the early material.

The landscape (figure 43) records a skirmish, probably at Frobisher Inlet, when a number of Eskimos were killed and an Englishman was wounded. White is not just concerned with that incident but is anxious to include a detailed view of Eskimo territory and of how Eskimos lived – their weapons, their clothing, their tents and boats. All these are shown: their sealskin dress high-lighted against the sky on the cliff top; their bows and arrows engaging the Englishmen; their harpoons and spears carried by the men on the opposite shore; their summer encampment of skin tents on the headland; most of all, their light and speedy kayaks being paddled among ice-floes, in particular the kayak drawn large in the foreground to show its construction, the Eskimo filling the cockpit and holding up his paddle, this in contrast to the heavy, solid English boat behind. Though the drawing is a copy, and we can be sure that the original would be clearer in detail, yet it gives a most convincing impression as the work of an eye-witness, one who was particularly impressed by the mobility of the Eskimos.

The portraits are close-ups and particularly detailed. They show the woman with her baby captured at the time of the skirmish, the man, no relation to her, taken on another occasion, all three brought back to Bristol. Michael Lok describes the Eskimo man captured on the first voyage in 1576: 'His eyes little and a little [cole] black beard. His cullor of skyn . . . and face of a dark sallow, much like to the tawny Mores, [or ra]ther to the Tartar nation whereof I think he was.' This comes somewhere near the type portrayed by White. The woman's physique is similar to the type found in Baffin Is-

land with the common female pattern of tattooing. Both wear sealskin coats with hoods, trousers and boots. But, though finely drawn, they are not quite the same garments as found in the region today. Their hoods would be more pointed and not so close fitting as the man's and would not be extended in front into a yoke below the neck as shown. Hood-yokes occur now only in Greenland. The jackets in Baffin Island today do not have the long flaps hanging down behind as indicated by White but are straight cut or with only a small dorsal flap. The 'sole boots', with the soles coming over to the top of the feet, are well drawn. But the thigh-length boots worn by the woman are today found only in Southampton Island and Greenland.

Though the Eskimo drawings among the Sloane copies are cruder than the original versions they add something to our information. Besides the bow in his right hand the man (figure 40) is grasping a paddle in his left with pointed blades (the top one is cut off by the edge of the sheet) and rings on the handle below each of the blades. There is also a back view of the man (figure 41), which has no counterpart among the originals. The portrait of the woman (figure 42) differs considerably in detail from the original version, and the face, as with the man, is definitely Europeanized but the composition is clearly derived from the same study as the original drawing.

Two woodcuts also appear to derive from the group of Eskimo studies made by White in Baffin Island (or afterwards in Bristol).[3] They illustrate two editions of Dionyse Settle's account of Frobisher's second voyage, one the French edition of 1578, the other the German edition of 1580. Both show similar Arctic landscapes with Eskimo figures which have something in common with the Sloane volume landscape already described, notably the feature of an Eskimo man paddling a kayak in the foreground. This time he is wielding a spear-thrower in his right hand and is about to discharge a triple-headed spear. A sea bird is shown pierced by one of the spears and coming down in the water. Standing on the shore in the background are immediately recognizable versions of White's Eskimo man and woman. The man is holding a bow in his right hand and carries a kayak in his left arm. In the German version the woman stands in profile

2 See *ibid.*, 'The Eskimos of southern Baffin Island', pp. 43–7, based largely on information supplied by Kaj Birket-Smith which is used by the present writer.

3 Reproduced in Hulton, 'John White's drawings of Eskimos', *The Beaver* (Winnipeg, Summer 1961), pp. 16–20, figs. 5, 6; Hulton and Quinn, *White*, pls. 147(a), (b).

showing the baby tied to her back by what appears to be a sling which is separate from her hood. In both woodcuts are tents with half-open flaps and vertical or near-vertical walls, and a dog-sledge much misunderstood, the sledge looking very like a kayak. Though both prints are at second or third remove from White and give a somewhat distorted view of Eskimo life, they also give glimpses of a wider range of studies. White's approach closely anticipates his manner of recording the Southeastern Algonquians eight years later. In all probability it was, without Harriot, less methodical. Though the original Eskimo portraits are as meticulously executed as are the Indian portraits, there was no De Bry to publish the sort of informative captions which Harriot was later to provide. Neither originals nor copies have between them a single inscription by White in the way of explanation.

But these Eskimos are not so anonymous as they may appear, for the end of the lives of each one of them is documented.[4] They died within a short time of reaching England where they immediately created something of a sensation. White was not the artist officially commissioned to paint them. That was Cornelis Ketel, a Flemish artist then resident in London. He came to Bristol to make five paintings of the man we may call Calichough – the name appears in a variety of spellings – three in native dress, one in English dress and one naked. He also made four paintings of the woman and, though all were commissioned (£5 for the largest size) by the Cathay Company, two were intended for the Queen. Pictures of the man and the woman were almost certainly hanging at Hampton Court and were traceable up to the time of James II but seem not to have survived. Only Ketel's portrait of Frobisher can be seen today in the Bodleian Library, Oxford. If the Queen became familiar with the Eskimo portraits she was never to meet their subjects. Within a month of giving a demonstration on the River Avon at Bristol of the Eskimo way of paddling their boats and of spearing birds (as shown in the woodcuts) Calichough died, quickly followed by the woman. Both were buried at St Stephen's church, Bristol, and were entered in the parish register – perhaps the first occasion on which the deaths of non-Christians were so recorded. The child came nearest to being presented at Court, and was taken to London and lodged at the *Three Swans* in

the City with that intention in the mind of his guardians, but he suddenly fell ill and died before anything could be arranged. Dr Edward Dodding attended Calichough in his last illness and conducted an autopsy. He made a lengthy report in Latin on his patient which has recently been newly translated. Dodding found the cause of death to be a lung infection caused by two broken ribs, an injury probably sustained aboard ship or shortly before the voyage to England and which had remained untreated. He was undoubtedly an able physician and not unsympathetic to the unhappy plight of his patient, though it is clear that his greatest sorrow was to have been unable to save the Eskimo's life, so destroying the Queen's hope of ever seeing the 'heathen man'.

White's Contribution to Natural History

A passage in Harriot's *Briefe and true report* makes clear his intention of publishing an illustrated account of the birds, beasts, fishes, trees, plants and herbs they found in the Roanoke colony and the areas they explored.[5] Whether because he and White were never able to make good the partial loss of their records which occurred when they left Roanoke Island, or whether the plan was too ambitious, the natural history of 'Virginia' was never published. For the most part White's drawings of natural life remained hidden. Only a few of them entered the mainstream of published records and then largely indirectly and after a long period of time. Only fairly recently have the majority of his drawings of fauna and flora come to the attention of natural history specialists. It is true that Baptista Boazio and Theodor de Bry both published incidental examples in engravings whose main purpose was information of a different kind. Boazio, Drake's artist, sailed back to England with White and was evidently given access to his work. He recorded Drake's attacks on Spanish bases at Santo Domingo, Cartagena and St Augustine between January and May 1586, and in his town-plans and maps included insets of land and sea animals taken from White – a flying-fish, turtle, iguana, alligator or crocodile, and a trigger-fish.[6] The iguana and trigger-fish are fairly close copies, the rest rather crude approximations. Most of them had de-

4 See Neil Cheshire, Tony Waldron, Alison Quinn, David Quinn, 'Frobisher's Eskimos in England', *Archivaria*, no. 10 (Ottawa, Summer 1980), pp. 23–50.

5 Dover Publications facsimile, p. 20, l. 19.
6 Reproduced in Keeler, *Drake's West Indian Voyage*, pls. I, III–VI.

scriptions, the one for the iguana perhaps written with White's help. In this way a few of White's zoological images were circulated but without mention of his name.

De Bry reproduced White's work far more accurately and in several of the plates of his 1590 edition of Harriot's *Briefe and true report* includes details of crops and of land and sea animals. The engraving of the palisaded village of Pomeiooc (figure 23) shows part of a field of maize and some sunflowers. The plate of the unenclosed village of Secoton (figure 24) includes additional crops. There is a plot of tobacco as well as sunflowers and a field of maize at three different stages of growth. There is also a border of pumpkins. The engraving of the Indian fishing scene (figure 17) is, exceptionally, less specific than the drawing in that the birds flying in the background cannot be identified whereas the original shows swans, a brown pelican and what is probably a flight of duck. But a number of sea creatures can be named without difficulty: loggerhead turtles, sting-rays, a land crab, hermit crabs, two king crabs, hammerhead sharks, catfish and in the canoe a gar. The engraving of Indians eating (figure 20) shows, in the foreground, walnuts, four husked ears of maize and a scallop or clam shell. All these would give De Bry's readers some idea of the crops the Indians grew, the food they ate and the fish that lived in their waters, showing too something of White's capabilities as a draughtsman of natural life. But later writers on natural history took no account of these details or of Boazio's insets.

White himself was in touch with at least two contemporary writers, Thomas Penny, the entomologist, and John Gerard, author of the *Herball* (1597). He gave Penny drawings and information about insects after his return from the second Roanoke colony of 1587.[7] Penny noted and preserved them for his manuscript work but died in 1589 leaving his younger colleague and friend, Dr Thomas Moffet, to edit his Latin treatise which he called 'Insectorum . . . Theatrum'. It contains a number of references to White, as *Candidus*, calling him a most skilful painter. His drawings of the swallow-tail butterfly, fireflies and the gadfly (plate 77) are pasted into the manuscript. The swallow-tail has inscribed on it *Mamankanois*, the Indian name, and a note in Latin which can be translated as: 'This White the painter brought me from American Virginia, 1587.' There is also a description and drawing of a cicada brought from 'Virginia' by White. The drawing is probably not by White himself. The work was not published until 1634 and the English edition did not appear until 1658. John Ray, the great seventeenth-century naturalist and writer, at least noted the swallow-tail and fireflies in his *Historia insectorum*, published after his death in 1710, and so they passed into the Linnaean system. White was also in touch with John Gerard, compiler of the most popular English herbal of this or any other period. Gerard seems to have been a member of the company which sponsored White's colony of 1587 and was in charge of a famous herb-garden in Holborn. Though not a highly original writer he was a most experienced plantsman. It is a curious fact that he mentions and illustrates the common milkweed in the *Herball* which he calls the 'Indian swallow woort' but makes no reference at this point to White, though the woodcut illustration is clearly derived from a drawing by him.[8] Nor does he give the plant's Indian name or medicinal properties which are found inscribed on White's original. Yet in Gerard's account of the sarsaparilla he says he learnt about the plant from White,[9] but there is no illustration of it though it would seem likely that White, if he gave Gerard the information, would also have given him a drawing.

It is perhaps strange that Richard Hakluyt, the famous editor of English maritime enterprise, should never have referred to White as a natural history artist. Yet Hakluyt had much to do with De Bry's publication of White's Indian drawings and certainly knew the value of well-observed natural history specimens. It is equally curious that he did not possess any of White's original drawings of this kind, yet came into possession of copies of some of them early in the 1600s. For, as we have seen, (p. 21) Edward Topsell, the writer of books on beasts and serpents, mentions Hakluyt as the source of the drawing of one of the 'Virginia' birds, the towhee, in his manuscript, 'The Fowles of Heauen', others of which are also based on White, though the manuscript nowhere mentions his name.[10] Thus, though some of White's American birds

7 Hulton and Quinn, *White*, pp. 48–9.

8 *Herball* (1597), p. 752; Hulton and Quinn, *White*, p. 114.
9 *Herball*, pp. 709–10.
10 Hulton and Quinn, *White*, pp. 49–50, 119–20. Thomas P. Harrison has published reproductions of Topsell's 'Virginia' birds with their equivalents in the Sloane volume in *Edward Topsell and John White, the first water colors of North American birds* (Austin, University of Texas Press, n.d.).

were known to Topsell and others in Jacobean London, they went unnoticed by seventeenth-century writers like Willoughby and Ray.

As mentioned above, Mark Catesby took careful note of, and copied no fewer than seven of the Sloane copies, using them as illustrations to his *Natural history of Carolina* (1731–48). It will be remembered that he made no acknowledgement to White, but in one instance, for the swallow-tail butterfly, to the Sloane volume and Sir Walter Raleigh. The catfish, iguana, land crab, remora, gar, puffer-fish and the swallow-tail reappear attractively engraved in new backgrounds. Catesby's work was hardly less pioneering than White's, though undertaken 125 years or more later, and had the inestimable advantage of successful publication, while the older work lay undiscovered or little known. Moreover, it was published at a time when new discoveries in natural history were eagerly awaited. This time White's images, if not their first author, were noticed and carefully appraised. Linnaeus in his great *Systema naturae* (10th edition, 1758) cited five of them, and two of Catesby's plates, showing the catfish and the gar, were taken as the basis for his binomial designation of the type *Silurus catus* and *Esox osseus*.[11] So White in disguise, so to speak, was brought in a small way into the mainstream of eighteenth-century scientific advance in natural history. It was to be more than another two hundred years before his drawings were belatedly evaluated as early and distinguished contributions to our knowledge in this field.

White's Maps

From the topographical survey carried out by Harriot and White from Roanoke Island, 1585–6, together possibly with observations made in 1584, 1587 and even 1590, there must have come many sketch-maps and a group of finished maps. Of these five have survived: the rough sketch-map of the Pamlico Sound–Albemarle Sound area, the related map engraved by De Bry illustrating the arrival of the English, White's manuscript map of Raleigh's Virginia, De Bry's engraved version of it, and, probably the last to be made, White's manuscript map of the east coast of North America from Florida to Chesapeake Bay. They reflect both the remarkable mapping

achievements of the two men and the limitations under which they worked.

The sketch-map representing the earliest stage in the mapping process, and only possibly attributable to White, has already been discussed (see chapter 2). The engraving in De Bry covering part of the same area but extending somewhat to the north, 'The arriual of the Englishemen in Virginia' (figure 6) represents the final product deriving from such sketch-maps. The shape of its coastline is very close to that of the same section of coast seen in White's map of 'Virginia'. Though it purports to show how the English reached Roanoke Island it does not accord with Barlowe's narrative for July 1584 (though that gives few precise details of the final stages of the voyage) or with accounts of the 1585 expedition. An English pinnace is shown sailing south (the map is oriented to the west) towards Roanoke Island. It has been suggested that perhaps Harriot, who wrote the caption, was basing it on the narrative of his lost chronicle and that Amadas made a first attempt to reach the island from Trinity Harbour, the opening in the Banks opposite Albemarle Sound but a little to the north, and was therefore sailing south.[12] Perhaps he was thwarted or discouraged by the shoals with which White so liberally garnished the sounds surrounding Roanoke Island. It is interesting to see that grapevines are indicated on the coast in the position shown in the sketch-map; even more, to find here the sole indication of the enclosed Indian village of Roanoke near the northern end of the island. White has also been anxious to emphasise, by means of sunken vessels shown half-submerged on the shoals, the extreme danger to shipping presented by the Outer Banks with their shallow openings and exposed ocean coastline. As in the sketch-map the artist has used easily recognizable symbols for vegetation, crops, villages, fish-weirs and shallows, though ecological information is not given by means of inscriptions as it is so liberally provided on the sketch-map.

White's manuscript map of Raleigh's Virginia, covering the area from the present Cape Lookout to the northern shore of Chesapeake Bay, has been described as 'the most careful detailed piece of cartography for any part of North America to be made in the sixteenth century'.[13] In comparing it with a modern map of the

11 Hulton and Quinn, *White*, pp. 51, 127.

12 Quinn, *Roanoke voyages*, p. 415, n. 5.
13 *Ibid.*, pp. 847–8.

same stretch of coast great differences of detail are immediately obvious but it should be remembered that the coastline has been changing its shape continuously since 1584. The Carolina Banks formed by silt discharged by rivers and sounds have never been a stable barrier. On the landward side there is constant pressure to make or widen openings to the ocean, on the ocean side the forces of winds, currents and tides erode the Banks, working in a south-westerly direction, filling in some openings and tearing others apart. It is a relentless process quickened on occasions by exceptional storms. Partly as a result of this ceaseless action, partly perhaps because of a particularly violent storm, 'Cape Kenrick', clearly marked on White's map (but not named) as the most easterly point of land on this coast, has been swept away leaving only the sandbanks known as Wimble Shoals. On average, it can be said that the present coastline lies about a mile further west than the one Harriot and White knew.[14] The movement westwards has been greatest between Cape Hatteras and Kitty Hawk and progressively less further south. The inlets through the Banks have changed just as dramatically, the southern side of openings generally being eroded, the northern filling up with sand so that the southward shift has been considerable, as much as several miles in some instances. But the process has not been uniform, the building up of the northern parts of inlets often exceeding the erosion of the southern parts, thus shifting and narrowing them at the same time. A violent storm might cause all narrow inlets to be bridged with sand, the pressures from within the Banks forcing an outlet in some other place.

From these observations it might be thought difficult to judge the accuracy of White's map. Yet whenever bearings have been taken at identifiable points, in places he could have visited, and this has happened extensively, White's bearings have been found to be accurate or nearly so, making his outlines acceptable. In the same way his distances are accurate to within a small degree of error. For those areas where he is unlikely to have travelled – south of the Pamlico River and the northern shores of Chesapeake Bay among them – where he would have to rely on second-hand information, there are inaccuracies and distortions. He and Harriot could not possibly have surveyed the whole territory. They would have had to work from a 'patchwork of surveyed

sheets',[15] filling in the gaps from the reports of other colonists, or Indians, or from conjecture.

With all the accuracy and careful drawing evident in the map, what surprises is the almost total absence of the topographical information required in Bavin's instructions. There are no magnetic data, no co-ordinates, no soundings, few shoals marked, equally no ecological symbols for human, zoological or botanical life. This would seem to indicate that White by training or natural bent was not a map-maker. Though he added some conventional symbols for the map of 'Virginia' which he gave De Bry for engraving, it is not so rich in ecological information as the sketch-map. It also covers a larger tract of country inland where its accuracy is much more questionable. Some of the village sites are not the same as on the manuscript map. These could be modifications by De Bry but are more likely to signify revision by White and Harriot. There are sixteen additional place-names, again probably additions given to De Bry, and some differences in the spelling of Indian place-names, which could mean that De Bry's difficulties with Indian words were as great as with English, but might again indicate second thoughts by the compilers. More difficult to account for is the appearance of the opening in the Outer Banks called 'Trinety harbour' just north of the entrance to Albemarle Sound. It also occurs in the map of the arrival of the English but does not appear on either manuscript map. This, too, is consistent with the belief that Harriot was concerned to see that De Bry had the fullest and most accurate information on the maps he was to publish.

For the opposite reasons, for its inaccuracies and distortions, it must be clear that Harriot had little to do with the final form of White's other manuscript map of the east coast of North America from Florida to Chesapeake Bay, which remained unpublished. Successful as was Harriot's and White's mapping when based on observation on the ground, there was no way by which their methods could be applied beyond the areas surveyed by the English. In his effort to produce so extensive a map White had to attempt to reconcile maps of different scales and origins for the coastline south of 'Virginia'. He must have carried out this exercise sometime after producing his manuscript map of that area. For Florida it is clear that he made use of information

14 *Ibid.*, p. 844.

15 *Ibid.*, p. 847.

obtained from Jacques Le Moyne which represented an intermediate stage in the latter's compilation of the map as published by De Bry in 1591. The place-names are in French (Latin in De Bry) and the coastal contours are similar to those of the engraved map, but there are differences and contradictions. While the latitude of the Florida Keys is approximately the same as that of the De Bry map (25°), the discrepancy increases further north until Port Royal is shown by White at approximately 34° 50′ and by Le Moyne in De Bry at 32°, a distortion which can only be explained by White's necessity to reconcile his own incorrect observations for latitude in the area he surveyed with Le Moyne's figures, but accepting only the latter's latitude for the Florida Keys and diverging from there northwards. White was also faced with the problem of using a much earlier Spanish map as the central link between Le Moyne's Florida and his own 'Virginia', now reduced to quarter scale. He carried this out with a totally incorrect east-west orientation and some conjecture. The Bahamas were likewise taken from a Spanish source.[16] White used yet another source, John Dee's map of 1580, for the promontory with islands in the top right-hand corner of his map with the name 'NORAM [BEGA]', and for 'La Be[rmuda]' half-way down on the right (partly trimmed away). These disparate sources, with some guesswork, produced marked distortions, particularly in the central areas, and many inconsistencies.

White's achievement must rest on his map of 'Virginia' and the version which De Bry engraved. He set new standards in cartography as surely as he did with his drawings of Algonquian Indians in ethnography. Within a short time White's map had become the model for new maps by other hands. His coastline reappears on Emery Molyneux's globe of 1592 with revised nomenclature from Harriot and published sources which remained unaltered in the second edition of the globe of 1603. The Velasco map, *c.* 1611, shows in its southern portion the same coastline with names based on White's manuscript map and the De Bry version, but incorporating inland information from the new Virginia colony (1607–11), perhaps again through Harriot.[17] John Smith's map of Virginia, which overlapped narrowly the territory which Harriot and White had surveyed at its southern end, made little use of White for the map itself but made great play as decoration with White's Indian images taken from De Bry, and conventional signs, such as trees and small figures with bows, in this way acknowledging the vision and influence of his predecessor. John Smith in 1624 took De Bry's map and, under the title 'Ould Virginia',[18] gave it a largely new nomenclature; none of his innovations have survived.

16 Hulton and Quinn, *White*, p. 55.

17 The southern section of the Velasco map reproduced in Quinn, *Roanoke voyages*, fig. 10, facing p. 851.

18 Thomas Smith, *The generall historie of Virginia* (1624), facing p. 32.

6 John White the Artist

The immediate impression made by John White's drawings is of strength and vividness made up of a denseness of colouring and precision of line. But looking at them more closely we soon become aware of another almost contradictory element, an ability to draw delicately and lightly with the brush. The combination of these qualities in a chance survival of about seventy-five original watercolours makes White unique. The diversity and range of his work was the result of special circumstances, the necessity of producing as full a record as possible of the different kinds of life, human and natural, in the area of the colony, and their geographic setting.

It is likely that White in ordinary circumstances would have made his living as a miniature portraitist. Even nearly two hundred years later when categories of artistic work such as landscape, figures, portraits, natural history (and its own sub-divisions) were becoming the specialities of individuals, the artists taken on Captain James Cook's voyages, for example, were often compelled by circumstances to diversify in precisely the way that White did in 'Virginia'.

Though contemporary English work comparable to White's is non-existent some contemporary foreign artists working in England were producing costume studies of nations of the world much in the way of White. One of these, Lucas de Heere of Ghent, comes close to him in his illustrative work. Some of the most interesting of De Heere's drawings, and the best known, are watercolours of prominent or characteristic English men or women, London aldermen for example.[1] He also drew, like White, an Eskimo brought back to England by Frobisher, the man taken on his first voyage in 1576, as well as figures of Picts. Though his interests in this way are seen to be close to White's, his technique is distinctively different, with outlines strongly drawn in pen, and bodycolours (opaque colours) and watercolours applied in traditional fashion.

White's method of drawing in watercolour is to a considerable extent traditional: his use of bodycolours, of metallic pigments of gold and silver and of opaque white heightening; and his employment of minute strokes of the brush to provide effects of texture. But there are other more surprising and more 'modern' elements: the use, nearly always, of the brush rather than the pen; the indication of outline in light strokes of black lead as a guide rather than to contain the image; the delicacy of some of his brush drawing and the broader, freer brush strokes in light washes which he sometimes uses. The only original drawings we have of White's are generally highly finished, taken from other finished drawings, or, more likely, as they are the basic compositions without elaboration, made from preliminary drawings or first sketches. None of these last have survived and we can only guess how they were made, probably with the brush rather than the pen for White's instinct clearly lies with the brush and there are spontaneous elements of rapid brush drawing within these finished compositions, as for example many of the creatures in the fishing-scene (plate 43) and the tiny figures of the heron, duck and crab in the otherwise rather cut and dried plan of the fortified encampment at Guayanilla Bay on Puerto Rico (plate 3), elements which help to give White's drawings freshness and conviction. Furthermore, he applies his brush direct to the paper which has not been prepared in any way and which he sometimes uses to provide the effect of light. Here he seems to anticipate some of the methods of the later English school of watercolour. He is, above all, an artist of the brush with which he succeeds in obtaining the minute precision required to indicate the texture of deerskin or sealskin but is equally effective in conveying the pale surface of water with the lightest and most transparent of washes. He was both a traditionalist and something of an innovator.

It has already been suggested that White's work gives some indication that he had been trained as a limner, a term which in his day signified a miniaturist in watercolours. There is plenty of evidence of his familiarity with miniaturist technique. The Elizabethan miniaturist was chiefly concerned with portraiture, and White's portrait studies, particularly those of the Indian priest (plate 42) and old man (plate 34), show considerable ability to convey the Indian cast of feature and the grave dignity of these individuals. His Eskimo woman (plate 64) is another convincing portrait and it is evident that he had developed this skill to a marked degree years before he was recruited for the Roanoke venture. This ability did not extend as expertly to the figure, particularly the nude figure. Drawing the nude with all its technical challenges was not part of the artist's training in Elizabethan England and was not to be until the opening of academies

1 Lucas de Heere, 'Corte beschryvinghe van England, Scotland ende Irland', British Library, Department of Manuscripts, Add. MS. 28330.

in the eighteenth century. So White's anatomical drawing was understandably deficient compared with that of many of his Italian contemporaries. Neither did he fully understand perspective, that device perfected by Italian Renaissance artists to create the illusion of three-dimensional reality. For all his technical shortcomings which make him appear by comparison with his Italian, and some of his north European, contemporaries somewhat naïve, his ability with the brush and quick eye for detail give his work a surprising liveliness and force.

It is not possible to point to a single artist by whom White was influenced stylistically. The one artist we know with whom he worked and exchanged ideas was Jacques Le Moyne,[2] yet it cannot be said that White's manner of drawing owes anything to him. Take for example the man and woman of Florida (plates 61, 62) drawn by White directly, we believe, from Le Moyne. It is likely that every detail was copied accurately, yet the style, the 'handwriting', is purely White's; so to a large extent is the colouring which is typical of White's, though the strong red and blue of the man's quiver and the woman's garment of Spanish moss are unusual in White's drawings. Yet White was unquestionably influenced by Le Moyne in his approach to the problem of portraying new and exotic subject-matter. The two artists are likely to have worked closely together by 1584, if not before,[3] so much so that there was a broad exchange of ideas and subject-matter between them. There are not only the copies of the Florida Indians as evidence of this but many examples of similar detail found in common in their work as for instance the way the coast is drawn in De Bry's plates of Florida, i.e. the arrival of the French at Port Royal (De Bry, *America*, part II, plate V), and the arrival of the English in 'Virginia' (figure 6). Each view is the same kind of half map, half bird's-eye view. Some of the details are interchangeable – the exploring pinnaces, some of the background trees, the ships and the sea monsters. Major elements of other drawings, such as the barbecue in White (plate 45), which is shown in the same way and seen from the same angle as the one in Le Moyne (De Bry, *America*, part II, plate XXIV), and the canoe (figure 16), again seen at the same angle and with

the same kind of wood grain as the one in Le Moyne (De Bry, *America*, part II, plates XXII and XXIV), also point to a collaboration between the two artists. The paddlers of White's canoe in the fishing-scene (plate 43) are closely reminiscent of their counterparts in Le Moyne.[4] It is not clear here which artist influenced the other. There are many more canoes evident in White's work than in the more land-locked scenes of Le Moyne so that in this instance it is possible that the older artist adopted the younger man's treatment. White's borrowing from Le Moyne in his general map of the south-east coast of North America has already been discussed. It is clear that White owed much to Le Moyne, not stylistically, nor even perhaps technically, so much as in approach and presentation and, more basically, in subject-matter.

Comparing the achievement of White and Le Moyne may help to reveal more about the former's true quality as an artist. There is, as one might suppose, very little in the way of contemporary opinion on the question. Richard Hakluyt, Theodor de Bry, and Thomas Penny the naturalist all make brief references to one or other of the artists as 'skilful'. When we make our own comparison we must take into account that by comparing their finished work we are not comparing like with like. There is no set of Florida drawings by Le Moyne which has survived but there is one miniature which seems to be the original of the engraving in De Bry, *America*, part II, plate VIII. Its technique is far removed from White's watercolours and it does not seem to be the product of direct observation but rather a later recollection when Le Moyne's memory was fading. It should be remembered that when he made his escape from the fort during the Spanish surprise assault on the French base in 1565 he is unlikely to have got away with any of his drawings, though some must have been brought out by ship beforehand. The miniature shows European flowers, fruits, vegetables and artifacts rather than local products, though there are a few genuinely observed Indian objects. The colour of the kneeling Indians, who are almost naked, and of their chief Athore is pale, which adds to the generally artificial quality of the composition. The same sort of elegant lassitude is apparent in the only

2 Paul Hulton, *Jacques Le Moyne de Morgues*, p. 80.
3 Le Moyne was domiciled in London, in Blackfriars, by the early 1580s and is very likely to have obtained Raleigh's patronage and a close relationship with the colonizing circle before the first Roanoke voyage in 1584.

4 The interchange of ideas between White and Le Moyne is discussed in more detail in Paul Hulton, 'Images of the New World: Jacques Le Moyne de Morgues and John White', in K.R. Andrews, N.P. Canny and P.E.H. Hair, eds, *The westward enterprise* (Liverpool University Press, 1978), pp. 212–13.

other miniature by Le Moyne, A young daughter of the Picts (Yale Center for British Art, New Haven, Conn. [B.1981.25.2646]) which is the original of the engraving in De Bry's *Virginia* (figure 31) taken by him as the work of John White. Naked, painted all over with flowers, wearing a sword and holding a spear, she appears to be anything but a warlike savage ancestor. Both miniatures so carefully composed and admirable, if unnatural, in their colouring were no doubt consistent with the rest of the set that De Bry engraved for his *Florida*. As observable in the plates, their lack of scientific interest and ethnographical accuracy, compared with White's work, may have had something to do, as already suggested, with the lapse of time between observation and commission. Possibly the lack of a scientist like Harriot to encourage a naturalistic focus may have contributed to their departure from reality. No doubt Le Moyne felt that the characteristics of his art of miniature painting with its heightened colouring would best please his royal or noble patrons. That said, there is no doubt of Le Moyne's ability to observe and portray with fidelity and skill those subjects that most interested him, in particular the world of flowers.[5] His plant paintings in miniature on vellum and in watercolour on paper are among the finest of the sixteenth century. Many of these subjects are closely observed and portrayed with a naturalism surprising for his time and always with a rare beauty and the most refined and subtle sense of colour. The Indians of Florida which White copied from him show that Le Moyne could observe and portray them as convincingly as White his Algonquians, and in this instance, we may confidently guess, without being tempted in any way to beautify or refine their facial and physical features.

It is clear that White lacked some of the qualities of artistry that are so outstanding in Le Moyne's paintings of plants. His colouring was less subtle and often less delicate so that it can appear primitive by comparison. As against Le Moyne's elegance he is sometimes awkward. Both artists may be judged deficient in their drawing of the human figure though adept in portraying costume. Whatever White's shortcomings in delineating human anatomy he managed to instil life into his figures clothed or naked, perhaps more so than Le Moyne. To convey the sense of movement in his drawing of the dance-scene

was surely a most difficult challenge to his ability. Yet he succeeds in suggesting that their sudden jerky motions have been frozen only for an instant and that they are about to resume them. The movements were no doubt entirely strange to him and probably differed more from his own experience of English dancing than the modern dance would differ to us from classical ballet. Again, the near-naked figures which he shows sitting round the fire, chanting and shaking rattles, convey something of the strange and mysterious quality of the occasion and of the sounds that they uttered. Of this ability to capture atmosphere, whether of a group of Indians engaged in some ceremony, or of a place, the fishing-scene is surely the best evidence. Whatever its faults of perspective, and the unlikely presence together in the shallows of all the creatures he portrays, White succeeds in planting in our minds an unforgettable image of shallow waters teeming with life, human and animal, against the low hills of this New World the English are experiencing for the first time. It is a considerable achievement involving a good deal of free drawing. When we view the work of White along the perspective of later artistic development in England it is tempting to think of him consciously anticipating a new freedom in the use of watercolour. It should not be forgotten that his object was to communicate information graphically and as much of it as possible. So he not only shows the different ways employed by the Indians to catch fish but fills the shallows with as many creatures as he had studies of (there are more in the engraving) and, for good measure, adds a pelican, two swans and a flight of duck in the air above. The drawing is a 'composite', and to some extent scientifically inaccurate in that some of the sea creatures are deep-water fish. White certainly had no intention of capturing atmosphere. The original qualities we see and enjoy in his work are unconscious by-products though no less significant for that.

White's ability to suggest the characteristics of living creatures with a few strokes of a fine brush, to produce a lively portrait in miniature, has already been mentioned. His more finished drawings of birds and fishes can show the same sensitivity. Not all do, but the flamingo (plate 15) is perhaps the finest of the bird drawings, its roseate plumage drawn with a wonderful lightness of touch. Others are less successfully drawn, no doubt from dead specimens. Long experience and a very special understanding are required to breathe life, graphically speak-

5 A large body of botanical drawings, almost all studies of North European plants, survive, none deriving from the Florida venture.

ing, into a dead bird! White's fishes are among his best studies, for here the problem of producing a lifelike image is rather less difficult. He sometimes uses the off-white colour of the paper to give form to his specimens, as for instance to the shad (?) he shows cooking on his barbecue (plate 45), the remora (plate 28), the puffer (plate 54) and the burrfish (plate 53). The form and colouring of the two groupers (plates 22, 23) are particularly attractive though not sufficiently accurate to allow certain identification of the species. Textures and patterns of colouring on living creatures had a special fascination for White. He is particularly attracted by the richness of texture and colour to be found on the host shells of his hermit crabs and on the carapaces of his turtles, to such a degree that in the latter these elements are emphasized somewhat to the disadvantage of their form.

We have only a few drawings of plants by White and it seems that they are the least 'finished' of all his watercolours. They appear also to have suffered most from water damage, the greens and yellows seemingly being most susceptible to damp. As botanical representations they are rather schematic and cannot compare with the finely observed and beautifully coloured plant portraits of Le Moyne. For all that the sabatia or rosegentian (plate 51) is well understood in such details as the pattern at the base of the corolla-lobes and in its habit and structure. The way the buds are held is sensitively drawn, as are the lines of what is perhaps the earliest banana plant to be drawn by a European, the horn plantain (plates 13, 14). Though his plant drawings do not immediately indicate a talent for botanical illustration, White's abilities in this direction were probably no less considerable than those more obviously indicated in his zoological drawings, though here too the evidence is incomplete as no drawings of mammals have survived.

Laurence Binyon suggested that White could be thought of as a founder of the English school of watercolour.[6] There is not sufficient evidence to support this since the idea presupposes followers who developed his methods. We know of none and there is no mention of

his name, no knowledge of him, we may guess, in seventeenth-century artistic circles, no looking back to him as a forerunner in the eighteenth century. Yet Binyon's theory contains an element of truth in that White is beginning to use watercolour in a new way. His precision and denseness of colour are traditional characteristics giving him sometimes the manner of a primitive, but when he avoids the hard contour, when he draws with his brush minutely or broadly using thin washes of colour, he is anticipating, however unconsciously, later developments. Though there could have been other English artists working in the same way at the time, that is extremely unlikely as there is no trace either of their names or their work. This is the extent of White's originality.

White can only be fairly judged as an artist of his time. From our modern viewpoint he is seen as a provincial artist influenced by the Mannerist school of northern Europe but comparatively unversed in some of the new technical devices of Italian Renaissance art. Equally, he is seen as a most versatile artist, less conditioned by his gifts and training than many other better endowed artists would have been and therefore perhaps seeing the life of the New World more plainly. He was fortunate in being able to work with Le Moyne, a more gifted and experienced artist, and with Harriot who may have helped him to develop a more scientific and analytical approach. Though his record has come down to us as far from complete, he can be seen to have accomplished his mission with an honest distinction. His methods are workmanlike, his work quietly utilitarian, but he could rise above his obvious defects to introduce fresh and imaginative touches which always convey his intense curiosity, pleasure and above all his total commitment to the new venture. It would be foolish to compare him with the great artists of his time but he deserves an honourable mention in English art history and a special place in the early history of the English-speaking peoples of North America.

6 Laurence Binyon, *English water-colours* (2nd edn, London, 1944), p. 2.

The Plates

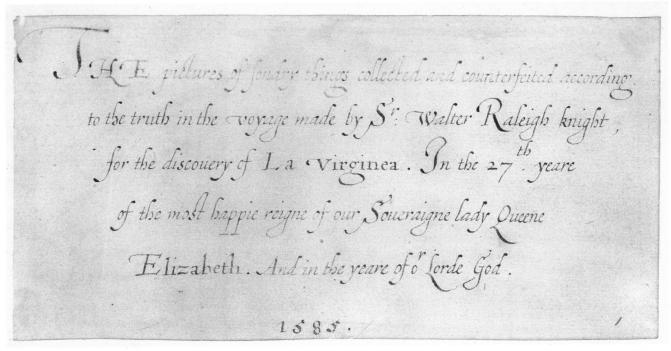

Plate 1. John White's Autograph Title (8 x 16.4 cm. or 3⅛ x 6½ in.)

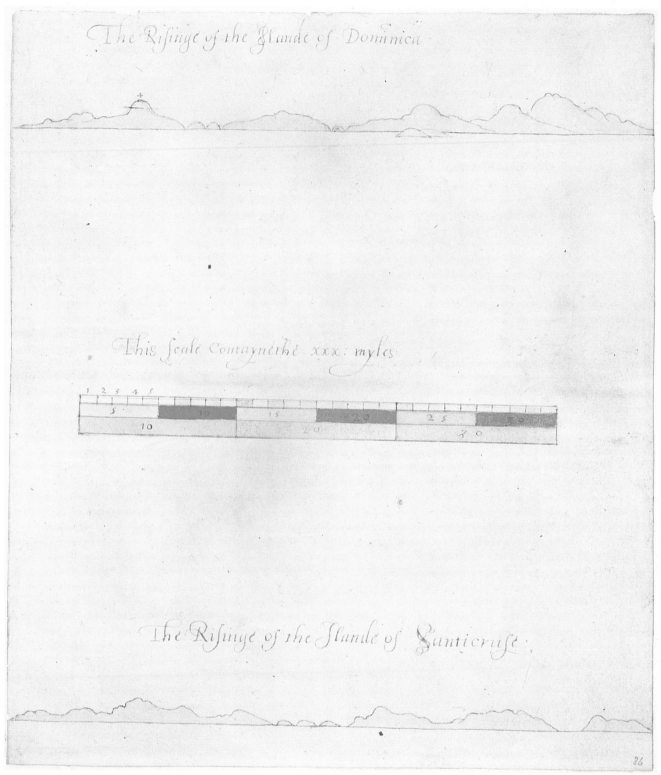

Plate 2. Coastal Profiles of Dominica and Santa Cruz (24.3 x 21.7 cm. or 9⅝ x 8½ in.)

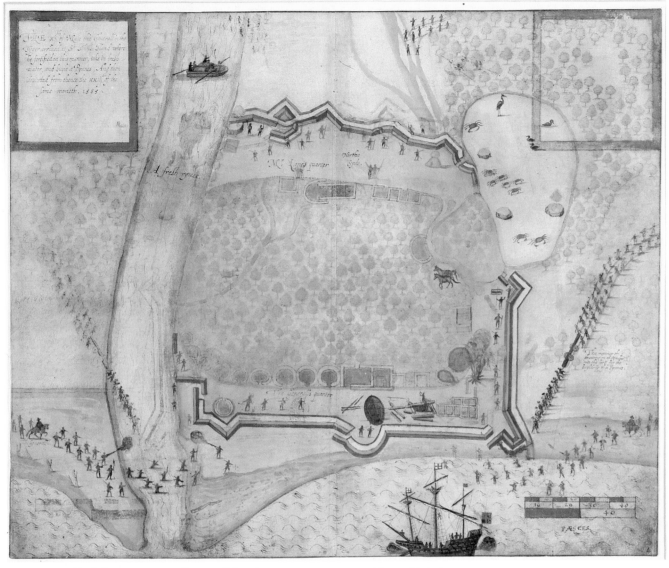

Plate 3. Fortified Encampment, Puerto Rico (36.3 x 44.5 cm. or 14¼ x 17½ in.)

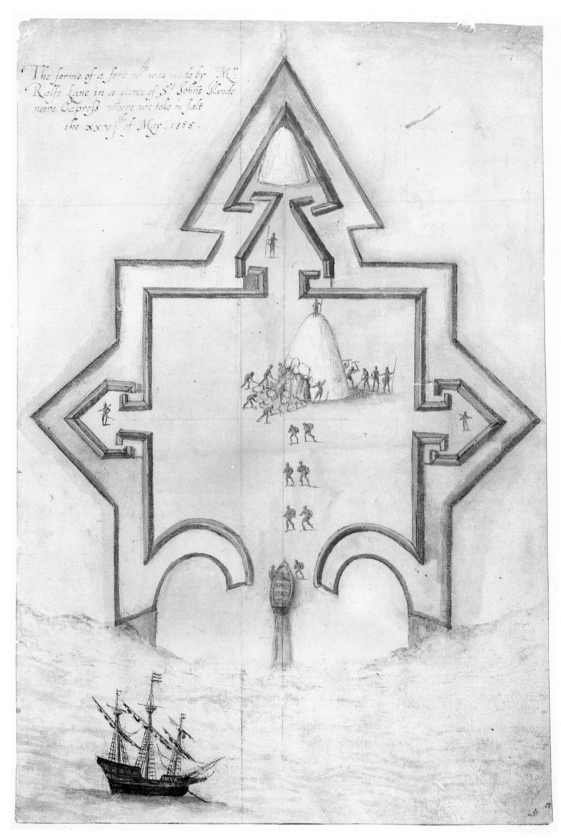

The forme of a fort w.^{ch} was made by M.^r
Ralfe Lane in a parte of S.^t Johns Ilende
neere Caproß where we toke in salt
the xxvj.th of May. 1585.

Plate 4. Entrenchments, Puerto Rico (31.5 x 22 cm. or 12⅜ x 8¾ in.)

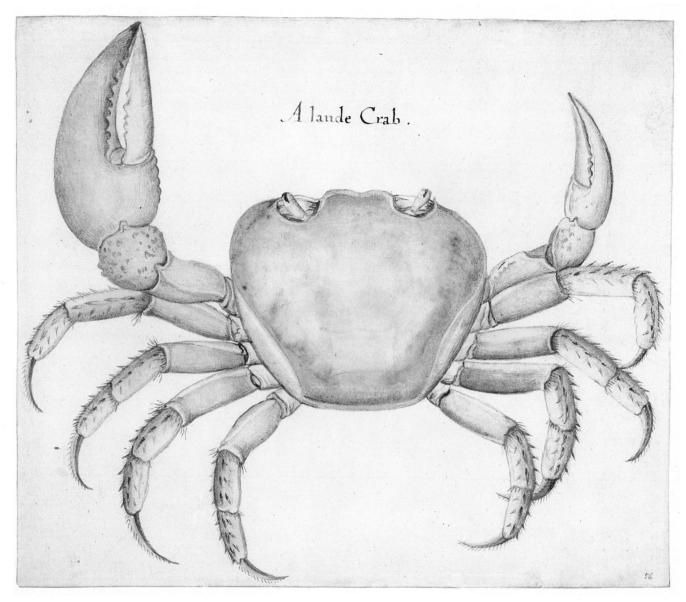

Plate 5. Land Crab (23.3 x 27.6 cm. or 9⅛ x 10⅞ in.)

Caracol.

Caracol.

Thes lyue on land neere the Sea syde, and breede in sondry shells
when they be empty.

1

57

Plate 6. Hermit Crab (18.8 x 15.5 cm. or 7⅜ x 6⅛ in.)

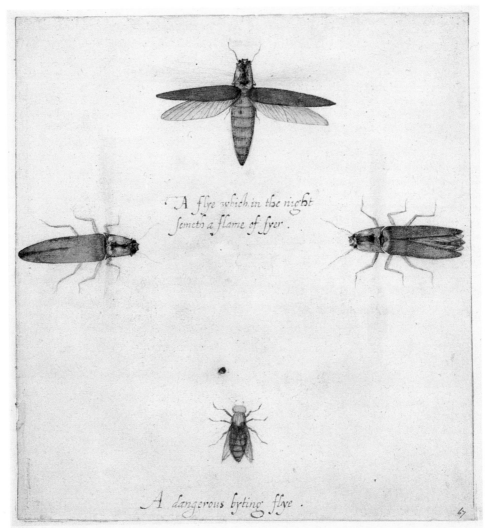

A flye which in the night semeth a flame of fyer.

A dangerous byting flye.

Plate 7. Fireflies and Gadfly (19.9 x 18.7 cm. or 7⅞ x 7⅜ in.)

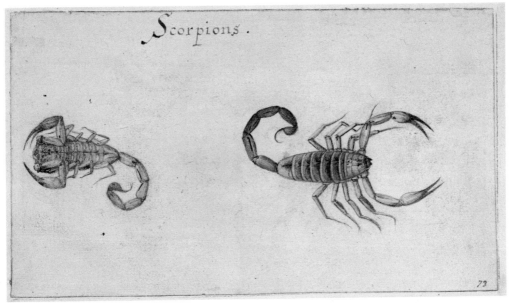

Scorpions.

Plate 8. Scorpions (10.4 x 18.6 cm. or 4⅛ x 7¼ in.)

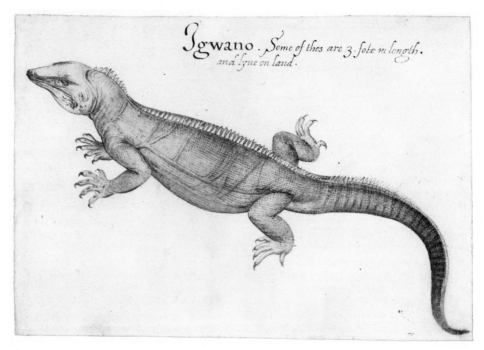

Plate 9. Iguana (14.4 x 21 cm. or 5⅝ x 8¼ in.)

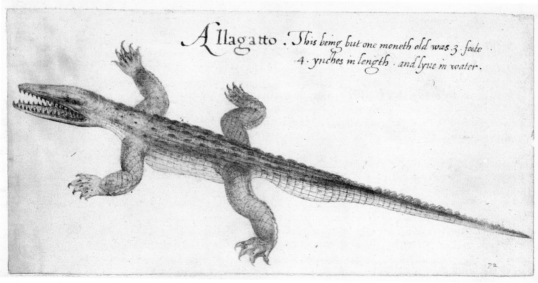

Plate 10. Alligator or Crocodile (11.1 x 23.3 cm. or 4⅜ x 9⅛ in.)

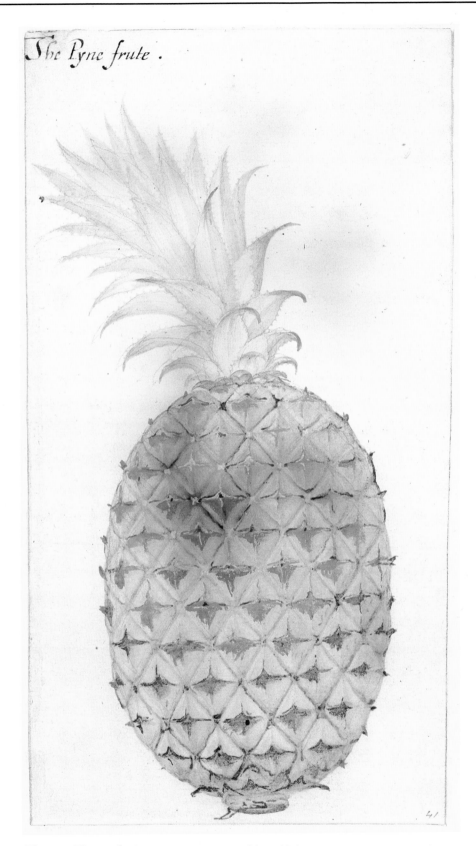

The Pyne frute.

Plate 11. Pineapple (25.8 x 14.1 cm. or 10⅛ x 5½ in.)

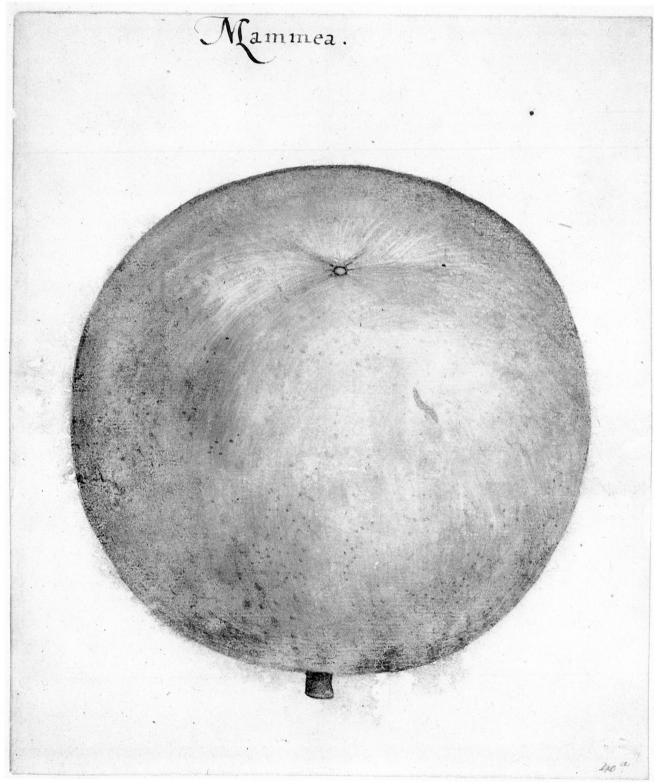

Mammea.

Plate 12. Mammee Apple (21 x 18.4 cm. or 8¼ x 7¼ in.)

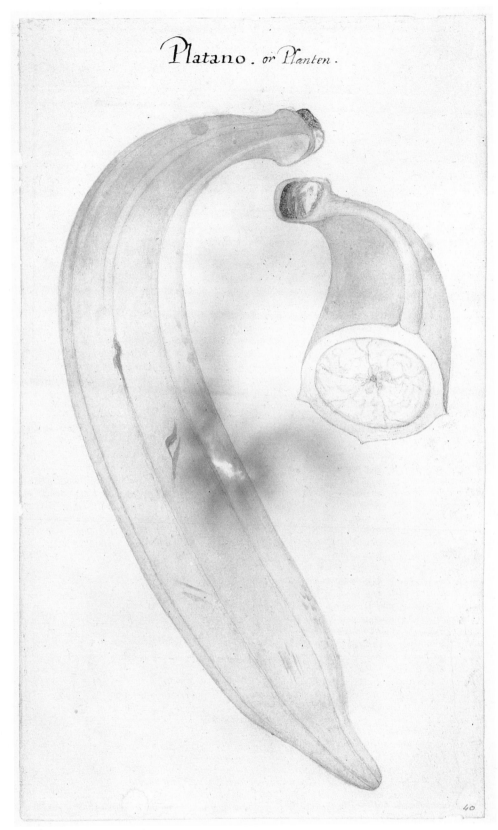

Platano . or Planten .

40

Plate 13. Horn Plantain (29.4 x 17.7 cm. or 11½ x 7 in.)

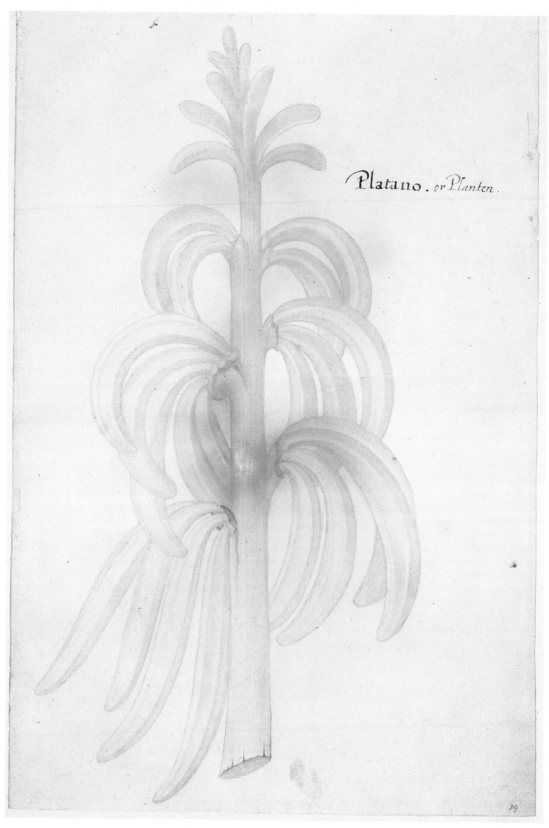

Platano . or Planten .

Plate 14. Horn Plantains on the Stalk (32.4 x 22.1 cm. or 12¾ x 8¾ in.)

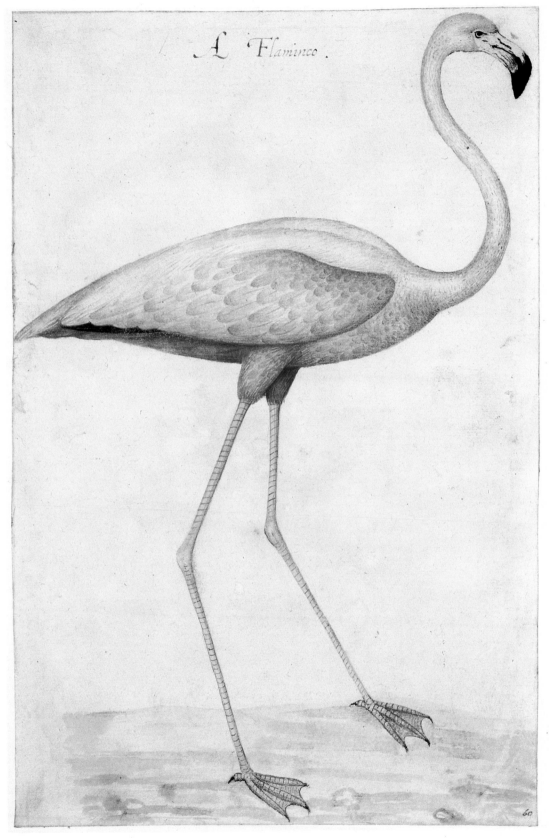

Plate 15. Flamingo (29.6 x 19.7 cm. or 11⅝ x 7¾ in.)

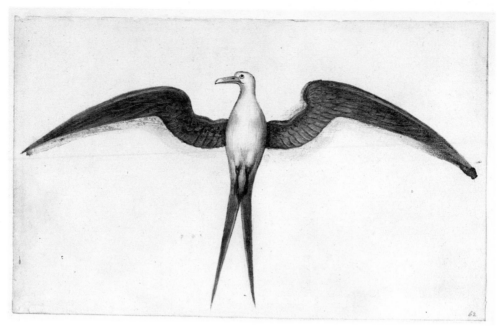

Plate 16. Frigate Bird (13.6 x 22.3 cm. or 5⅜ x 8¾ in.)

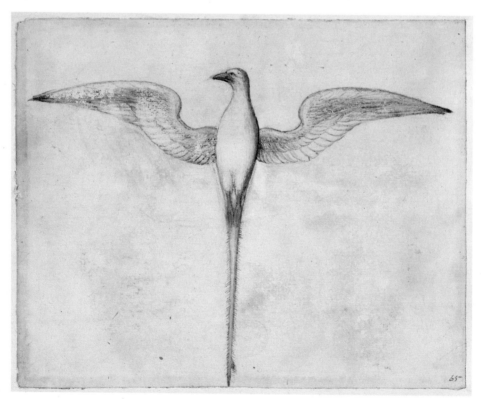

Plate 17. Tropic Bird (16.2 x 20.4 cm. or 6⅜ x 8 in.)

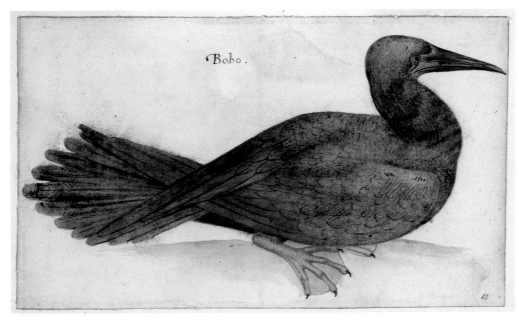

Plate 18. Brown Booby (13.2 x 23.1 cm. or 5⅛ x 9⅛ in.)

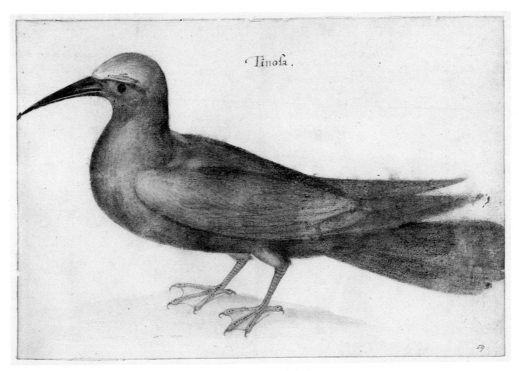

Plate 19. Noddy Tern (15.7 x 23.4 cm. or 6⅛ x 9¼ in.)

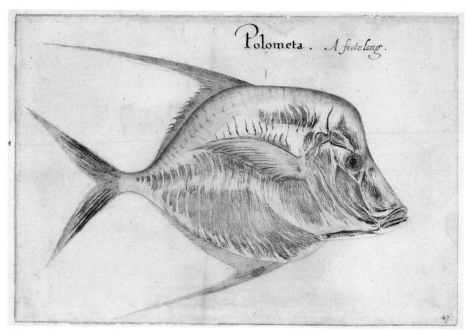

Plate 20. Lookdown or Moonfish (14.9 x 22 cm. or 5⅞ x 8¾ in.)

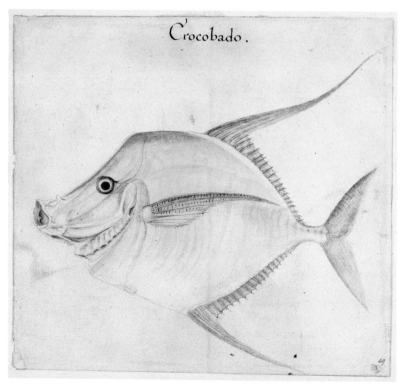

Plate 21. Lookdown or Moonfish (19.1 x 21 cm. or 7½ x 8¼ in.)

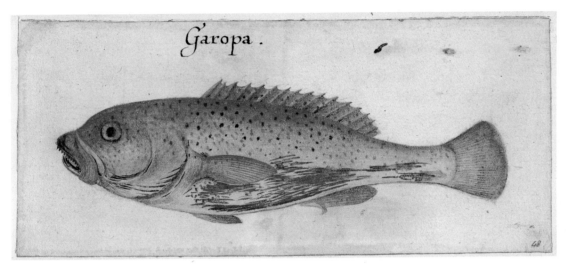

Plate 22. Grouper (9.3 x 21.8 cm. or 3⅝ x 8⅝ in.)

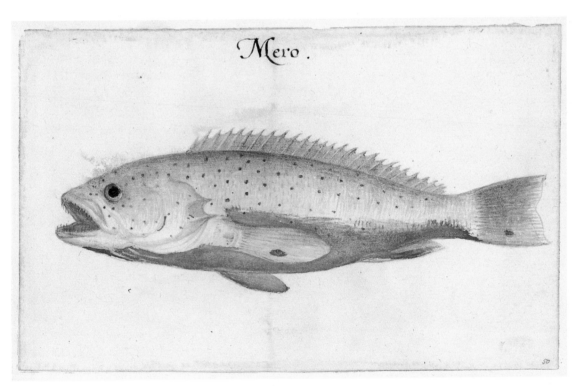

Plate 23. Grouper (13.1 x 21.3 cm. or 5⅛ x 8⅜ in.)

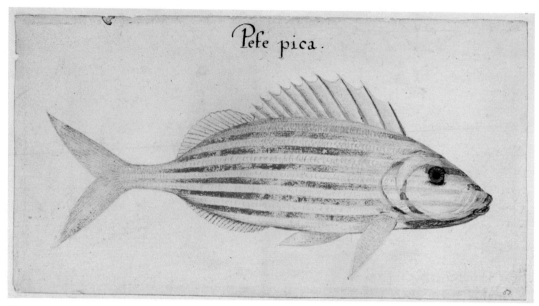

Plate 24. Grunt (11.2 x 21.3 cm. or 4⅜ x 8⅜ in.)

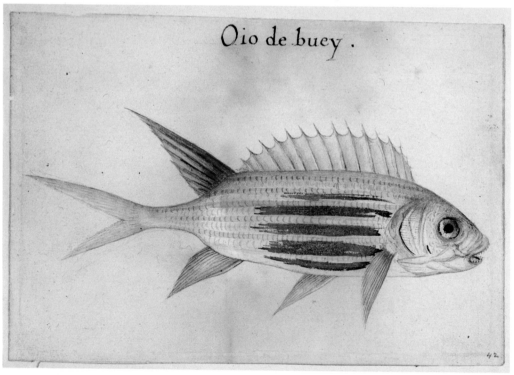

Plate 25. Soldier-Fish (13.2 x 19.9 cm. or 5⅛ x 7¾ in.)

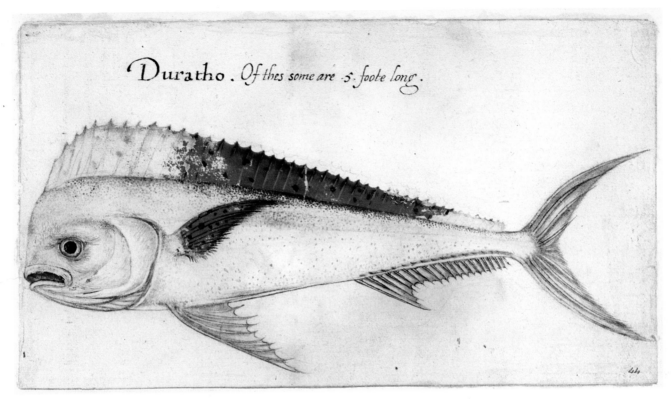

Duratho . Of thes some are 5. foote long .

Plate 26. Dolphin (12.6 x 22.7 cm. or 5 x 9 in.)

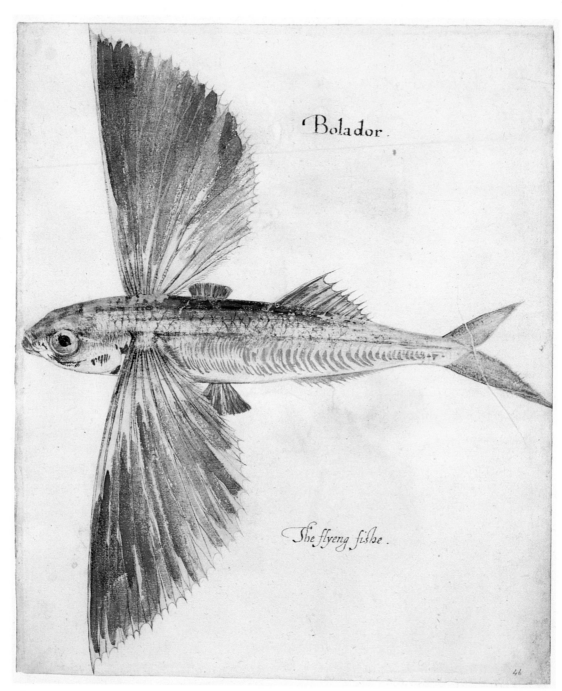

Bolador.

The flyeng fishe.

46

Plate 27. Flying-Fish (27.4 x 23.4 cm. or 10⅞ x 9⅛ in.)

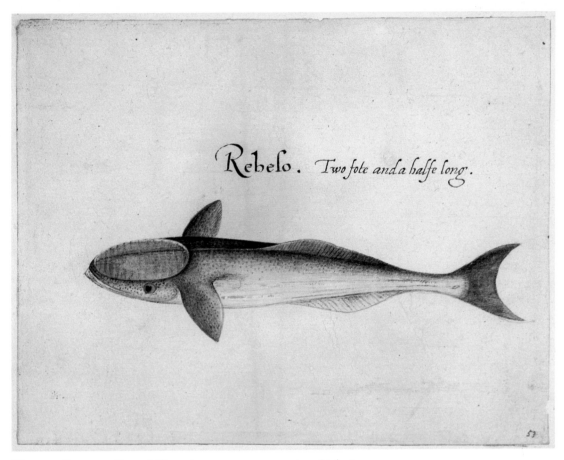

Plate 28. Remora, Dorsal View (15.3 x 19.7 cm. or 6 x 7¾ in.)

Plate 29. Remora, Ventral View (12 x 15.5 cm. or 4¾ x 6⅛ in.)

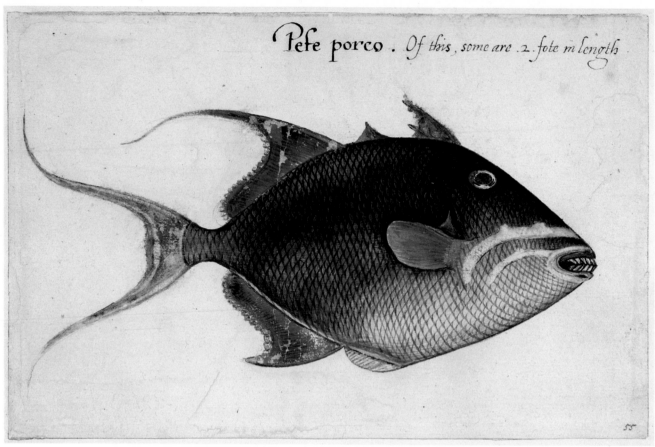

Pese porco. Of this, some are .2. fote in length

55

Plate 30. Trigger-Fish (14.2 x 22.3 cm. or 5⅝ x 8¾ in.)

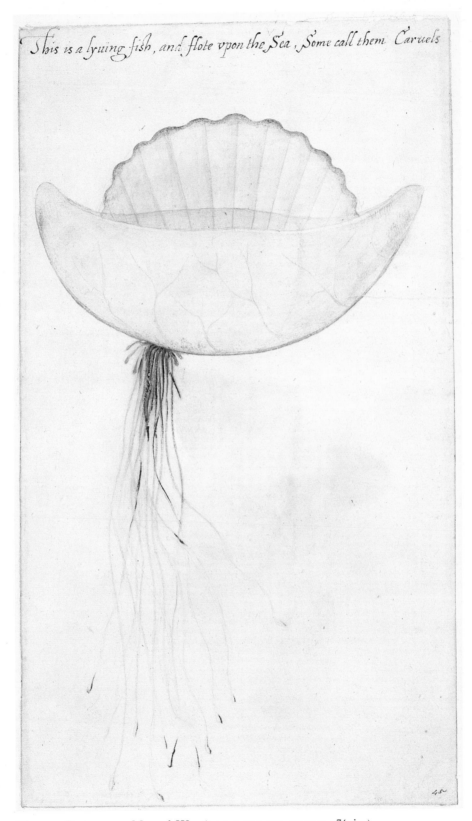

This is a lyuing fish, and flote vpon the Sea, Some call them Caruels

Plate 31. Portuguese Man-o'-War (30.5 x 17.5 cm. or 12 x 6⅞ in.)

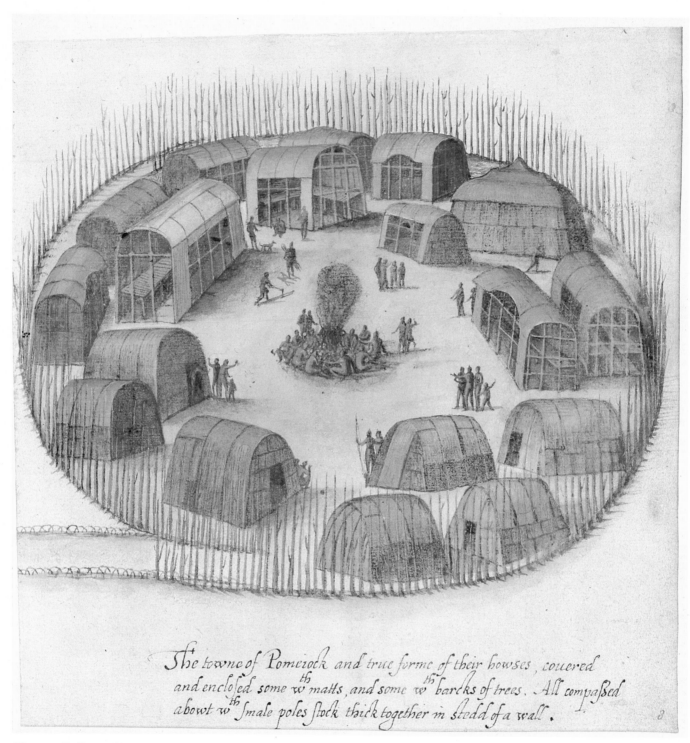

The towne of Pomeiock and true forme of their howses, couered
and enclosed some w^th matts, and some w^th barcks of trees. All compassed
abowt w^th smale poles stock thick together in stedd of a wall.

Plate 32. Indian Village of Pomeiooc (22.2 x 21.5 cm. or 8¾ x 8½ in.)

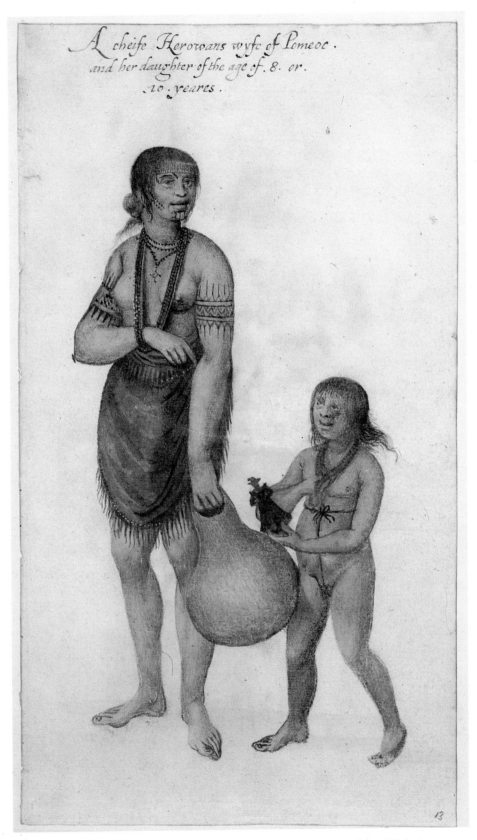

A cheife Herowans wyfe of Pomeoc.
and her daughter of the age of. 8. or.
10. yeares.

Plate 33. Indian Woman and Young Girl (26.3 x 14.9 cm. or 10⅜ x 5⅞ in.)

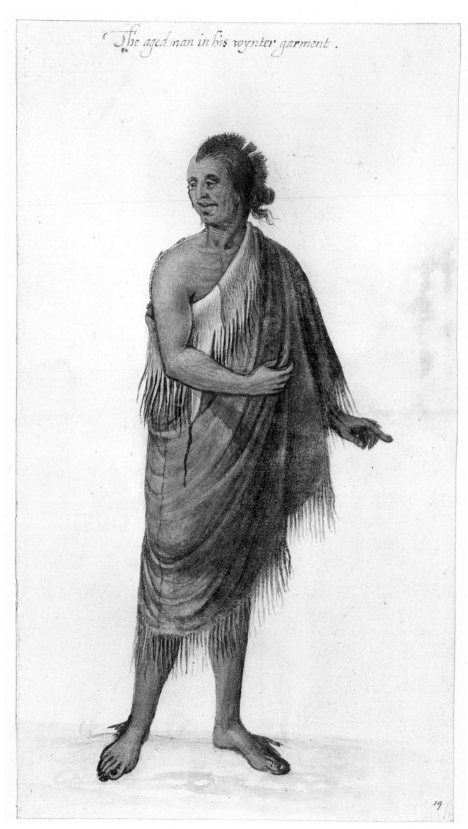

The aged man in his wynter garment.

Plate 34. Old Indian Man (26.1 x 15 cm. or 10¼ x 5⅞ in.)

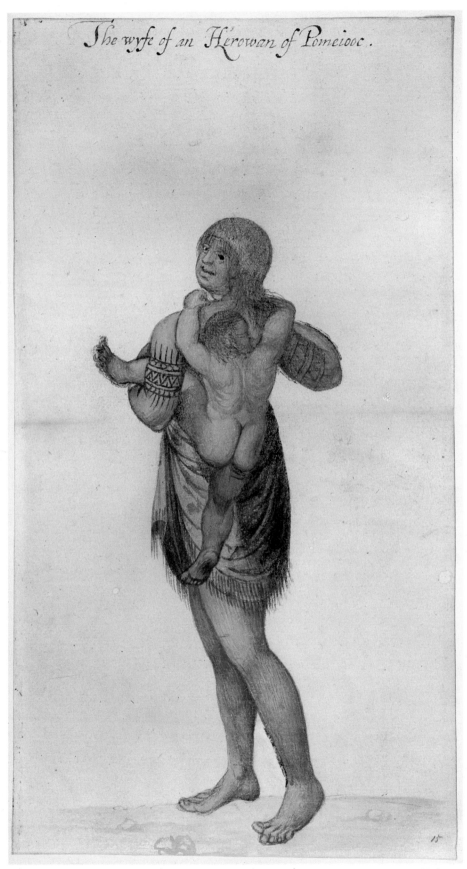

The wyfe of an Herowan of Pomeiooc.

Plate 35. Indian Woman and Baby of Pomeiooc (25.7 x 14.1 cm. or 10⅛ x 5⅝ in.)

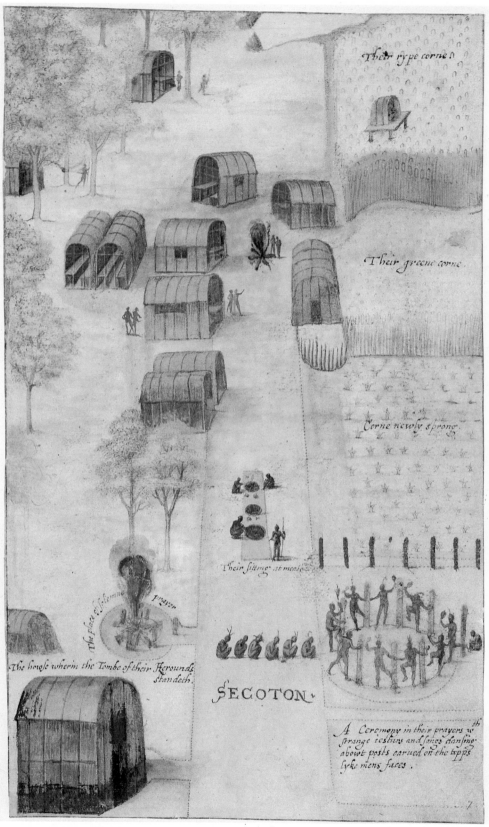

Plate 36. Indian Village of Secoton (32.4 x 19.9 cm. or 12¾ x 7¾ in.)

The wyfe of an Herowan of Secotan.

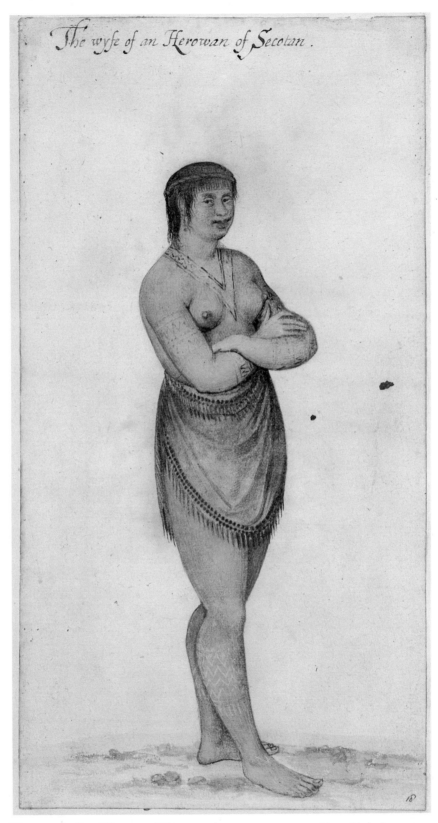

Plate 37. Indian Woman of Secoton (26 x 13.9 cm. or 10¼ x 5½ in.)

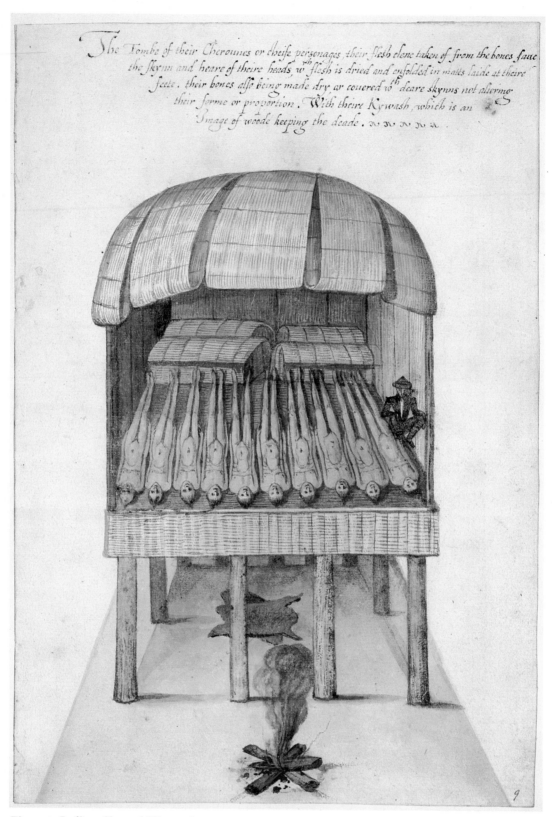

The Tombe of their Cherounes or cheife personages, their flesh clene taken of from the bones saue the skynn and heare of theire heads, wth flesh is dried and enfolded in matts laide at theire feete, their bones also being made dry or couered wth deare skynns not altering their forme or proportion. With theire Kywash, which is an Image of woode keeping the deade.

Plate 38. Indian Charnel House (29.5 x 20.4 cm. or 11⅝ x 8 in.)

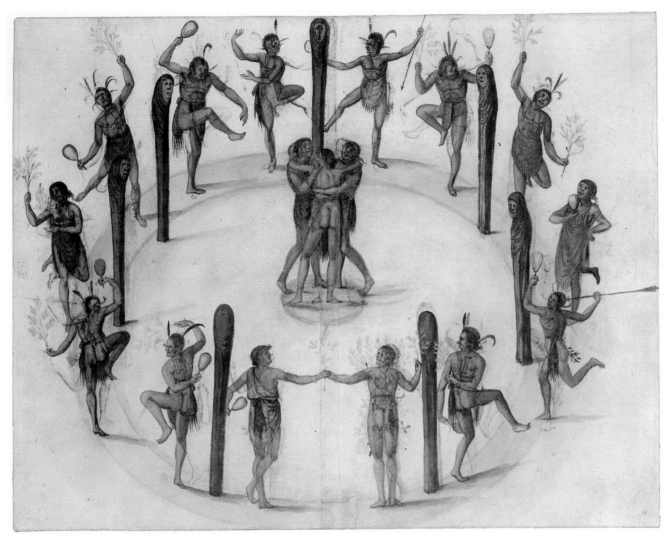

Plate 39. Indians Dancing (27.4 x 35.6 cm. or 10¾ x 14 in.)

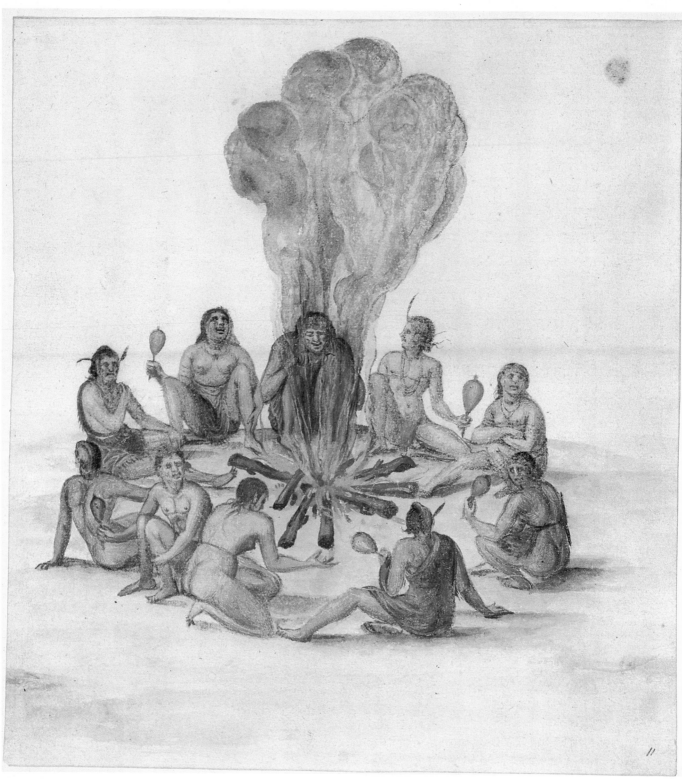

Plate 40. Indians round a Fire (21.8 x 20.2 cm. or 8⅝ x 8 in.)

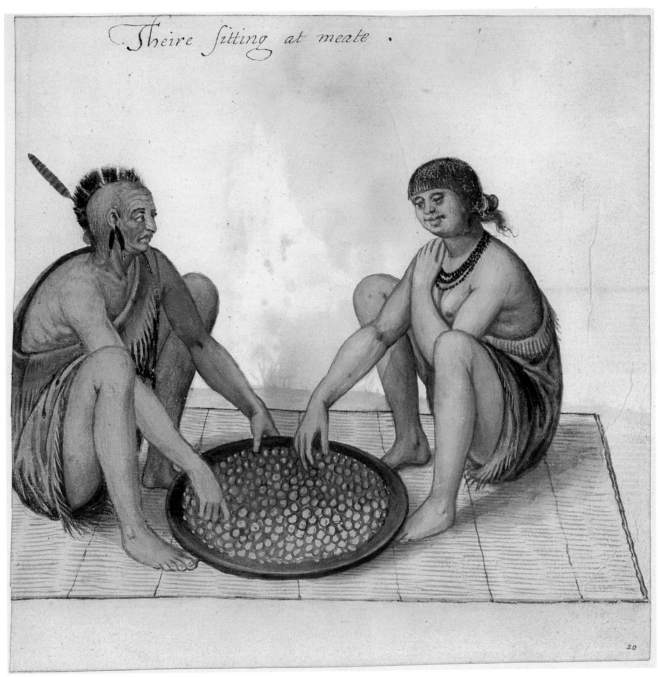

Theire sitting at meate .

20

Plate 41. Indian Man and Woman Eating (20.9 x 21.4 cm. or 8¼ x 8½ in.)

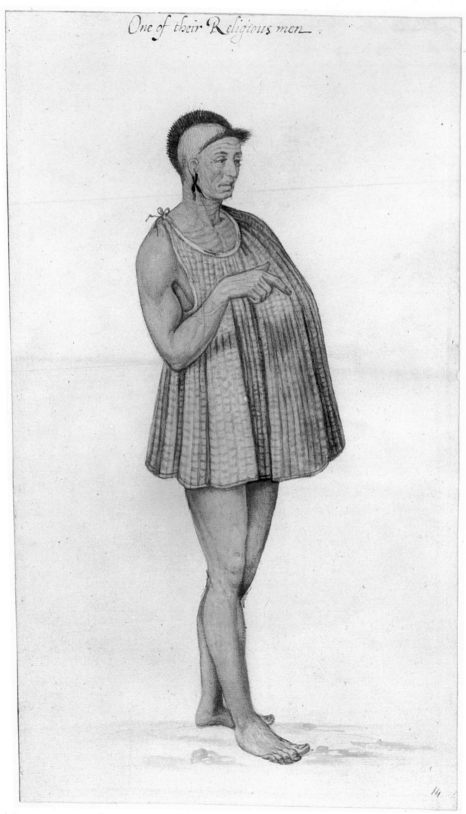

One of their Religious men

Plate 42. Indian Priest (26.2 x 15.1 cm. or 10¼ x 5⅞ in.)

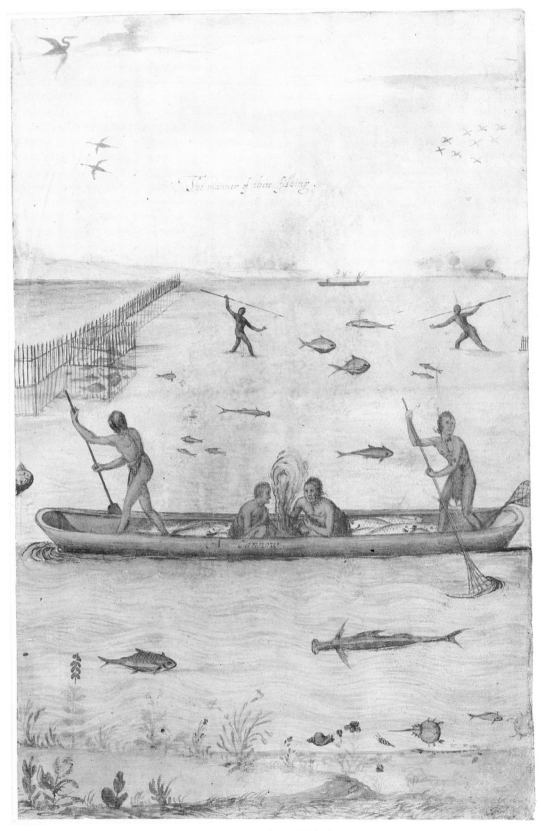

The manner of their fishing.

Plate 43. Indians Fishing (35.3 x 23.5 cm. or 13⁷⁄₈ x 9¼ in.)

The seething of
in Potts

their meate.
of earth.

Plate 44. Cooking in a Pot (15 x 19.5 cm. or 5⅞ x 7⅝ in.)

The broyling of their fish ouer th' flame of fier. 11.B

Plate 45. Cooking Fish (14.6 x 17 cm. or 5¾ x 6¾ in.)

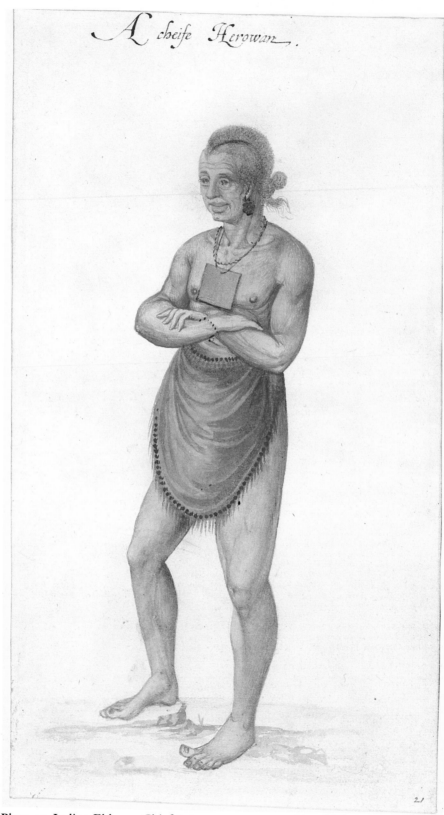

A cheife Herowan.

Plate 46. Indian Elder or Chief (26.2 x 14.7 cm. or 10⅜ x 5¾ in.)

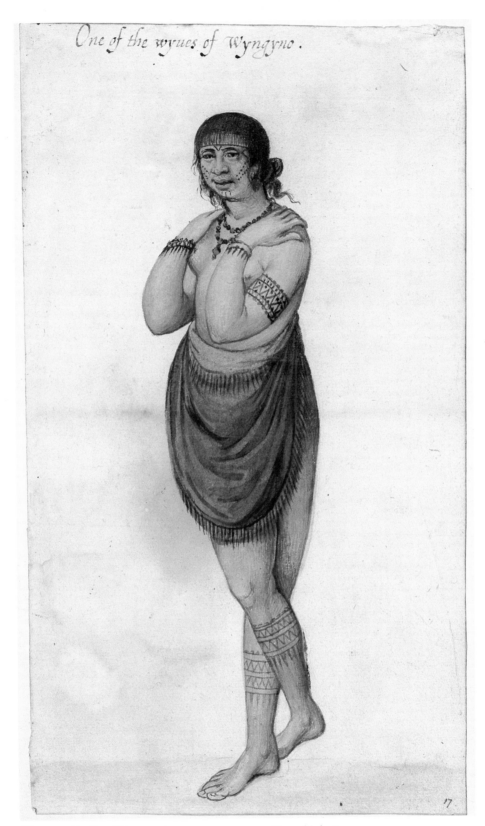

One of the wyues of Wyngyno.

Plate 47. Indian Woman (23.4 x 13.5 cm. or 9¼ x 5¼ in.)

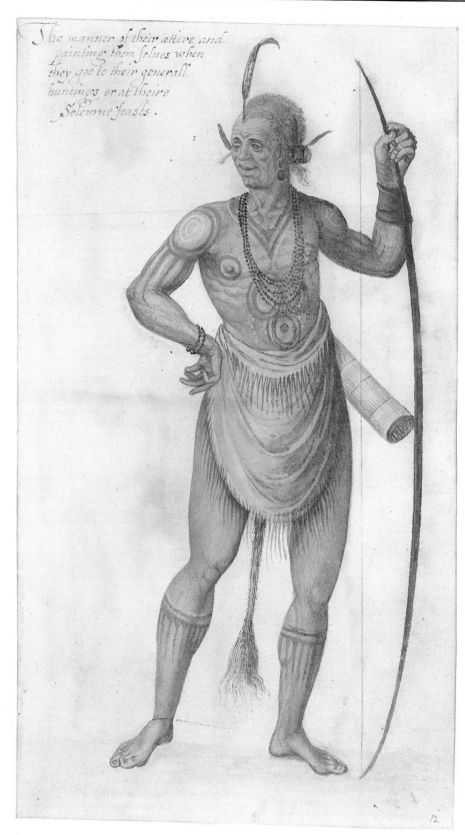

The manner of their attire and painting them selues when they goe to their generall huntings, or at theire Solemne feasts.

Plate 48. Indian in Body Paint (26.3 x 15 cm. or 10⅜ x 5⅞ in.)

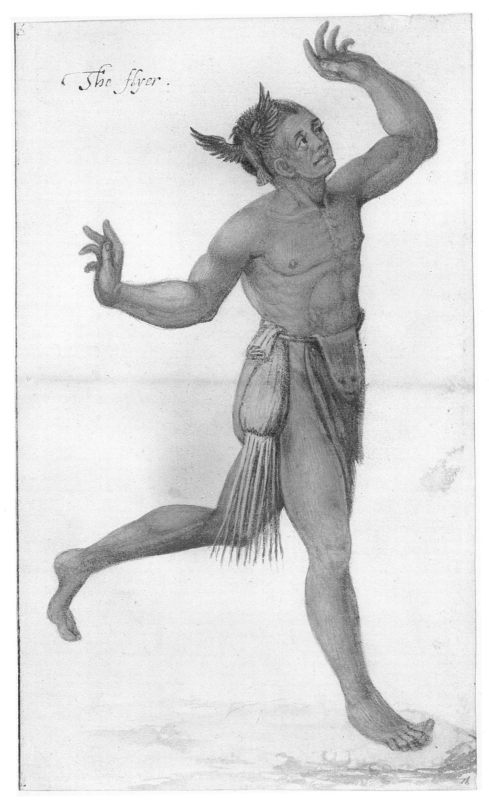

The flyer.

Plate 49. Indian Conjuror (24.6 x 15.1 cm. or 9¾ x 6 in.)

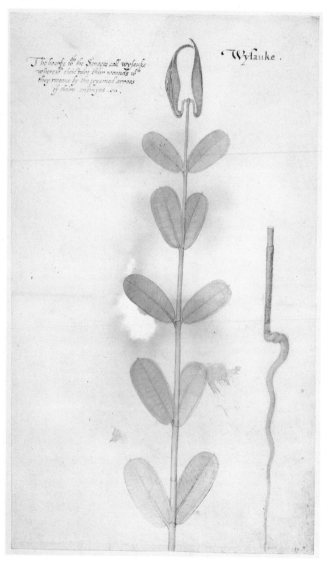

Plate 50. Milkweed (35.6 x 20.9 cm. or 14 x 8¼ in.)

Plate 51. Sabatia (34.9 x 17.9 cm. or 13¾ x 7 in.)

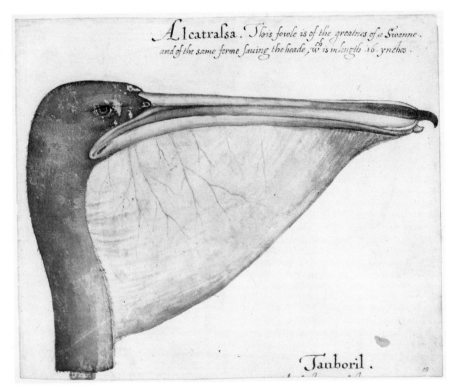

Plate 52. Head of a Brown Pelican (18.5 x 22.3 cm. or 7¼ x 8¾ in.)

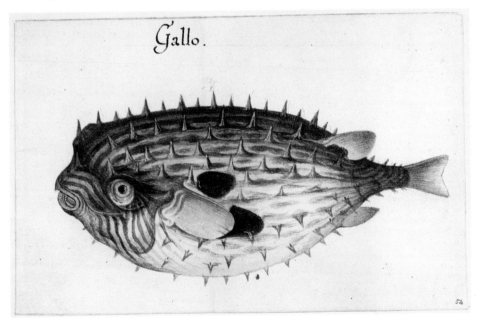

Plate 53. Burrfish (13 x 20.5 cm. or 5⅛ x 8 in.)

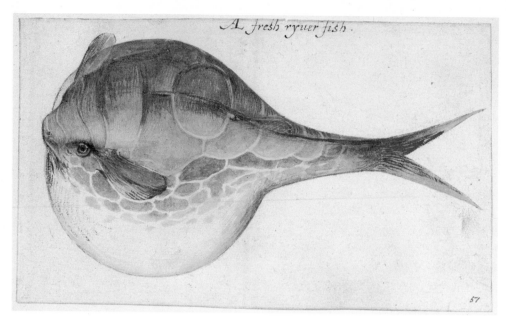

Plate 54. Puffer (9.8 x 16.9 cm. or 3⅞ x 6⅝ in.)

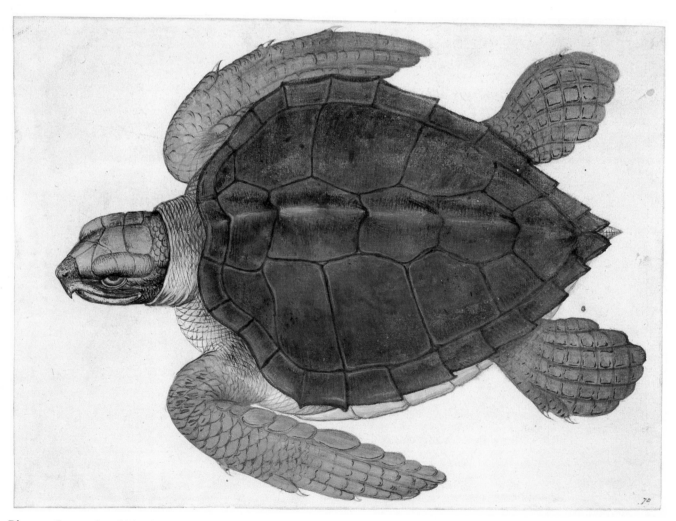

Plate 55. Loggerhead Turtle (18.7 x 26 cm. or 7⅜ x 10¼ in.)

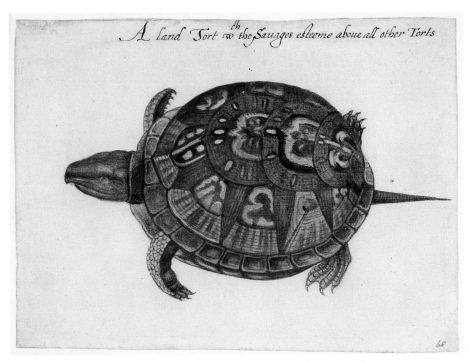

Plate 56. Common Box Tortoise (14.4 x 19.7 cm. or 5⅝ x 7¾ in.)

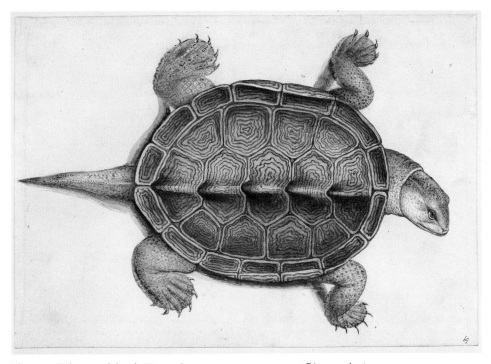

Plate 57. Diamond-back Terrapin (17.4 x 25.3 cm. or 6⅞ x 10 in.)

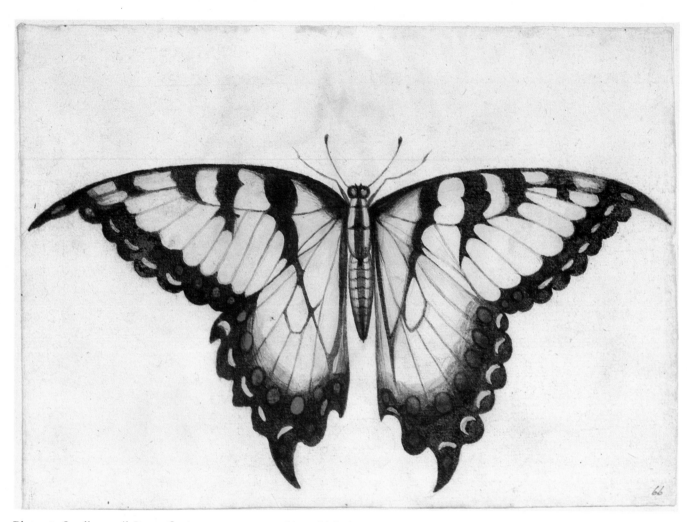

Plate 58. Swallow-tail Butterfly (14 x 19.8 cm. or 5½ x 7¾ in.)

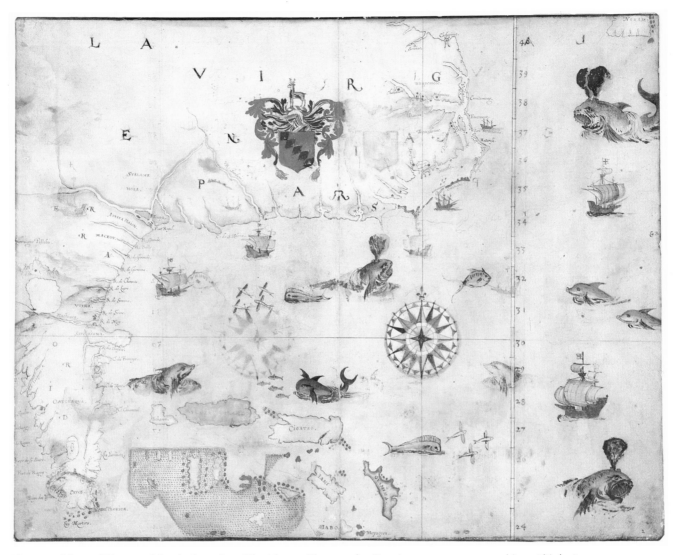

Plate 59. Map of Eastern North America: Florida to Chesapeake Bay (37 x 47.2 cm. or 14½ x 18½ in.)

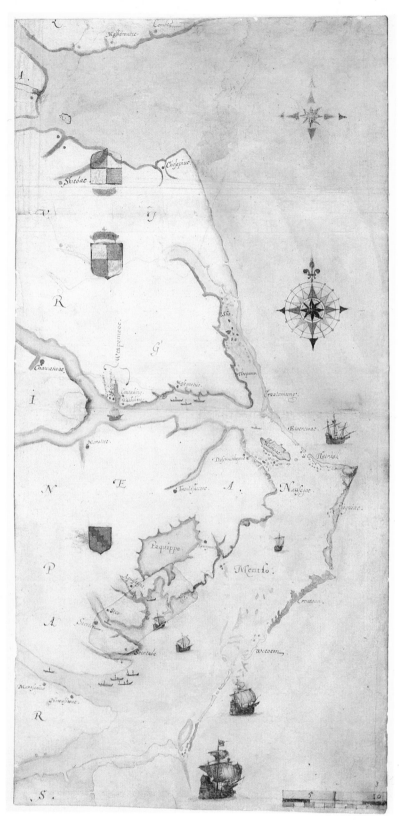

Plate 60. Map of Raleigh's Virginia (48 x 23.5 cm. or 18⅞ x 9¼ in.)

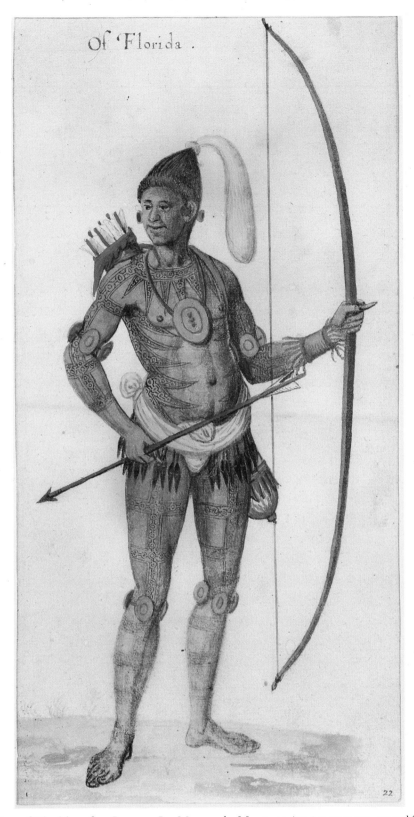

Plate 61. Indian Man of Florida, after Jacques Le Moyne de Morgues (26.8 x 13.7 cm. or 10½ x 5⅝ in.)

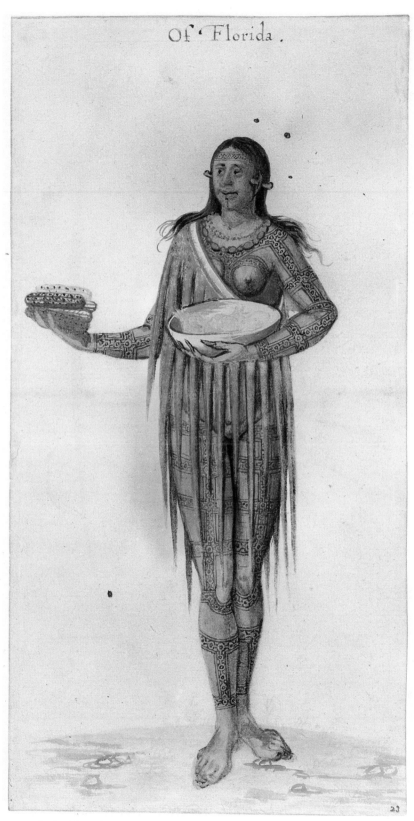

Of Florida.

Plate 62. Indian Woman of Florida, after Jacques Le Moyne de Morgues (26.1 x 13.5 cm. or 10¼ x 5⅜ in.)

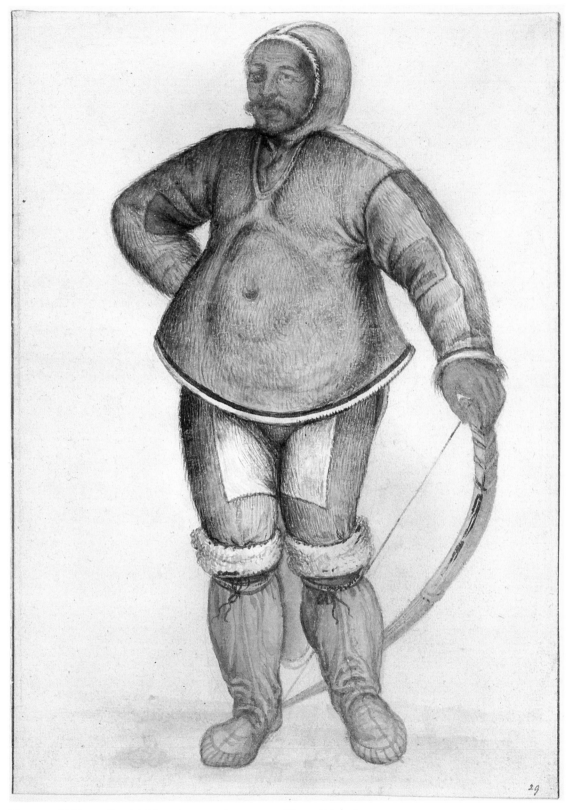

Plate 63. Eskimo (Inuit) Man (22.7 x 16.4 cm. or 8⅞ x 6½ in.)

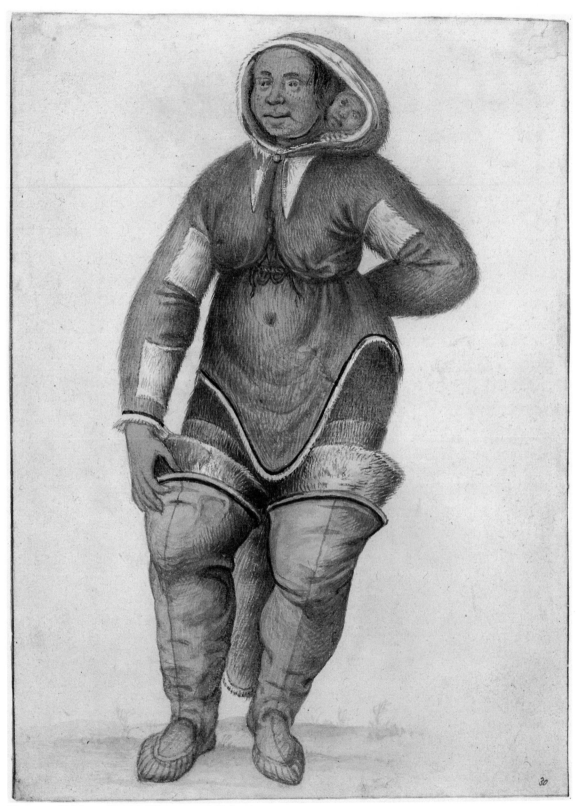

Plate 64. Eskimo (Inuit) Woman and Baby (22.2 x 16.6 cm. or 8¾ x 6½ in.)

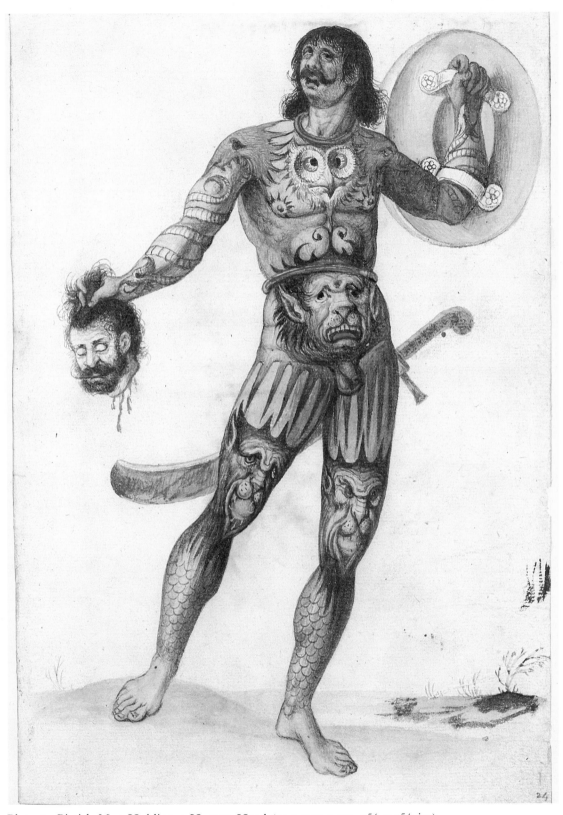

Plate 65. Pictish Man Holding a Human Head (24.3 x 16.9 cm. 9⅝ x 6⅝ in.)

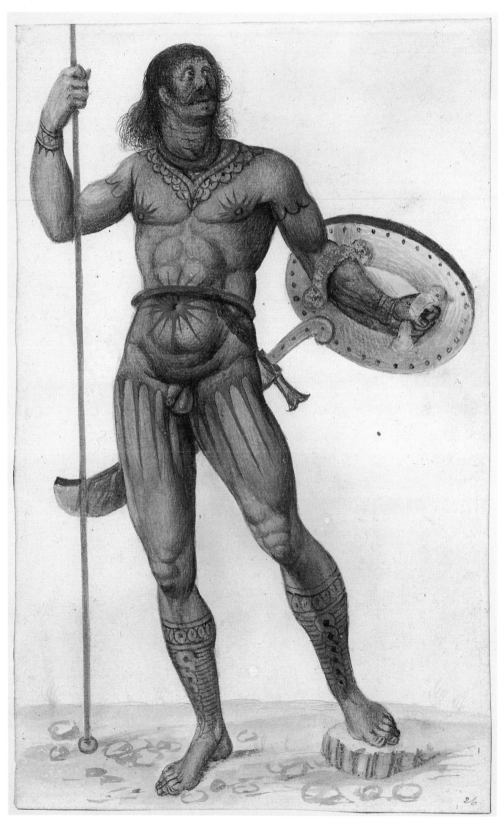

Plate 66. Pictish Man (24.2 x 15.2 cm. or 9½ x 6 in.)

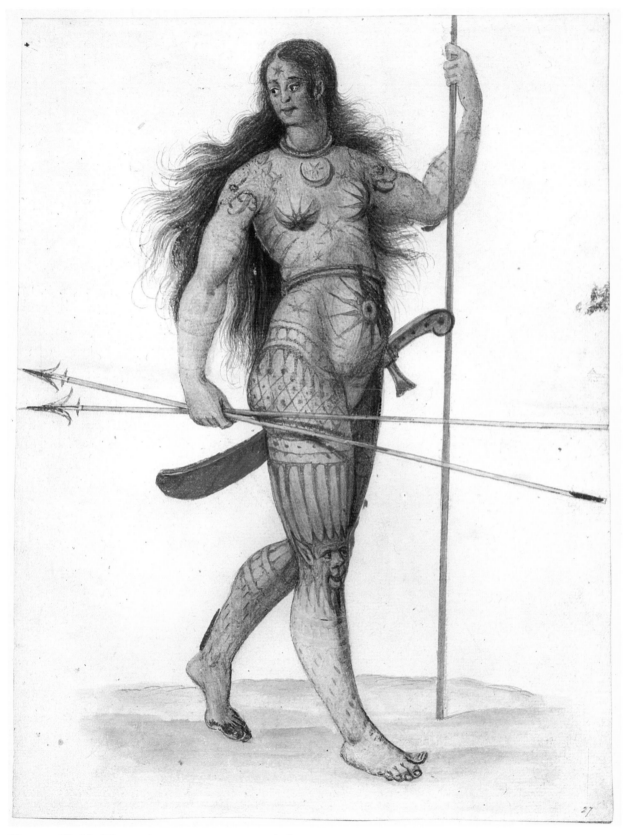

Plate 67. Pictish Woman (23 x 17.8 cm. or 9 x 7 in.)

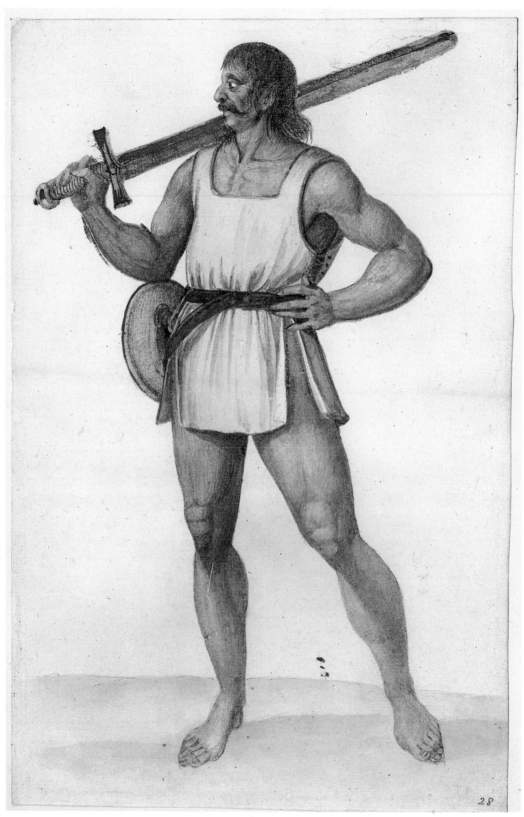

Plate 68. Ancient British Man (23.6 x 15.4 cm. or 9¼ x 6 in.)

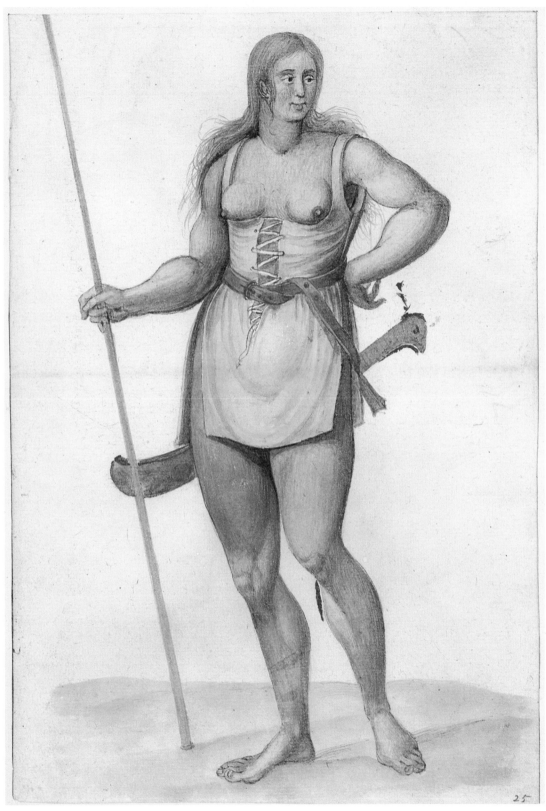

Plate 69. Ancient British Woman (22.1 x 15.3 cm. or 8¾ x 6 in.)

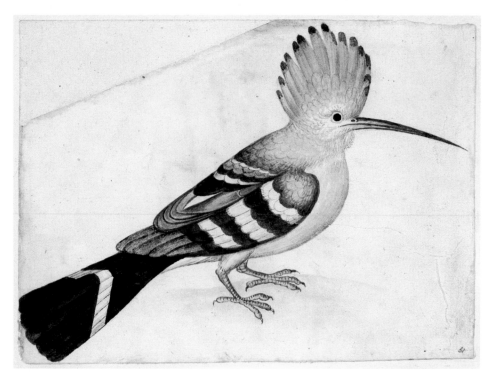

Plate 70. Hoopoe (15 x 21.1 cm. or 6⅞ x 8¾ in.)

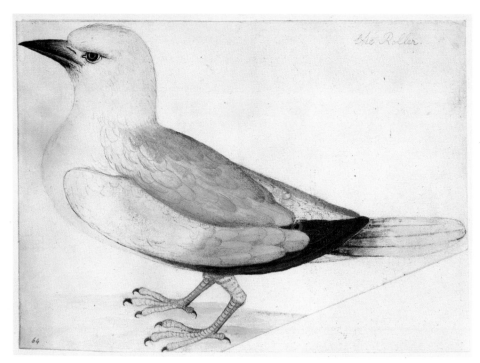

Plate 71. Roller (16 x 22.6 cm. or 6¼ x 8⅞ in.)

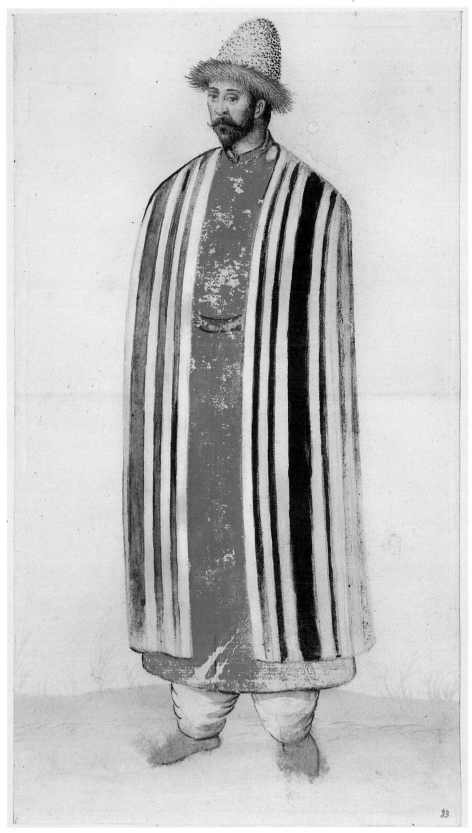

Plate 72. Tartar or Uzbek Man (24.3 x 13.9 cm. or 9⅝ x 5½ in.)

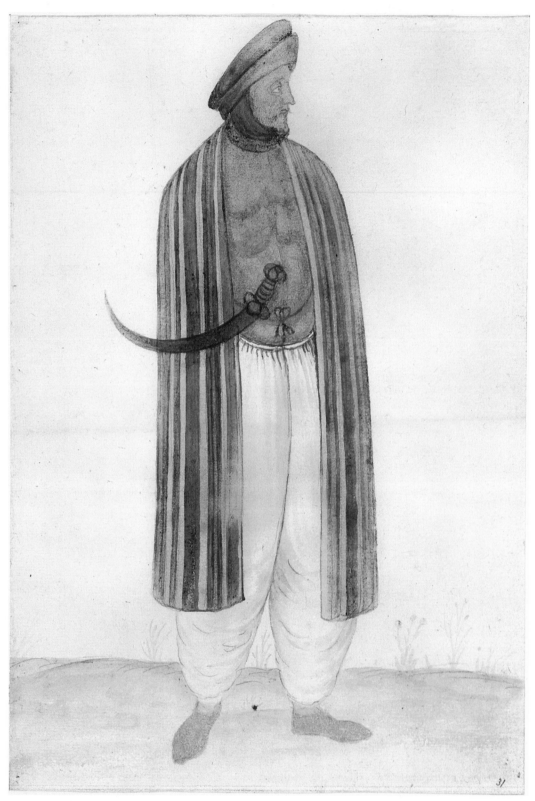

Plate 73. Turkish(?) Man (22.6 x 15.6 cm. or 8⅞ x 6⅛ in.)

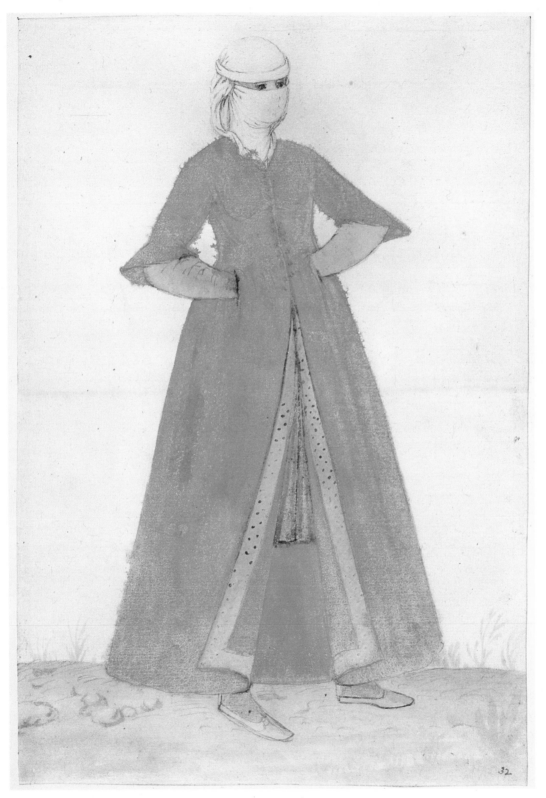

Plate 74. Turkish Woman (22.2 x 15.3 cm. or 8¾ x 6 in.)

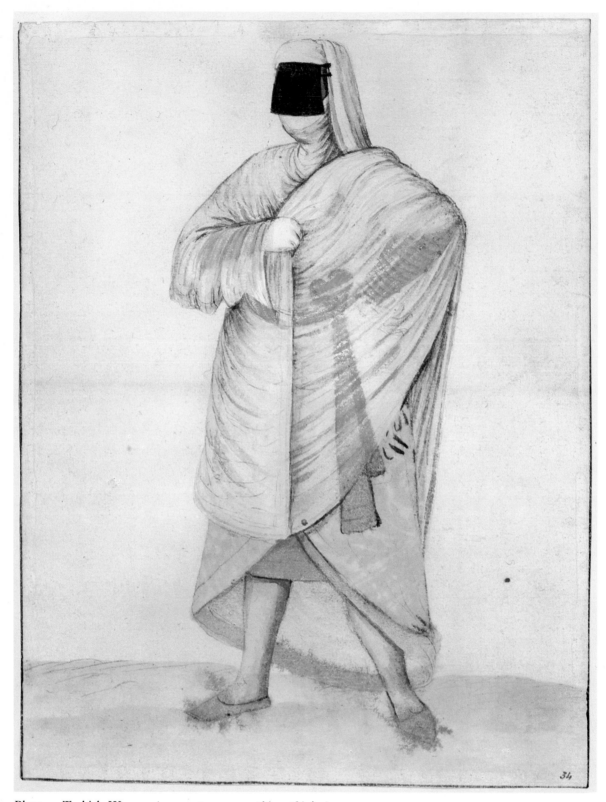

Plate 75. Turkish Woman (21.1 x 16.3 cm. or 8¼ x 6⅜ in.)

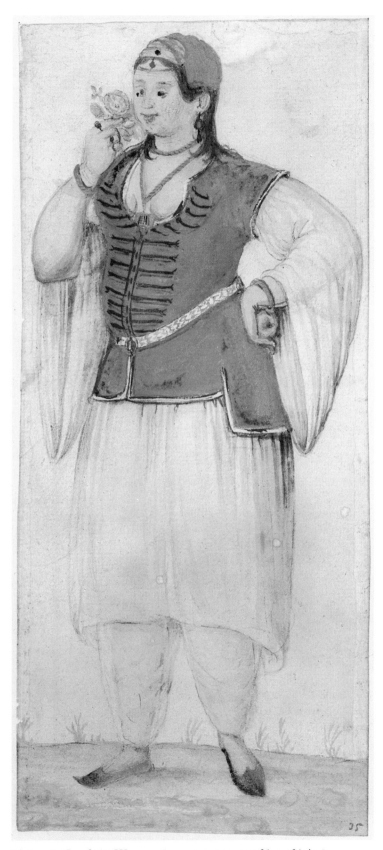

Plate 76. Greek(?) Woman (21 x 9.4 cm. or 8⅜ x 3¾ in.)

a. Swallow-tail Butterfly (11 x 19.7 cm. or 4⅜ x 7¾ in.)

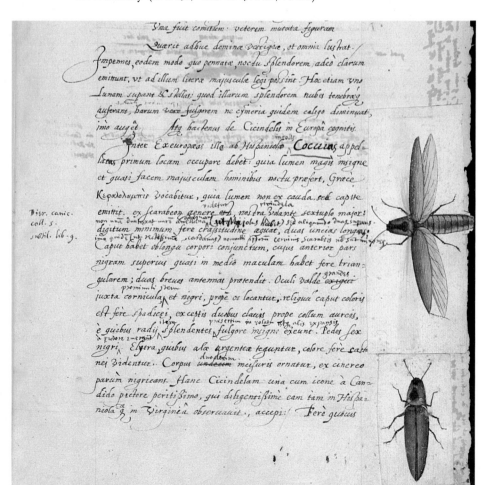

c. Gadfly (2.9 x 2.3 cm. or 1⅛ x ⅞ in.)

b. Fireflies (upper, 11.6 x 4.7 cm. or 4⅝ x 1⅞ in.; lower, 6.2 x 3.5 cm. or 2½ x 1⅜ in.)

Plate 77. From Thomas Moffet 'Insectorum . . . Theatrum'

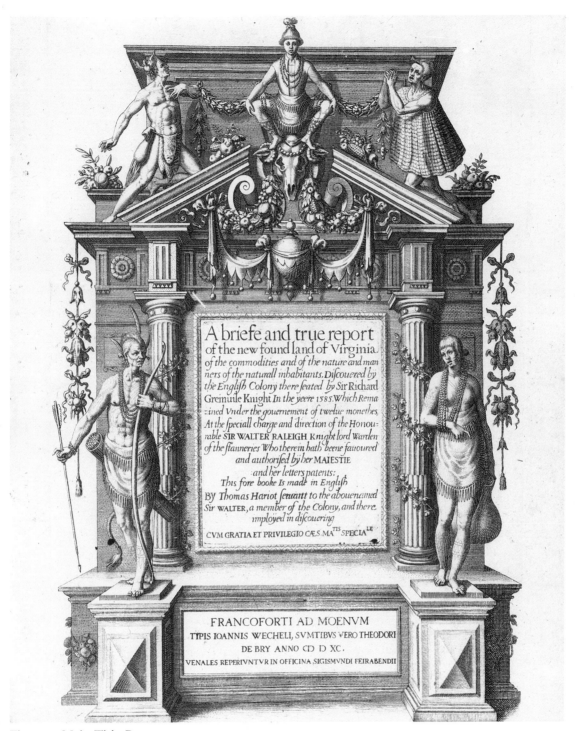

Figure 1. Main Title-Page

TO THE RIGHT
WORTHIE AND HONOV-
RABLE, SIR VVALTER RALEGH,
KNIGHT, SENESCHAL OF THE DVCHIES OF
Cornewall and Exeter, and L. Warden of the ftannaries in Deuon
and Cornewall. T.B. wisheth true felictie.

AMORE ET VIRTVTE.

IR, feeing that the parte of the Worlde, which is betwene the FLORIDA and the Cap BRETON nowe nammed VIRGINIA, to the honneur of yours moft fouueraine Layde and Queene ELIZABETZ, hath ben defcouerd by yours meanes. And great chardges. And that your Collonye hath been theer eftablished to your great honnor and prayffe, and noe leffer proffit vnto the common

4 2

welth: Yt ys good raifon that euery man euert xe him felfe for to showe the benefit which they haue receue of yt. Theerfore, for my parte I haue been allwayes Defirous for to make yow knowe the good will that I haue to remayne ftill your moft humble feruant. I haue thincke that I cold faynde noe better occafion to declare yt, then takinge the paines to cött in copper (the moft diligent ye and well that wear in my poffible to doe) the Figures which doe leuelye reprefent the forme aud maner of the Jnhabitants of thefame countrye with theirs ceremonies, follenne, feaftes, and the manner and fituation of their Townes, or Villages. Addinge vnto euery figure a brief declaration of thefame, to that ende that euerye man cold the better vnderftand that which is in liuelye reprefented. Moreouer I haue thincke that the aforefaid figures wear of greater commendation, Jf fomme Hiftoire which traitinge of the commodites and fertillitye of the faid coütrye weare Ioyned with thefame, therfore haue I ferue mifelfe of the rapport which Thomas Hariot hath lattely fett foorth, and haue caufe them booth togither to be printed for to dedicated vnto you, as a thinge which by reigtte dooth allreadye apparteyne vnto you. Therfore doe I creaue that you will accept this litle Booke, and take yt In goode parite. And defiringe that fauor that you will receue me in the nomber of one of your moft humble feruantz, befechinge the lord to bleff and further you in all yours good doinges and actions, and allfo to preferne, and keepe you allwayes in good helthe. And foe I comitt you vnto the almyhttie, from Franckfort the firft of Apprill 1 5 9 0.

Your moft humble feruant,

THEODORVS de BRY.

Figure 2. Dedication to Sir Walter Raleigh

THE TRVE PICTVRES
AND FASHIONS OF
THE PEOPLE IN THAT PAR-
TE OF AMERICA NOVV CAL-
LED VIRGINIA, DISCOWRED BY ENGLISMEN
sent thither in the years of our Lorde 1585. att the speciall charge and direction of
the Honourable SIR WALTER RALEGH Knigt Lord Warden
of the stannaries in the duchies of Cornwal and Oxford who
therin hath bynne fauored and auctorised by her
MAAIESTIE and her let-
ters patents.

Translated out of Latin into English by
RICHARD HACKLVIT.

DILIGENTLYE COLLECTED AND DRAOW-
ne by IHON WHITE who was sent thiter speciallye and for the same pur-
pose by the said SIR WALTER RALEGH the year abouesaid
1585. and also the year 1588. now cutt in copper and first
published by THEODORE de BRY att
his wone chardges.

Figure 3. Title-Page to the Indian Plates

To the gentle Reader.

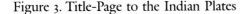

Although (frendlye Reader) man by his disobedience, we are depriued of those good Gifts wher with he was indued in his creation, yet he was not berefte of wit to prouyde for hym selfe, nor discretion to de-uise things necessarie for his vse, except suche as appartayne to his soules healthe, as may be gathered by this sauage nations, of whiome this present worke intreateth. For although they haue noe true knoledge of God nor of his holye worde and are destituted of all lerninge, Yet they passe vs in many thinges, as in Sober seedinge and Dexteritye of witte, in makinge without any instrument of mettall thinges so neate and so fine, as a man would scarselye beleue the same, Vnless the Englishemen Had made proofe Therof by their trauailes into the contrye. Consideringe, Therfore that yt was a thinge worthie of admiration, I was verye willinge to offer vnto you the true Pictures of those people wich by the helfe of Maister Richard Hakluyt of Oxford Mi-nister of Gods Word, who first Incouraged me to publish the Worke, I creaued out of the verye original of Maister Ihon White an Englisch paynter who was sent into the contrye by the queenes Maiestye, onlye to draw the description of the place, lynelye to describe the shapes of the Inhabitants their apparell, manners of Liuinge, and fashions, att the speciall Charges of the worthy knighte, Sir WALTER RA-LEGH, who bestowed noe Small Sume of monnye in the serche and Discouerye of that countrye, From te yeers, 1584. to the ende of The years 1588. Morouer this booke which intreateth of that parte of the new World which the Englishemen call by the name of Virginia I heer sett out in the first place, beinge thereunto requested of my Frends, by Raeson of the memorye of the fresh and laue performance ther of, albeyt I haue in hand the Historye of Florida wich should bee first sett foorthe be-cause yt was discoured by the Frencheman longe befor the discouerye of Virginia, yet I hope shortlye also to publish the same, A Victorye, doubtless so Rare, as I thinke the like hath not ben heard nor seene. I craeued both of them at London, an brought, Them hither to Franckfurt, wher I and my sonnes hauen taken ernest paynes in gra-uinge the pictures ther of in Copper, seeing yt is a matter of noe small importance. Touchinge the stile of both the Discourses, I haue caused yt to bee Reduced into verye Good Frenche and Latin by the aide of verye worshipfull frend of myne. Fi-nallye I hartly Request thee, that yf any seeke to Contrefaict thes my books, (for in this dayes many are so malicious that they seeke to gayne by other men labours) thow wouldest giue noe credit vnto suche conterfaited Drawghte. For dyuers secret marks lye hiddin in my pictures, which wil breede Con-fusion vnless they bee well obserued.

Figure 4. Epistle to the Gentle Reader

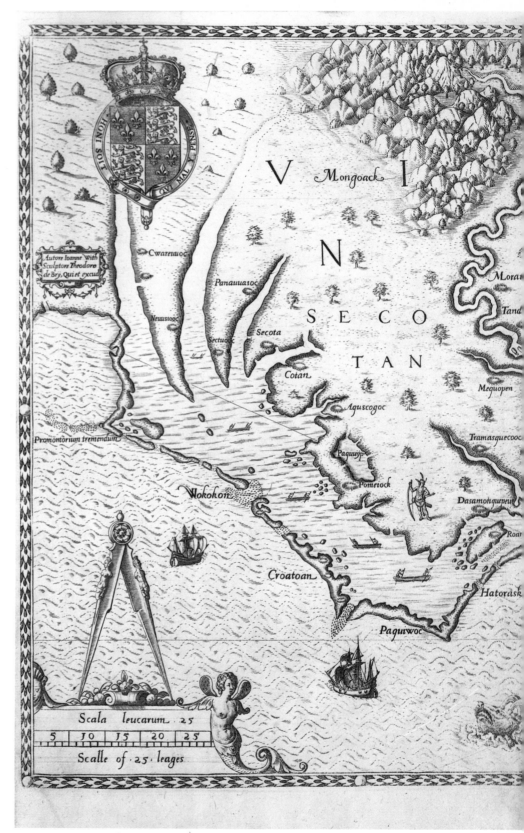

Figure 5. Map of Raleigh's Virginia

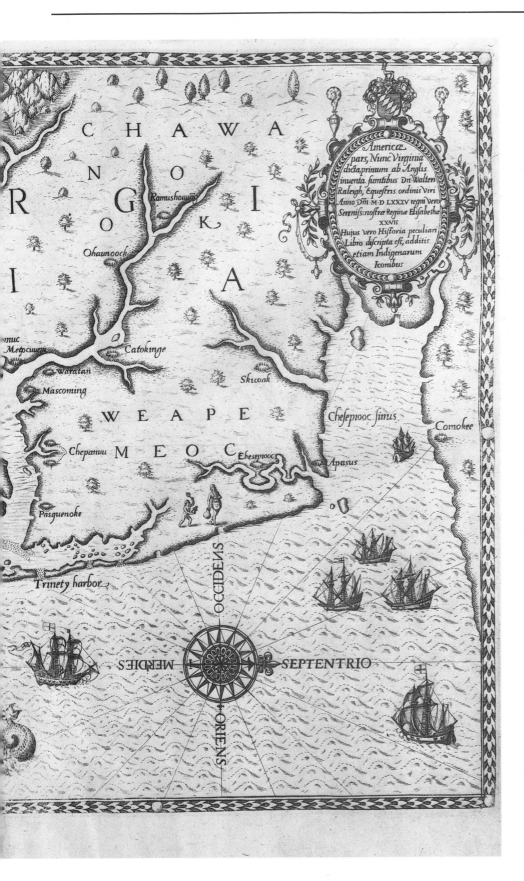

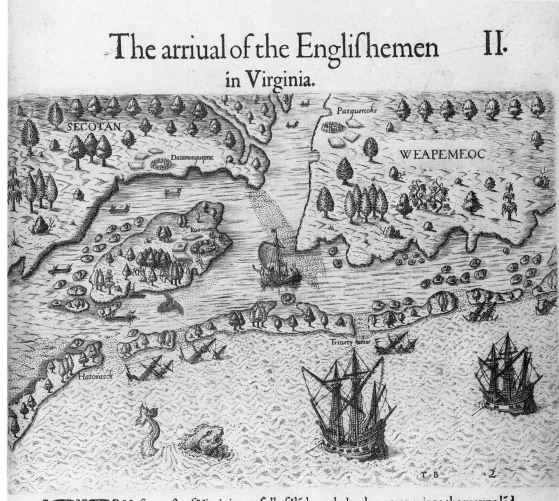

The arriual of the Englishemen in Virginia. II.

THe sea coasts of Virginia arre full of Ilāds, wehr by the entrance into the mayne lād is hard to finde. For although they bee separated with diuers and sundrie large Diuision, which seeme to yeeld conuenient entrance, yet to our great perill we proued that they wear shallowe, and full of dangerous flatts, and could neuer perce opp into the mayne lād, vntill wee made trialls in many places with or small pinneß. At lengthe wee fownd an entrance vppon our mens diligent serche therof. Affter that wee had passed opp, and sayled ther in for a short space we discouered a migthye riuer fallnige downe in to the sownde ouer against those Ilands, which neuertheless wee could not saile opp any thinge far by Reason of the shallownes, the mouth ther of beinge annoyed with sands driuen in with the tyde therfore saylinge further, wee came vnto a Good bigg yland, the Inhabitante therof as soone as they saw vs began to make a great an horrible crye, as people which meuer befoer had seene men apparelled like vs, and camme a way makinge out crys like wild beasts or men out of their wyts. But beenge gentlye called backe, wee offred thē of our wares, as glasses, kniues, babies, and other trifles, which wee thougt they deligted in. Soe they stood still, and perceuinge our Good will and courtesie came fawninge vppon vs, and bade us welcome. Then they brougt vs to their village in the iland called, Roanoac, and vnto their Weroans or Prince, which entertained vs with Reasonable curtesie, althoug the wear amased at the first sight of vs. Suche was our arriuall into the parte of the world, which we call Virginia, the stature of bodee of wich people, theyr attire, and maneer of lyuinge, their feasts, and banketts, I will particullerlye declare vnto yow.

Figure 6. Arrival of the English

A weroan or great Lorde of Virginia. III.

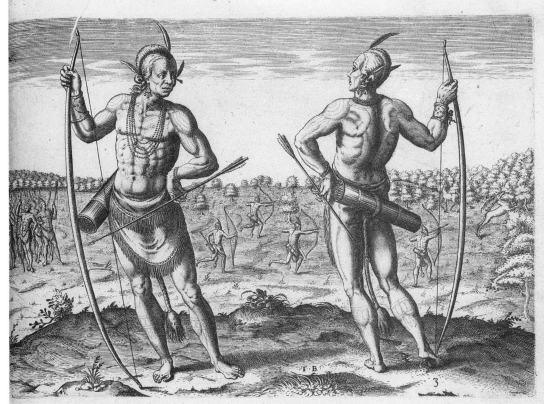

THe Princes of Virginia are attyred in suche manner as is expreſſed in this figure. They weare the haire of their heades long and bynde opp the ende of theſame in a knot vnder thier eares. Yet they cutt the topp of their heades from the forehead to the nape of the necke in manner of a cokſcombe, ſtirkinge a faier lóge pecher of ſome berd att the Begininge of the creſte vppun their foreheads, and another ſhort one on bothe ſeides about their eares. They hange at their eares ether thicke pearles, or ſomwhat els, as the clawe of ſome great birde, as cometh in to their fanſye. Moreouer They ether pownes, or paynt their forehead, cheeks, chynne, bodye, armes, and leggs, yet in another ſorte then the inhabitantz of Florida. They weare a chaine about their necks of pearles or beades of copper, wich they muche eſteeme, and ther of wear they alſo braſelets ohn their armes. Vnder their breſts about their bellyes appeir certayne ſpotts, whear they vſe to lett them ſelues bloode, when they are ſicke. They hange before thē the ſkinne of ſome beaſte verye ſeinelye dreſſet in ſuche ſorte, that the tayle hangeth downe behynde. They carye a quiuer made of ſmall ruſhes holding their bowe readie bent in on hand, and an arrowe in the other, radie to defend themſelues. In this manner they goe to warr, or tho their ſolemne feaſts and banquetts. They take muche pleaſure in huntinge of deer wher of theris great ſtore in the contrye, for yt is fruit full, pleaſant, and full of Goodly woods. Yt hathe alſo ſtore of riuers full of diuers ſorts of fiſhe. When they go to battel they paynt their bodyes in the moſt terible manner that thei can deuiſe.

Figure 7. Indian in Body Paint

On of the chieff Ladyes of Secota. IIII.

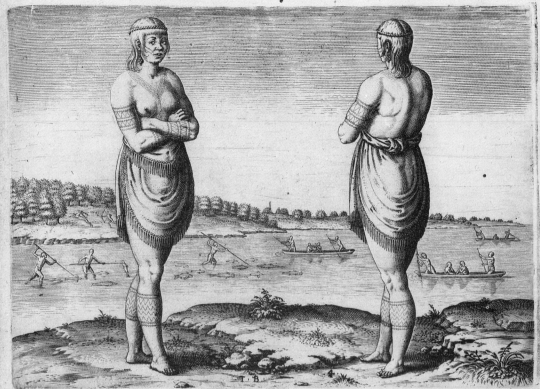

T He woemē of Secotam are of Reasonable good proportion. In their goinge they
carrye their hāds danglinge downe, and air dadil in a deer skinne verye excellētlye
wel dressed, hanginge downe frō their nauell vnto the mydds of their thighes, which
also couereth their hynder partz. The reste of their bodies are all bare. The forr parte
of their haire is cutt shorte, the rest is not ouer Longe, thinne, and softe, and falling
downe about their shoulders: They weare a Wrrath about their heads. Their foreheads, cheeks,
chynne, armes and leggs are pownced. About their necks they wear a chaine, ether pricked or
paynted. They haue small eyes, plaine and flatt noses, narrow foreheads, and broade mowths. For
the most parte they hange at their eares chaynes of longe Pearles, and of some smootht bones.
Yet their nayles are not longe, as the woemen of Florida. They are also deligtted
with walkinge in to the fields, and besides the riuers, to see the
huntinge of deers and catchinge of
fische.

A 2

Figure 8. Indian Woman of Secoton

On of the Religeous men in the V.
towne of Secota.

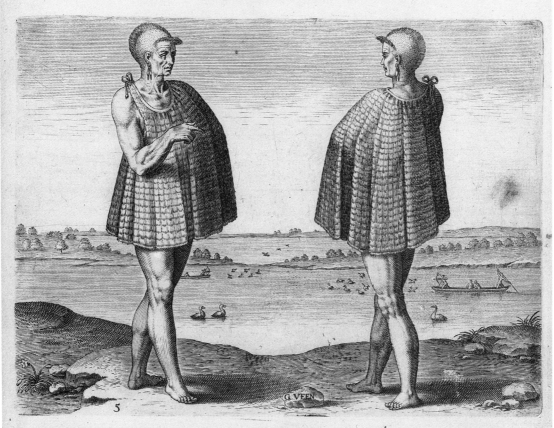

He Priefts of the aforefaid Towne of Secota are well ftricken in yeers, and as yt fee-
meth of more experience then the comon forte. They weare their heare cutt like a
crefte, on the topps of thier heades as other doe, but the reft are cutt fhorte, fauinge
thofe which growe aboue their foreheads in manner of a perriwigge. They alfo ha-
ue fomwhat hanginge in their ears. They weare a fhorte clocke made of fine hares
skinnes quilted with the hayre outwarde. The reft of thier bodie is naked. They
are notable enchaunters, and for their pleafure they frequent the riuers, to kill with
their bowes, and catche wilde ducks, fwannes, and
other fowles.

Figure 9. Indian Priest

A younge gentill woeman doughter VI.
of Secota.

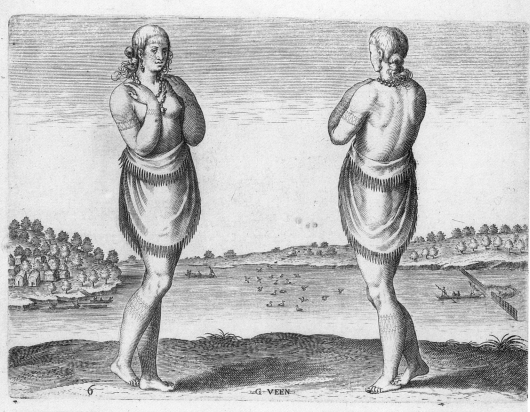

Irgins of good parentage are apparelled altogether like the woemen of Secota aboue mentionned, sauing that they weare hanginge abowt their necks in steede of a chaine certaine thicke, and rownde pearles, with little beades of copper, or polished bones betweene them. They pounce their foreheads, cheeckes, armes and legs. Their haire is cutt with two ridges aboue their foreheads, the rest is trussed opp on a knott behinde, they haue broade mowthes, reasonable fair black eyes: they lay their hands often vppon their Shoulders, and couer their brests in token of maydenlike modestye. The rest of their bodyes are naked, as in the picture is to bee seene.

They deligt also in seeinge fishe taken in
the riuers.

A 4

Figure 10. Indian Woman

A cheiff Lorde of Roanoac. VII.

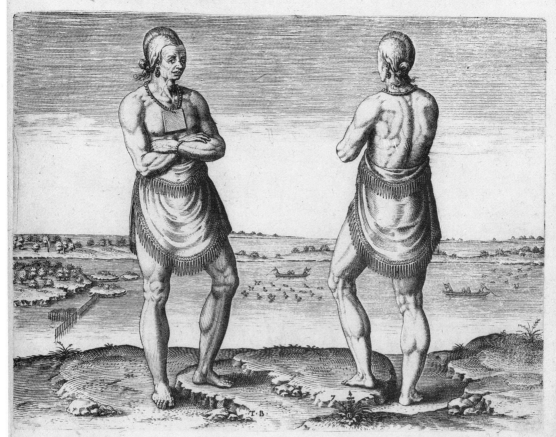

He cheefe men of the yland and towne of Roanoac reace the haire of their crou-
nes of theyr heades cutt like a cokes cõbe, as thes other doe. The reft they wear lóge
as woemen and truß them opp in a knott in the nape of their necks. They hange
pearles ftringe copper a threed att their eares, and weare bracelets on their armes of
pearles, or fmall beades of copper or of fmoothe bone called minfal, nether pain-
tinge nor powncings of themfelues, but in token of authoritye, and honor, they wear a chaine of
great pearles, or copper beades or fmoothe bones abowt their necks, and a plate of copper hinge v-
pon a ftringe, from the nauel vnto the midds of their thighes. They couer themfelues before and be-
hynde as the woemé doe with a deers skynne handfomley dreffed, and fringed, More ouer they fold
their armes together as they walke, or as they talke one wjth another in figne of wifdome.
The yle of Roanoac is verye pleifant, ond hath plaintie of fifhe by rea-
fon of the Water that enuironeth thefame.

Figure 11. Indian Elder or Chief

A cheiff Ladye of Pomeiooc. VIII.

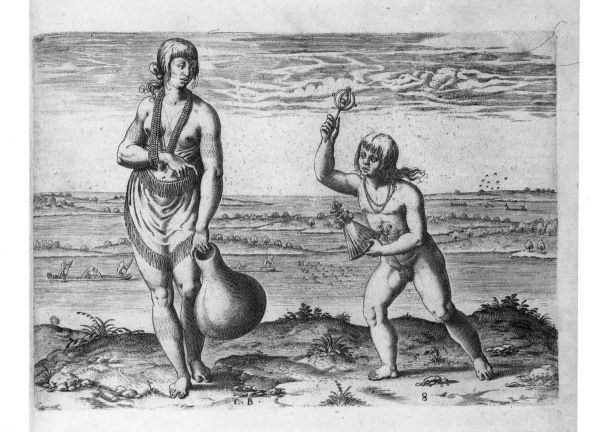

bout 20. milles from that Iland, neere the lake of Paquippe, ther is another towne
called Pomeioock hard by the fea. The apparell of the cheefe ladyes of dat towne
differeth but litle from the attyre of thofe which lyue in Roanaac. For they weare
their haire truffed opp in a knott, as the maiden doe which we fpake of before, and
haue their fkinnes pownced in thefame manner, yet they wear a chaine of great
pearles, or beades of copper, or fmoothe bones 5. or 6. fold obout their necks, be-
aringe one arme in the fame, in the other hand they carye a gourde full of fome kinde of pleafant
liquor. They tye deers fkinne doubled about them crochinge hygher about their breafts, which
hange downe before almoft to their knees, and are almoft altogither naked behinde. Commonlye
their yonge daugters of 7. or 8. yeares olde do waigt vpon them wearinge abowt them a girdle of
fkinne, which hangeth downe behinde, and is drawen vnder neath betwene their twifte, and bown-
de aboue their nauel with mofe of trees betwene that and thier fkinnes to couer their priuiliers
withall. After they be once paft 10. yeares of age, they wear deer fkinnes as the older forte do.
They are greatlye Diligted with puppetts, and babes which wear brought
oute of England.

Figure 12. Indian Woman and Young Girl

An ageed manne in his winter IX.
garment.

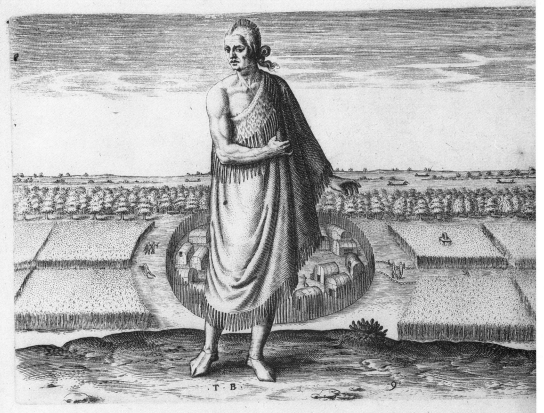

He aged men of Pommeioocke are couered with a large skinne which is tyed vppon their shoulders on one side and hangeth downe beneath their knees wearinge their other arme naked out of the skinne, that they maye bee at more libertie. Those skynnes are Dressed with the hair on, and lyned with other furred skinnes. The yonnge men suffer noe hairr at all to growe vppon their faces but assoone as they growe they put them away, but when thy are come to yeeres they suffer them to growe although to say truthe they come opp verye thinne. They also weare their haire bownde op behynde, and, haue a creste on their heads like the others. The contrye abowt this plase is soe fruit full and good, that England is not to bee compared to yt.

B

Figure 13. Old Indian Man

Their manner of careynge ther Chil- X.
dern and a tyere of the cheiffe Ladyes of the
towne of Dasamonquepeuc.

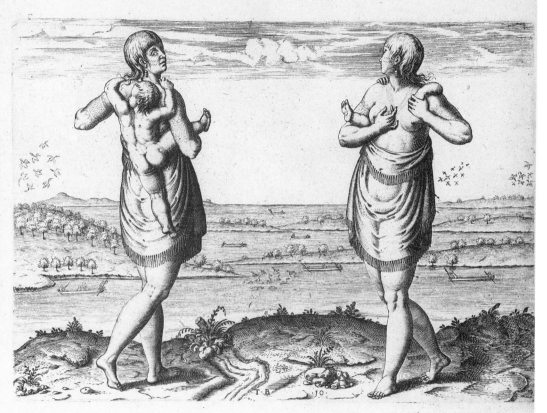

IN the towne of Dasemonquepeuc distant from Roanoac 4. or 5. milles, the woemen are attired, and pownced, in suche sorte as the woemen of Roanoac are, yet they weare noe worathes vppon their heads, nether haue they their thighes painted with small pricks. They haue a strange manner of bearing their children, and quite contrarie to ours. For our woemen carrie their children in their armes before their brests, but they taking their sonne by the right hand, bear him on their backs, holdinge the left thighe in their lefte arme after a strange, and conuesnall fashion, as in the picture is to bee seene.

B 2

Figure 14. Indian Woman and Baby

The Coniuerer. XI.

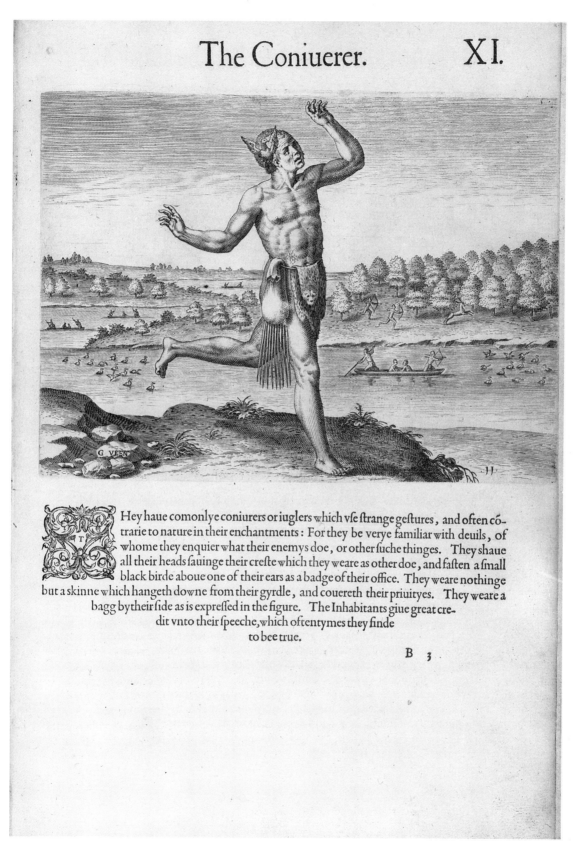

Hey haue comonlye coniurers or iuglers which vse strange gestures, and often cō-
trarie to nature in their enchantments : For they be verye familiar with deuils, of
whome they enquier what their enemys doe, or other suche thinges. They shaue
all their heads sauinge their creste which they weare as other doe, and fasten a small
black birde aboue one of their ears as a badge of their office. They weare nothinge
but a skinne which hangeth downe from their gyrdle, and couereth their priuityes. They weare a
bagg by their side as is expressed in the figure. The Inhabitants giue great cre-
dit vnto their speeche, which oftentymes they finde
to bee true.

B 3

Figure 15. Indian Conjuror

The manner of makinge their boates. XII.

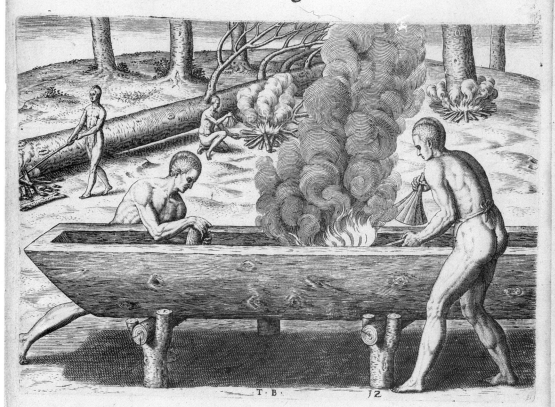

He manner of makinge their boates in Virginia is verye wonderfull. For wheras they want Inftruments of yron , or other like vnto ours , yet they knowe howe to make them as handfomelye , to faile with whear they lifte in their Riuers , and to fifhe with all, as ours. Firft they choofe fome longe , and thicke tree , according to the bignes of the boate which they would frame , and make a fyre on the grownd abowt the Roote therof, kindlinge the fame by little , and little with drie moffe of trees , and chipps of woode that the flame fhould not mounte opp to highe , and burne to muche of the lengte of the tree· When yt is almoft burnt thorough, and readye to fall they make a new fyre, which they fuffer to burne vntill the tree fall of yt owne accord. Then burninge of the topp , and bowghs of the tree in fuche wyfe that the bodie of thefame may Retayne his iuft lengthe , they raife yt vppon potes laid ouer croff wife vppon forked pofts, at fuche a reafonable heighte as rhey may handfomlye worke vp-pó yt. Then take they of the barke with certayne fhells: thy referue the, innermoft parte of the lenn-ke , for the nethermoft parte of the boate. On the other fide they make a fyre according to the lengthe of the bodye of the tree , fauinge at both the endes. That which they thinke is fufficientlye burned they quenche and fcrape away with fhells, and makinge a new fyre they burne yt agayne, and foe they continne fomtymes burninge and fometymes fcrapinge , vntill the boate haue fufficient bothowmes. This god indueth thife fauage people with fufficient reafon to make thinges neceffarie to ferue their turnes.

Figure 16. Indians Making Canoes

XIII.

Their manner of fishynge in Virginia.

Hey haue likewise a notable way to catche fishe in their Riuers. for wheat as they lacke both yron, and steele, they faste vnto their Reedes or longe Rodds, the hollowe tayle of a certaine fishe like to a sea crabb in steede of a poynte, wehr with by nighte or day they stricke fishes, and take them opp into their boates. They also know how to vse the prickles, and pricks of other fishes. They also make weares, with settinge opp reedes or twigges in the water, which they soe plant one within a nother, that they growe still narrower, and narrower, as appeareth by this figure. Ther was neuer seene amonge vs soe cunninge a way to take fish withall, wherof sondrie sortes as they fownde in their Riuers vnlike vnto ours. which are also of a verye good taste. Dowbtleß yt is a pleasant sighte to see the people, somtymes wadinge, and goinge somtymes sailinge in thofe Riuers, which are shallowe and not deepe, free from all care of heapinge opp Riches for their posterite, content with their state, and liuinge frendlye together of thofe thinges which god of his bountye hath giuen vnto them, yet without giuinge hym any thankes according to his defarte. So sauage is this people, and depriued of the true knowledge of god. For they haue none other then is mentionned before in this worke.

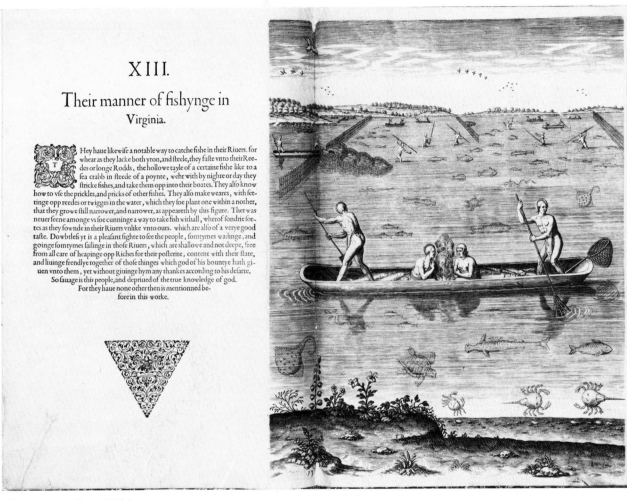

Figure 17. Indians Fishing

The brovvyllinge of their fifhe XIIII.
ouer the flame.

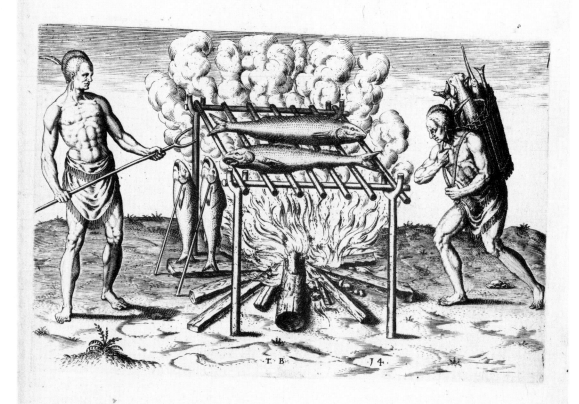

A Fter they haue taken ftore of fifhe, they gett them vnto a place fitt to drefs yt. Ther they fticke vpp in the grownde 4. ftakes in a fquare roome, and lay 4 potes vppon them, and others ouer thwart thefame like vnto an hurdle, of fufficient heigthe. and layinge their fifhe vppon this hurdle, they make a fyre vnderneathe to broile the fame, not after the manner of the people of Florida, which doe but fchorte, and harden their meate in the fmoke onlye to Referue thefame duringe all the winter. For this people referuinge nothinge for ftore, thei do broile, and fpend away all att once and when they haue further neede, they rofte or feethe frefh, as wee fhall fee heraffter. And when as the hurdle can not holde all the fifhes, they hange the Reft by the fyrres on fticks fett vpp in the grounde a gainft the fyre, and than they finifhe the reft of their cookerye. They take good heede that they bee not burntt. When the firft are broyled they lay others on, that weare newlye broughte, continuinge the dreffinge of their meate in this forte, vntill they thincke they haue fufficient.

Figure 18. Cooking Fish

Their ſeetheynge of their meate in earthen pottes. XV.

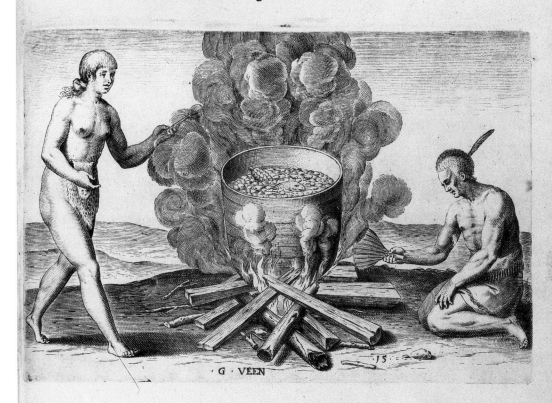

G · VEEN

Heir woemen know how to make earthen veſſells with ſpecial Cunninge and that ſo large and fine, that our potters with lhoye wheles can make noe better: ant then Remoue them from place to place as eaſelye as we candoe our braſſen kettles. After they haue ſet them vppon an heape of erthe to ſtay them from fallinge, they putt wood vnder which being kyndled one of them taketh great care that the fyre burne equallye Rounde abowt. They or their woemen fill the veſſel with water, and then putt they in fruite, fleſh, and fiſh, and lett all boyle together like a galliemaufrye, which the Spaniarde call, olla podrida. Then they putte yt out into diſches, and ſett before the companye, and then they make good cheere together. Yet are they moderate in their eatinge wher by they auoide ſicknes. I would to god wee would followe their exemple. For wee ſhould bee free from many kynes of diſeaſyes which wee fall into by ſumptwous and vnſeaſonable banketts, continuallye deuiſinge new ſawces, and prouocation of gluttonnye to ſatiſſie our vnſatiable appetite.

Figure 19. Cooking in a Pot

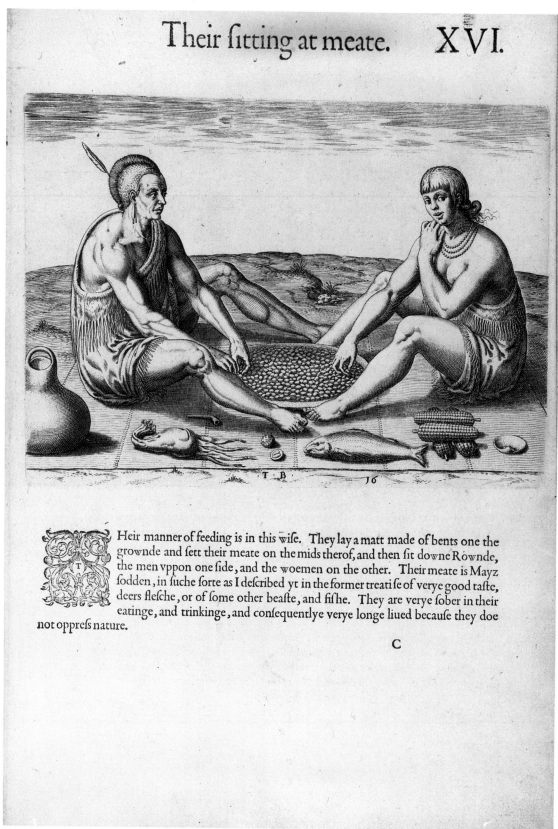

Their sitting at meate. XVI.

Heir manner of feeding is in this wise. They lay a matt made of bents one the grownde and sett their meate on the mids therof, and then sit downe Rownde, the men vppon one side, and the woemen on the other. Their meate is Mayz sodden, in suche sorte as I described yt in the former treatise of verye good taste, deers flesche, or of some other beaste, and fische. They are verye sober in their eatinge, and trinkinge, and consequentlye verye longe liued because they doe not oppress nature.

C

Figure 20. Indian Man and Woman Eating

XVII.

Their manner of prainge vvith Rat-
tels abowt te fyer.

VVhen they haue escaped any great danger by sea or lande, or be re-
turned from the warr in token of Ioye they make a great fyer a-
bowt which the men, and woemen sitt together, holdinge a cer-
taine fruite in their hands like vnto a rownde pompió or a gourde,
which after they haue taken out the fruits, and the seedes, then fill
with smal stons or certayne bigg kernellt to make the more noise,
and fasten that vppon a sticke, and singinge after their manner, they make mer-
rie: as my selfe obserued and noted downe at my beinge amonge them.
For it is a strange custome, and worth the
obseruation.

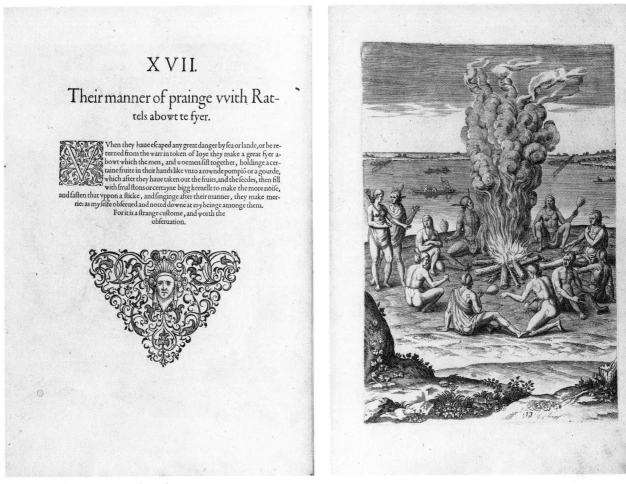

Figure 21. Indians round a Fire

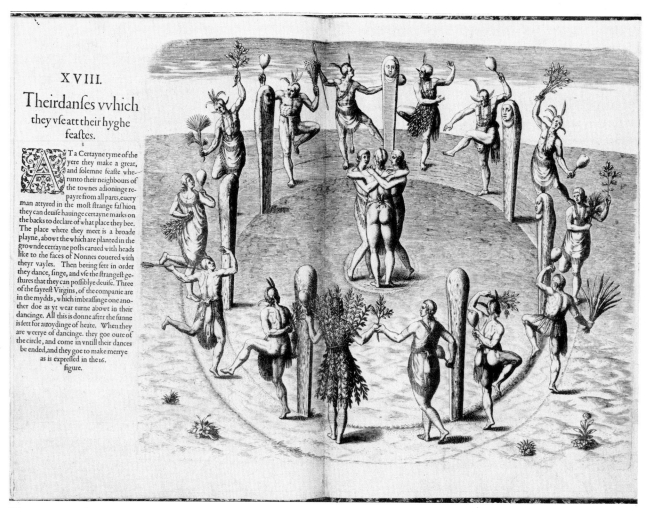

XVIII.

Their danſes vvhich they vſe att their hyghe feaſtes.

AT a certayne tyme of the yere they make a great, and ſolemne feaſte wherunto their neighbours of the townes adioninge repayre from all parts, euery man attyred in the moſt ſtrange faſhion they can deuiſe hauinge certayne marks on the backs to declare of what place they bee. The place where they meet is a broade playne, abowt the which are planted in the grownde certayne poſts carued with heads like to the faces of Nonnes couered with theyr vayles. Then beeing ſett in order they dance, ſinge, and vſe the ſtrangeſt geſtures that they can poſſiblye deuiſe. Three of the fayreſt Virgins, of the companie are in the mydds, which imbraſſinge one another doe as yt wear turne abowt in their dancinge. All this is donne after the ſunne is ſett for auoydinge of heate. When they are weerye of dancinge. they goe oute of the circle, and come in vntill their dances be ended, and they goe to make merrye as is expreſſed in the 16. figure.

Figure 22. Indians Dancing

XIX.

The Tovvne of Pomeiooc.

He townes of this contrie are in a maner like vnto those which are in Florida, yet are they not soe stronge nor yet preserued with soe great care. They are compassed abowt with poles starcke faste in the grownd, but they are not verye stronge. The entrance is verye narrowe as may be seene by this picture, which is made accordinge to the forme of the towne of Pomeiooc. Ther are but few howses therin, saue those which belonge to the kinge and his nobles. On the one side is their tempel separated from the other howses, and marked with the letter A. yt is builded rownde, and couered with skynne matts, and as yt wear compassed abowt. With cortynes without windowes, and hath noe ligthe but by the doore. On the other side is the kings lodginge marked with the letter B. Their dwellinges are builded with certaine potes fastened together, and couered with matts which they turne op as high as they thinke good, and soe receue in the lighte and other. Some are also couered with boughes of trees, as euery man lusteth or liketh best. They keepe their feasts and make good cheer together in the midds of the towne as yt is described in they 17. Figure. When the towne standeth fare from the water they digg a great poude noted with the letter C. wherhence they fetche as muche water as they neede.

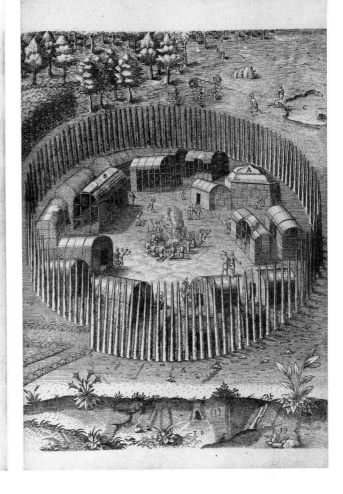

Figure 23. Indian Village of Pomeiooc

X X.

The Tovvne of Secota.

Heir townes that are not inclosed with poles aire common-
lye fayrer. Then suche as are inclosed, as appereth in this fi-
gure which liuelye expresseth the towne of Secotam. For
the howses are Scattered heer and ther, and they haue garde-
in expressed by the letter E. wherin groweth Tobacco which
the inhabitants call Vppowoc. They haue also groaues whe-
rin thei take deer, and fields vherin they sowe their corne. In their corne
fields they builde as yt weare a scaffolde wher on they sett a cottage like to a
rownde chaire, signiffied by F. wherin they place one to watche, for there are
suche number of fowles, and beasts, that vnless they keepe the better wat-
che, they would soone deuoure all their corne. For which cause the wat-
cheman maketh continual cryes and noyse. They sowe their corne with a
certaine distance noted by H. otherwise one stalke would choke the growthe
of another and the corne would not come vnto his rypeurs G. For the leaues
therof are large, like vnto the leaues of great reedes. They haue also a seuerall
broade plotte C. whear they meete with their neighbours, to celebrate their
cheefe solemne feastes as the 18. picture doth declare: and a place D. whear af-
ter they haue ended their feaste they make merrie togither. Ouer against
this place they haue a rownd plott B. wher they assemble themselues to
make their solemne prayers. Not far from which place ther is a lardge buil-
dinge A. wherin are the tombes of their kings and princes, as will appere by
the 22. figure likewise they haue garden notted bey the letter I. wherin they
vse to sowe pompions. Also a place marked with K. wherin the make a fyre
att their solemne feasts, and hard without the towne a riuer L. from whence
they fetche their water. This people therfore voyde of all couetousnes lyue
cherfullye and att their harts ease. Butt they solemnise their feasts
in the nigt, and therfore they keepe verye great
fyres to auoyde darkenes, ant to
testifie their Ioye.

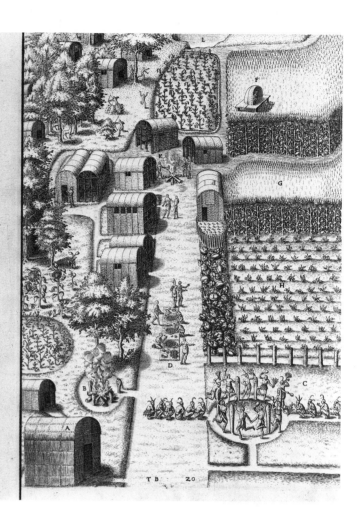

Figure 24. Indian Village of Secoton

Ther Idol Kivvasa. XXI.

He people of this cuntrie haue an Idol, which they call KIWASA: yt is carued of woode in lengthe 4. foote whose heade is like the heades of the people of Florida, the face is of a flesh colour, the brest white, the rest is all blacke, the thighes are also spottet with whitte. He hath a chayne abowt his necke of white beades, betweene which are other Rownde beades of copper which they esteeme more then golde or siluer. This Idol is placed in the temple of the towne of Secotam, as the keper of the kings dead corpses. Somtyme they haue two of thes idoles in theyr churches, and somtine 3. but neuer aboue, which they place in a darke corner wher they shew tetrible. Thes poore soules haue none other knowledge of god although I thinke them verye Desirous to know the truthe. For when as wee kneeled downe on our knees to make our prayers vnto god, they went abowt to imitate vs, and when they saw we moued our lipps, they also dyd the like. Wherfore that is verye like that they might easelye be brongt to the knowledge of the gospel. God of his mercie grant them this grace.

D 2

Figure 25. Indian Idol

XXII.

The Tombe of their Werovvans
or Cheiff Lordes.

He builde a Scaffolde 9. or 10. foote hihe as is expressed in this figure vnder the tobs of theit Weroans, or cheefe lordes which they couer with matts, and lai the dead corpses of their weroans thereuppon in manner followinge. first the bowells are taken forthe. Then layinge downe the skinne, they cutt all the flesh cleane from the bones, which the drye in the sonne, and well dryed the inclose in Matts, and place at their feete. Then their bones (remaininge still fastened together with the ligaments whole and vn-corrupted) are couered a gayne with leather, and their carcase fashioned as yf their flesh wear not taken away. They lapp eache corps in his owne skinne after thesame in thus handled, and lay yt in his order by the corpses of the other cheef lordes. By the dead bodies they sett their Idol Kiwasa, wher of we spake in the former chapiter: For they are persuaded that thesame doth kepe the dead bodyes of their cheefe lordes that nothinge may hurt them. Moreouer vnder the foresaid scaffolde some on of their preists hath his lod-ginge, which Mumbleth his prayers nighte and day, and hath charge of the corpses. For his bedd he hath two deares skinnes spredd on the grownde, yf the wether bee cold hee maketh a fyre to warme by withall. Thes poore soules are thus instructed by natute to reuerence their princes euen after their death.

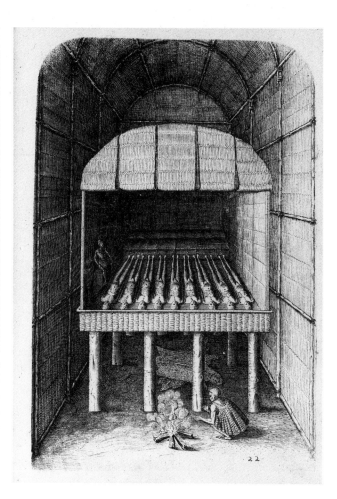

Figure 26. Indian Charnel House

The Marckes of fundrye of the XXIII.
Cheif mene of Virginia.

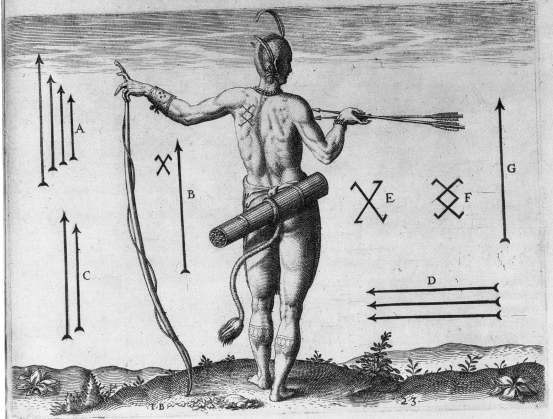

He inhabitãts of all the cũntrie for the most parte haue marks rafed on their backs, wherby yt may be knowen what Princes fubiects they bee, or of what place they haue their originall. For which caufe we haue fet downe thofe marks in this figure, and haue annexed the names of the places, that they might more eafelye be difcerned. Which induftrie hath god indued them withal although they be verye finple, and rude. And to confeffe a truthe I cannot remember, that euer I faw a better or quietter people then they.

The marks which I obferued amonge them, are heere put downe in order folowinge.

The marke which is expreffed by A. belongeth tho Wingino, the cheefe lorde of Roanoac.

That which hath B. is the marke of Wingino his fifters hufbande.

Thofe which be noted with the letters, of C. and D. belonge vnto diverfe chefe lordes in Secotam.

Thofe which haue the letters E. F. G. are certaine cheefe men of Pomeiooc, and Aquafcogoc.

Figure 27. Indian Markings

SOM PICTVRE,
OF THE PICTES
WHICH IN THE OLDE
tyme dyd habite one part of the
great Bretainne.

THE PAINTER OF WHOM J HAVE
had the firft of the Inhabitans of *Virginia*, giue my allfo thees 5. Figures
fallowinge, fownd as hy did affured my in a oolld English cronicle, the which
I wold well fett to the ende of thees firft Figures, for to showe how that
the Inhabitants of the great Bretannie haue bin in ti-
mes paft as fauuage as thofe of
Virginia.

E

Figure 28. Third Title-Page

The trvve picture of one
Pic̆te I.

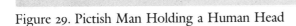

N tymes paſt the Pic̆tes, habitans of one part of great Bretainne, which is nowe nammed England, wear ſauuages, and did paint all their bodye after the maner followinge. the did lett their haire growe as fare as their Shoulders, ſauinge thoſe which hange vppon their forehead, the which the did cutt. They ſhaue all their berde except the muſtaches, vppon their breaſt wear painted the head of ſom birde, ant about the pappes as yt waere beames of the ſune, vppon the bellye ſum feere full and monſtreus face, ſpreedinge the beames verye fare vppon the thighes. Vppon the tow kneés ſom faces of lion, and vppon their leggs as yt hath been ſhelles of fiſh. Vppon their Shoulders griffones heades, and then they hath ſerpents abowt their armes : They caried abowt their necks one ayerne ringe, and another abowt the midds of their bodye, abowt the bellye, and the ſaids hange on a chaine, a cimeterre or turkie ſoorde, the did carye in one arme a target made of wode, and in the other hande a picke, of which the ayerne was after the manner of a Lick, whith taſſels on, and the other ende with a Rounde boule. And when they hath ouercomme ſome of their ennemis, they did neuer felle to carye awe their heads with them.

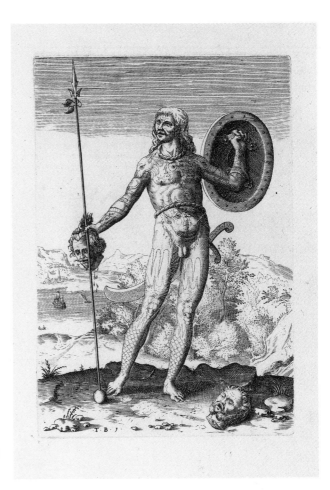

Figure 29. Pictish Man Holding a Human Head

The trvve picture of a vvomen
Picte II.

He woemen of the pictes aboue said wear noe worser for the warres then the men. And wear paynted after the manner followinge, hauinge their heads bear, did lett their hairre flyinge. abowt their Showlders wear painted with griffon heades, the lowe parts and thighes with lion faces, or some other beaste as yt commeth best into their fansye, their brest hath a maner of a halfe moone, with a great stare, and fowre lesser in booth the sides, their pappes painted in maner of beames of the sonne, and amóg all this a great litteninge starre vppon their brests. The saids of som pointes or beames, and the hoolle bellye as a sonne, the armes, thighes, and leggs well painted, of diuerses Figures: The dyd also carye abowt theyr necks an ayern Ringe, as the men did, and suche a girdle with the soorde hainginge, hauinge a Picke or a lance in one hande, and twoe dardz in the other.

Figure 30. Pictish Woman

The trvve picture of a yonge
dowgter of the Pictes III.

He yong dougters of the pictes, did also lett their haire flyinge, and wear also painted ouer all the body, so much that noe men could not faynde any different, yf the hath not vse of another fashion of paininge, for the did paint themselues of sondrye kinds of flours, and of the fairest that they cowld feynde being fournished for the rest of such kinds of weappon as the woemen wear as you may see by this present picture a thinge trwelly worthie of admiration.

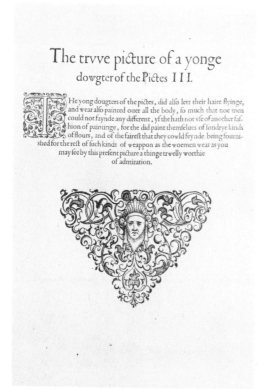

Figure 31. Young Pictish Woman

The trvve picture of a man of nation neigbour vnto the Picte IIII.

Herwas in the said great Bretainne yet another nation nigbour vnto the Pictes, which did apparell them selfues with a kind of caſſake other cloath Ierkin, the reſt of the bodye wear naked. The did alſo wear lónge heares, and their mouſtaches, butt the chin wear alſo ſhaued as the other before. The dyd wear a lardge girdle abowt them, in which hange a croket ſoorde, with the target, and did carye the picke or the lance in their hande, which hath at the lowe end a rownde bowlle, as you may ſee by this picture.

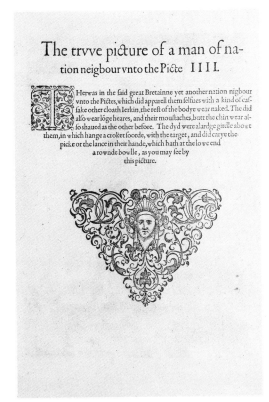

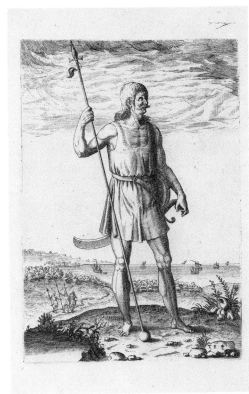

Figure 32. British Man

The trvve picture of a vvomen nigbour to the Pictes V.

Heir woemen wear apparelled after this manner, butt that their apparell was opne before the breſt, and did faſtened with a little leſſe, as our woemen doe faſten their peticott. They lett hange their breſts outt, as for the reſt the dyd carye ſuche waeppens as the men did, and wear as good as the men for the warre.

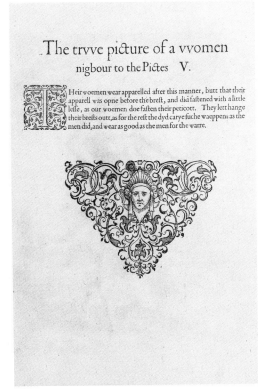

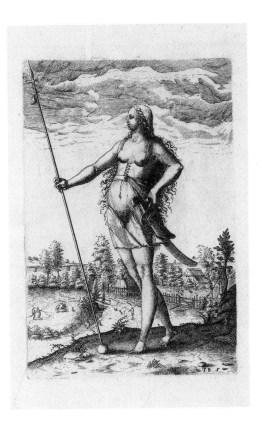

Figure 33. British Woman

Figure 34. Sloane Volume: Inscribed Titles

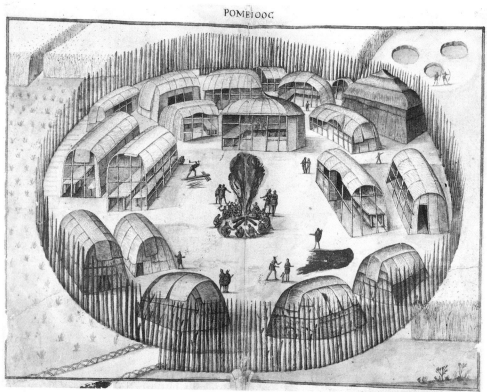

Figure 35. Indian Village of Pomeiooc

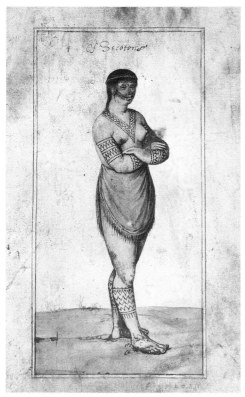

Figure 36. Indian Woman of Secoton

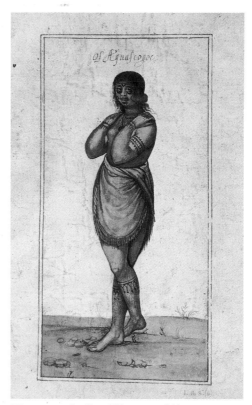

Figure 37. Indian Woman of 'Aquascogoc'

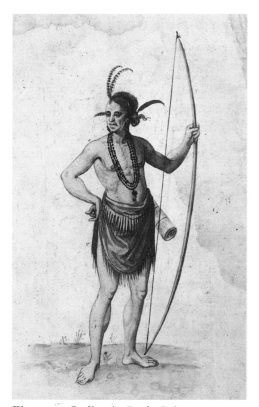

Figure 38. Indian in Body Paint

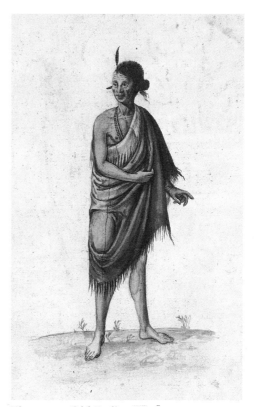

Figure 39. Old Indian Man

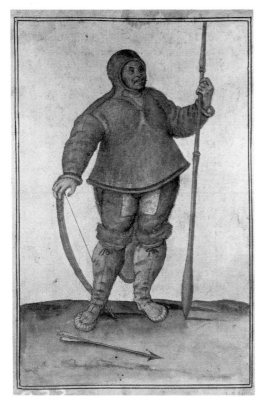

Figure 40. Eskimo (Inuit) Man

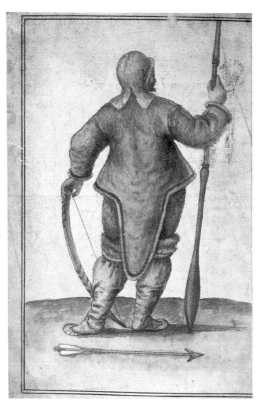

Figure 41. Eskimo (Inuit) Man Seen from Behind

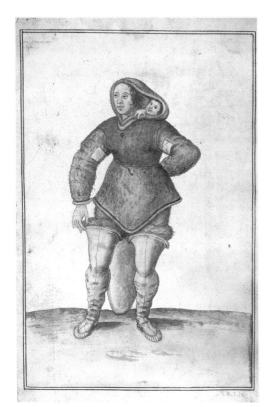

Figure 42. Eskimo (Inuit) Woman and Baby

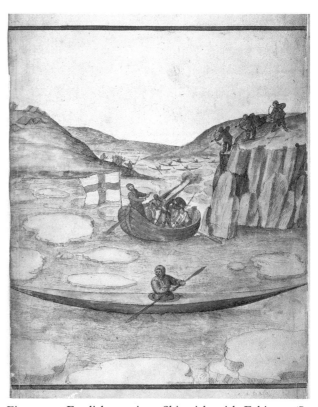

Figure 43. Englishman in a Skirmish with Eskimos (Inuit)

Figure 44. Indians of Brazil Mourning over a Dead Man

Figure 45. Indians of Brazil Welcoming a Frenchman

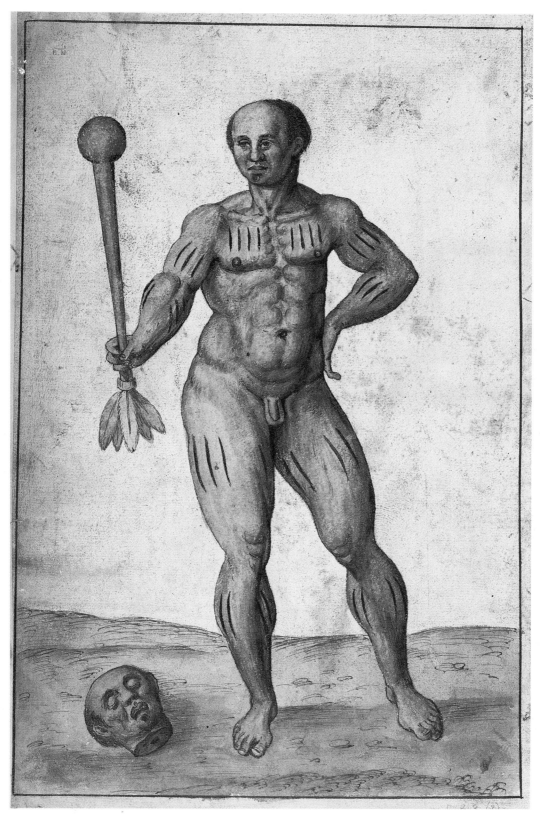

Figure 46. Cannibal Indian of Brazil

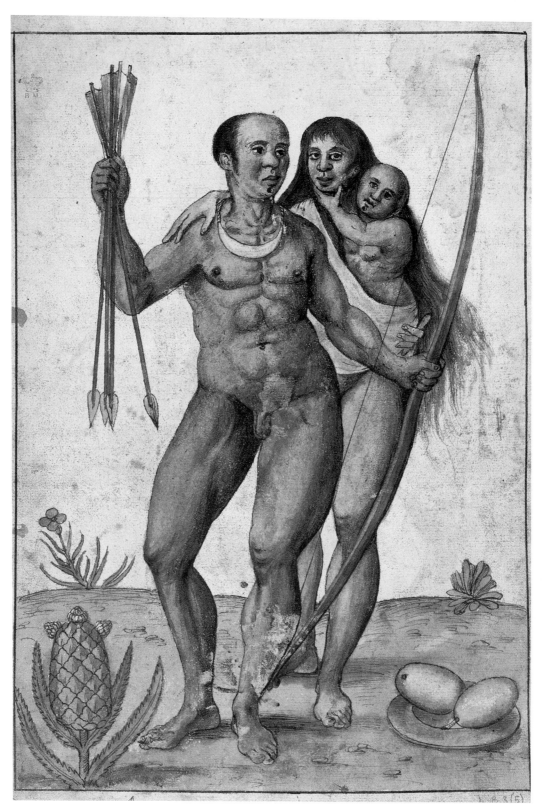

Figure 47. Brazilian Indian Man, Woman and Child

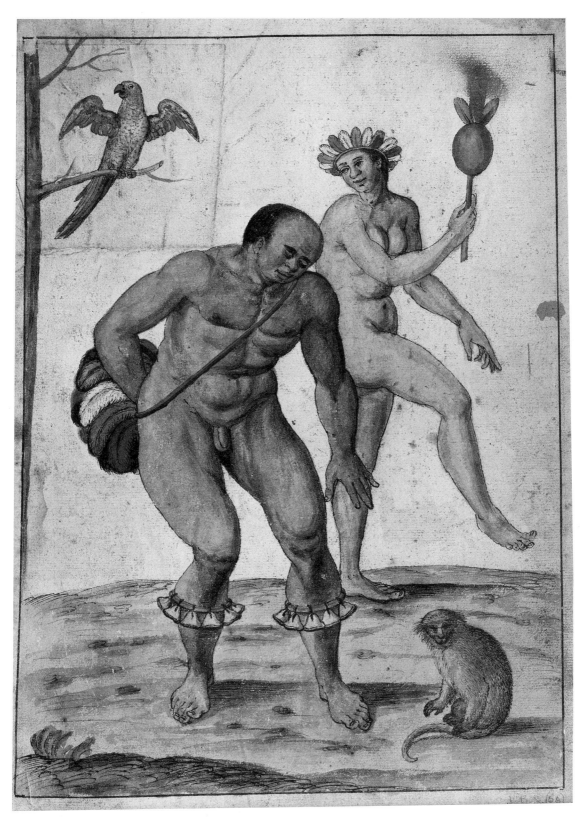

Figure 48. Brazilian Indians Dancing

Figure 49. Roman Soldier

Figure 50. Doge of Genoa

Figure 51. Medieval Man

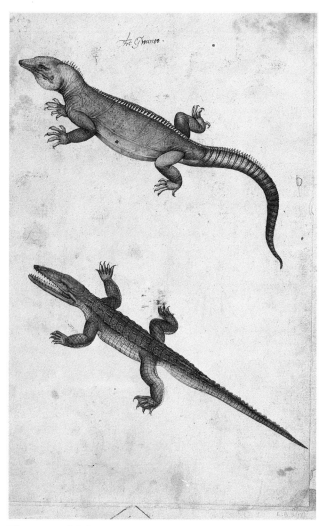

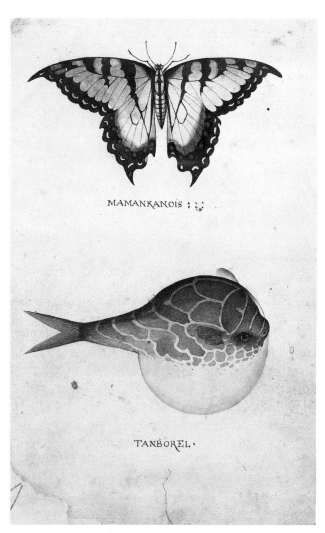

Figure 52. (a) Iguana
 (b) Alligator or Crocodile

Figure 53. (a) Swallow-tail Butterfly
 (b) Puffer

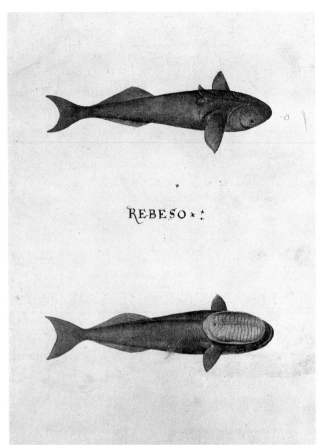

REBESO

Figure 54. (a) Remora, Ventral View
(b) Remora, Dorsal View

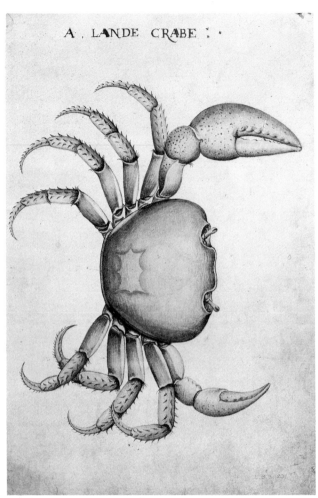

A . LANDE CRABE

Figure 55. Land Crab

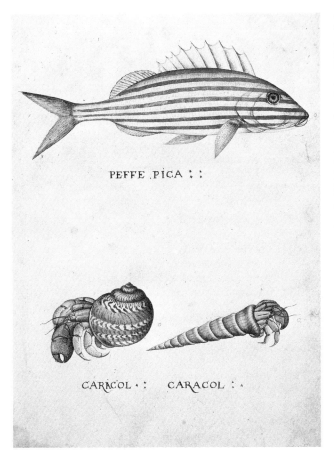

PEFFE PICA

CARACOL CARACOL

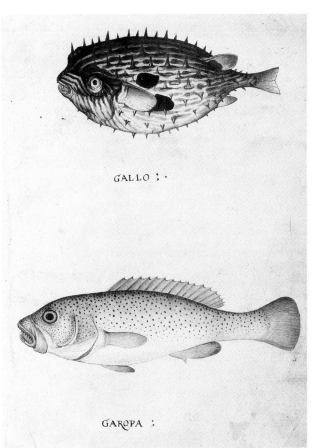

GALLO

GAROPA

Figure 56. (a) Grunt
 (b) Hermit Crabs

Figure 57. (a) Burrfish
 (b) Grouper

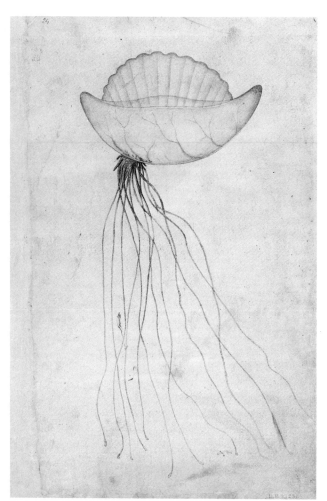

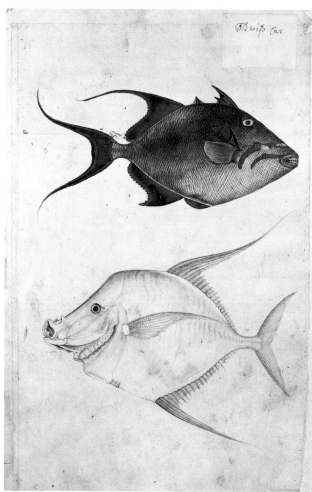

Figure 58. Portuguese Man-o'-War

Figure 59. (a) Trigger-Fish
(b) Lookdown or Moonfish

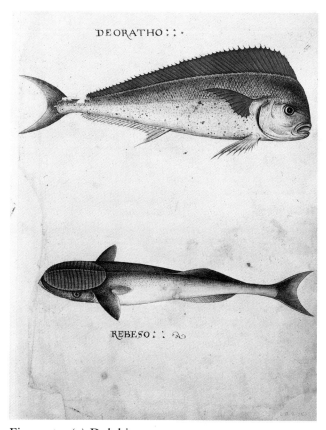

DEORATHO

REBESO

Figure 60. (a) Dolphin
(b) Remora, Dorsal View

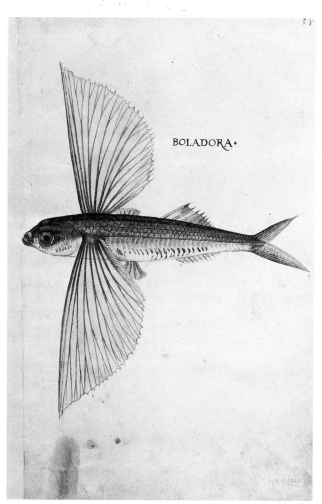

BOLADORA

Figure 61. Flying-Fish

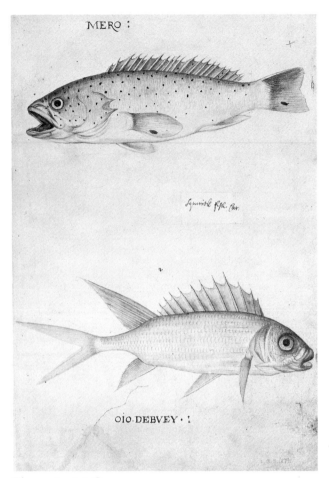

Figure 62. (a) Grouper
 (b) Soldier-Fish

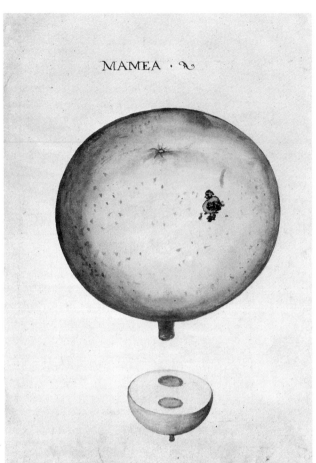

Figure 63. Mammee Apple

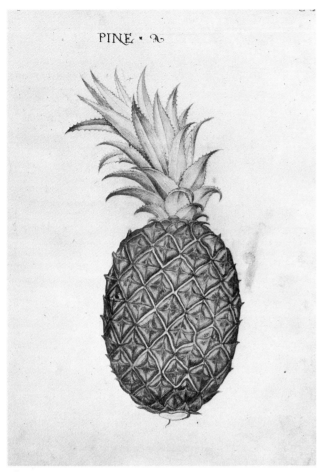

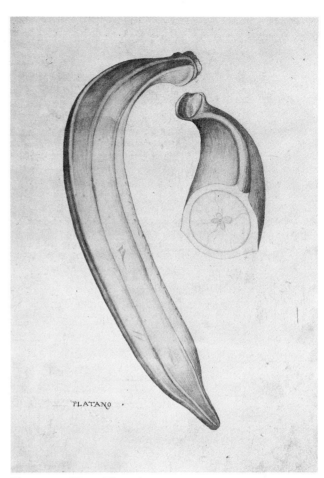

Figure 64. Pineapple

Figure 65. Horn Plantain

Figure 66. Milkweed

Figure 67. Bald Eagle

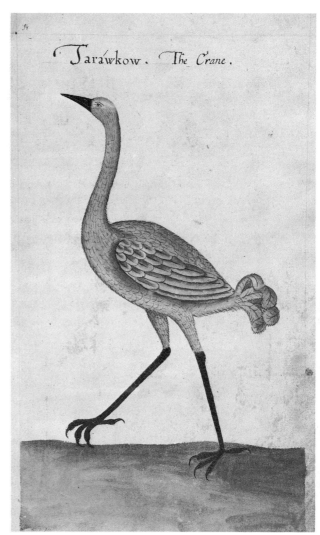

Figure 68. Sandhill Crane

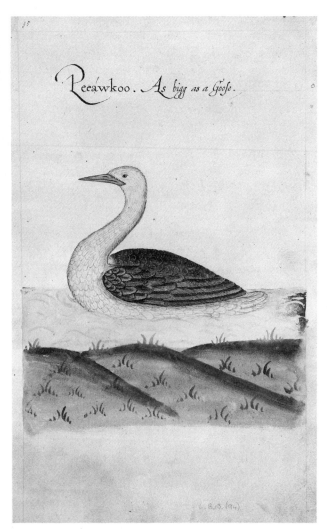

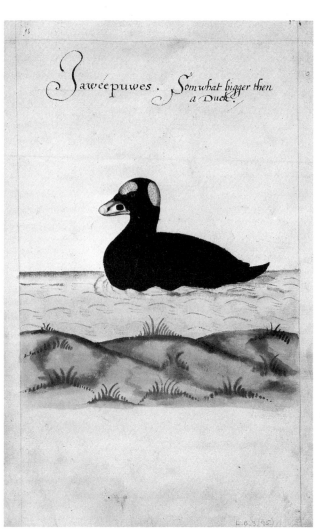

Figure 69. Common Loon

Figure 70. Surf Scoter

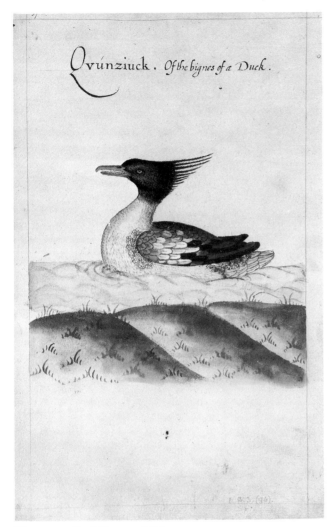

Qvúnziuck. *Of the bignes of a Duck.*

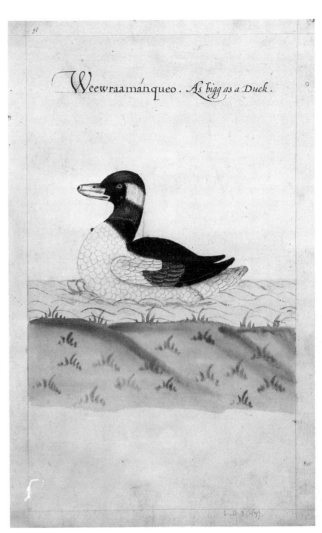

Weewraamánqueo. *As bigg as a Duck.*

Figure 71. Red-Breasted Merganser

Figure 72. Bufflehead Duck

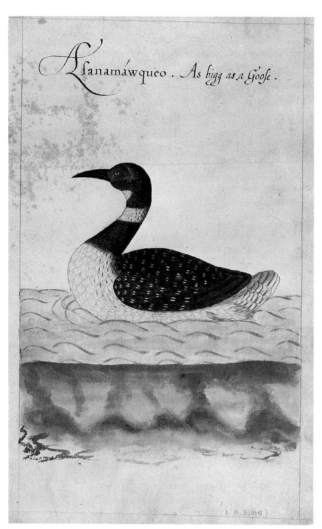

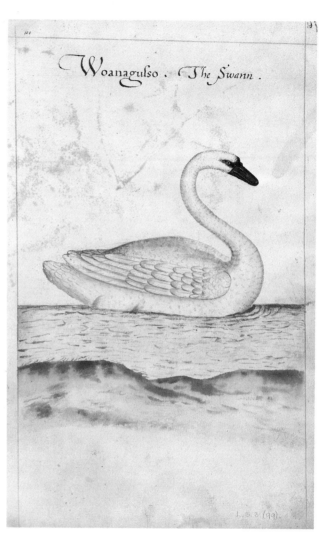

Figure 73. Common Loon

Figure 74. Trumpeter Swan

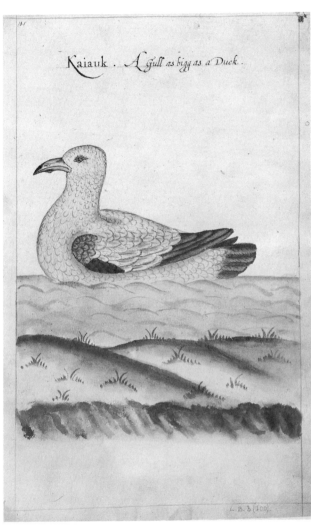

Figure 75. Gull

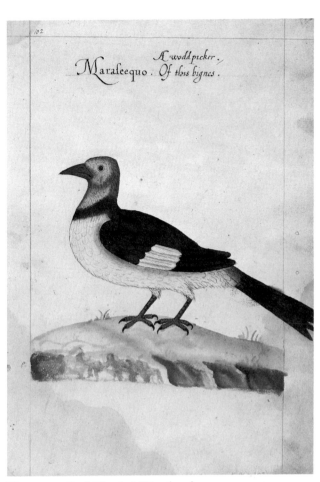

Figure 76. Red-Headed Woodpecker

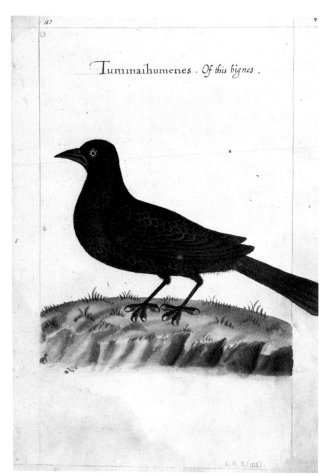

Tummaihumenes . *Of this bignes* .

Figure 77. Common Grackle

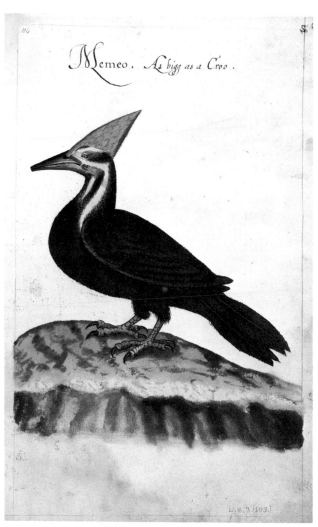

Memeo . *As bigg as a Croo* .

Figure 78. Pileated Woodpecker

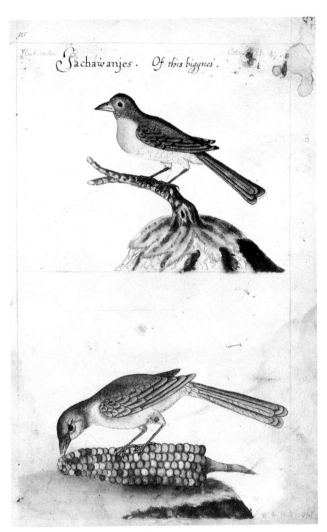

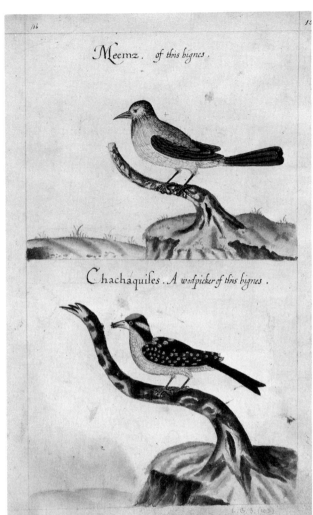

Figure 79. (a) Bluebird (?)
 (b) Towhee (?)

Figure 80. (a) Blue-Grey Gnatcatcher
 (b) Downy Woodpecker

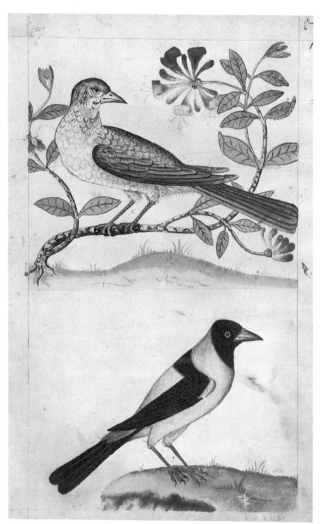

Figure 81. (a) Brown Thrasher
(b) Baltimore Oriole

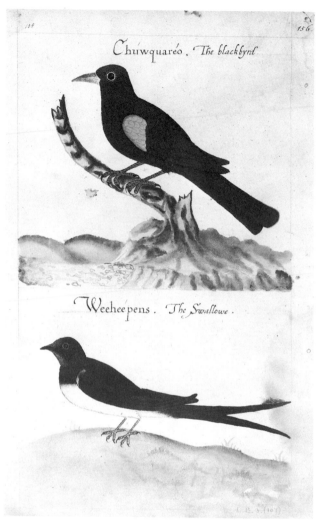

Figure 82. (a) Eastern Red-Wing
(b) Barn Swallow

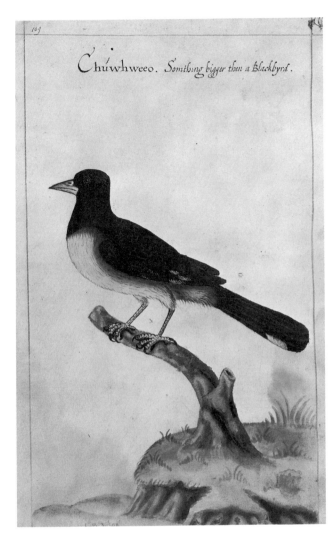

Chúwhweeo. *Somthing bigger then a Blackbyrd.*

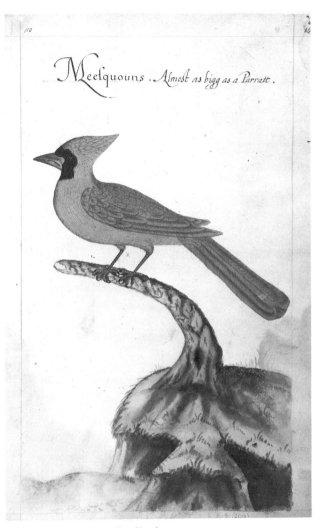

Meeſquouns. *Almoſt as bigg as a Parratt.*

Figure 83. Towhee

Figure 84. Eastern Cardinal

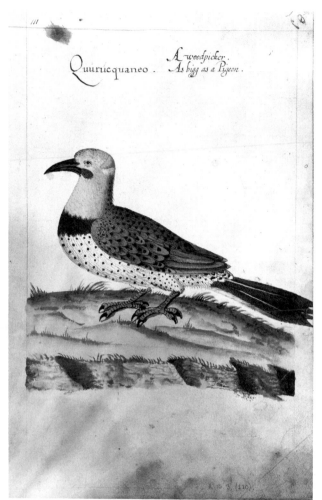

Figure 85. Yellow-Shafted Flicker

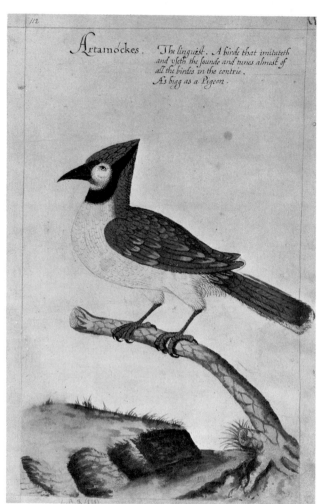

Figure 86. Blue Jay

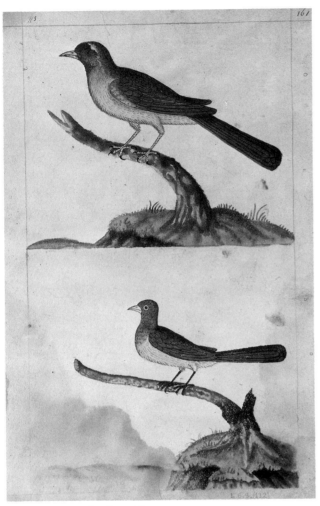

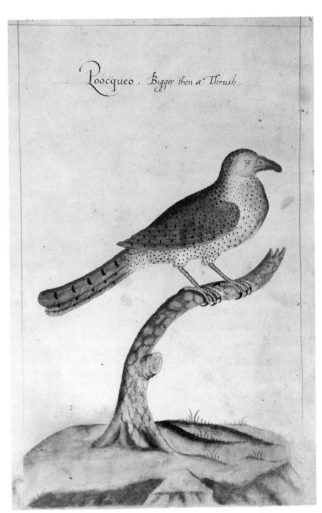

Figure 87. (a) Cuckoo (?)
 (b) Junco (?)

Figure 88. Thrasher (?)

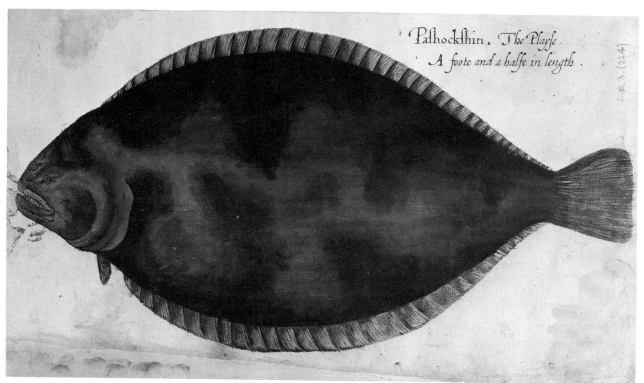

Figure 89. Flounder

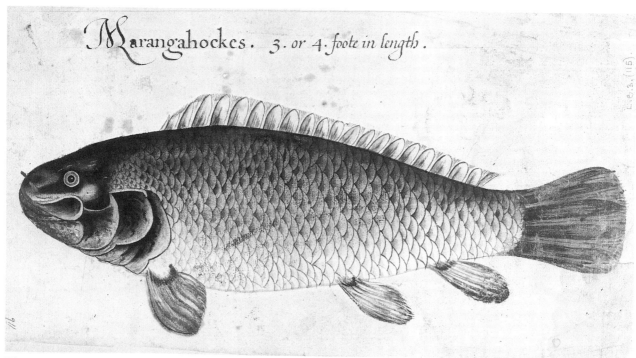

Figure 90. Bowfin

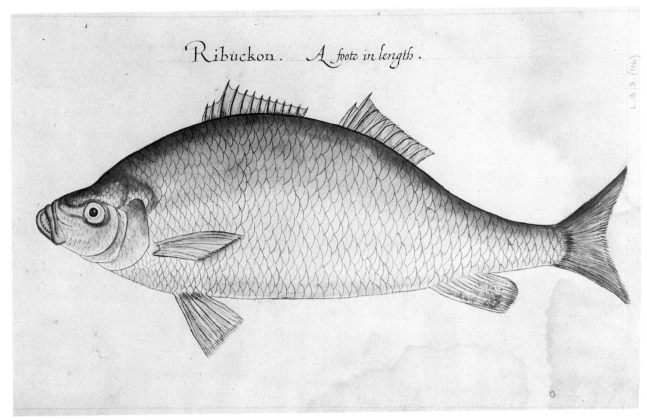

Figure 91. White Perch

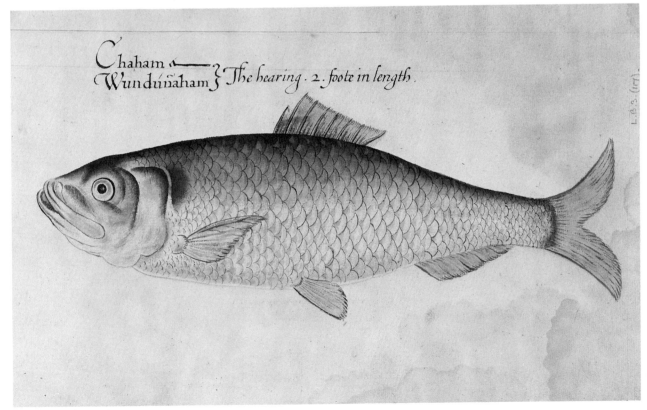

Figure 92. Alewife

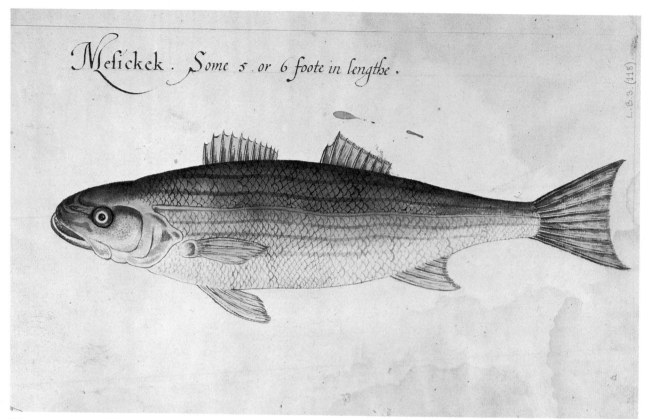

Mesickek . Some 5 . or 6 foote in lengthe .

Figure 93. Striped Bass

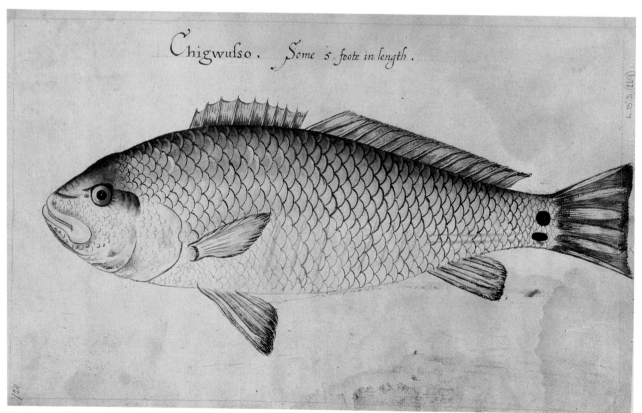

Chigwuso . Some 5 . foote in length .

Figure 94. Drum or Channel Bass

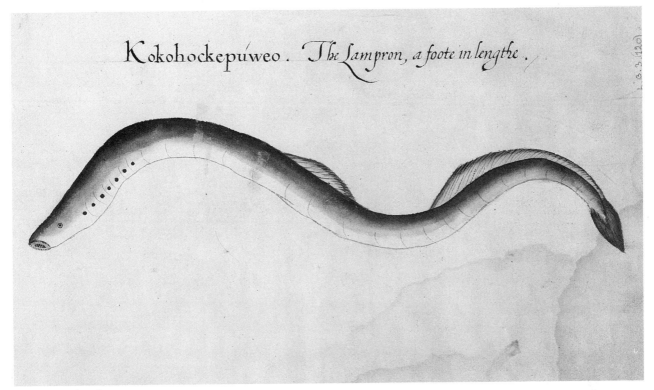

Kokohockepúweo. The Lampron, a foote in lengthe.

Figure 95. Sea Lamprey

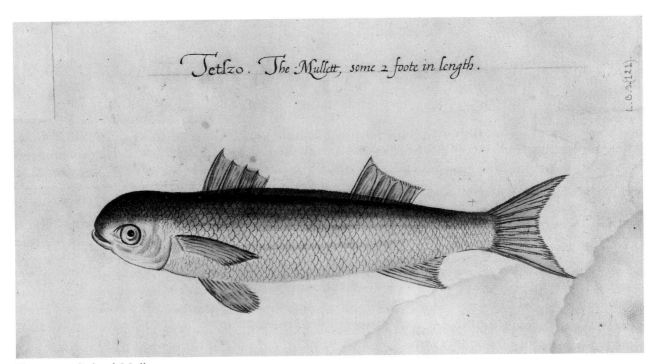

Tetlzo. The Mullett, some 2 foote in length.

Figure 96. Striped Mullet

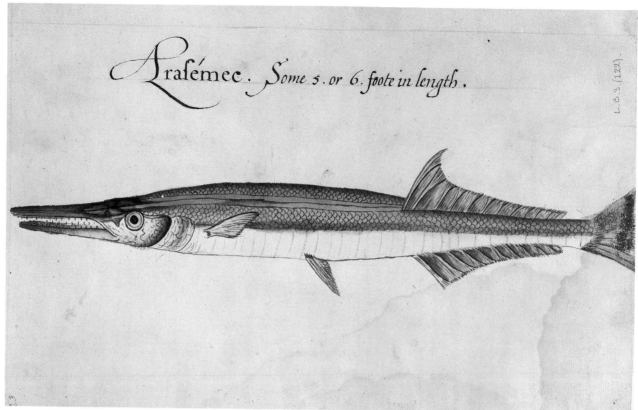

Figure 97. Needlefish or Houndfish

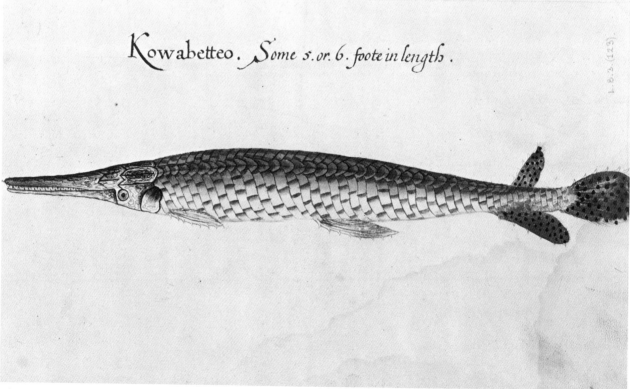

Figure 98. Gar

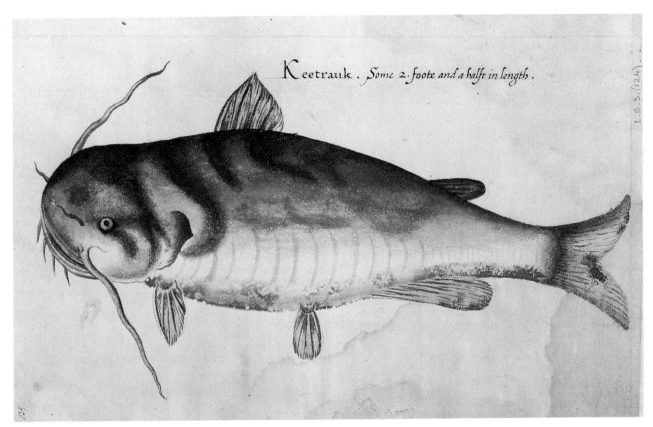

Figure 99. Catfish

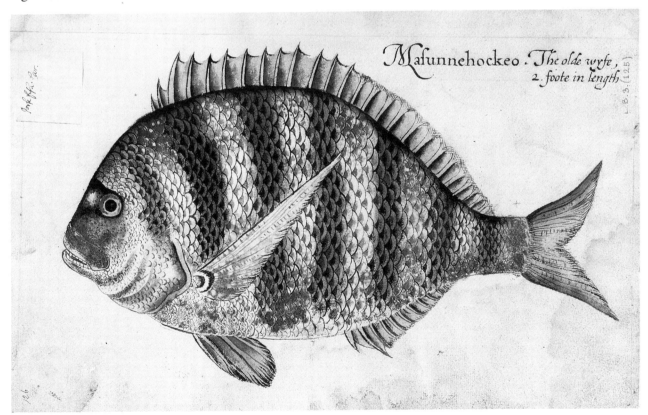

Figure 100. Sheepshead

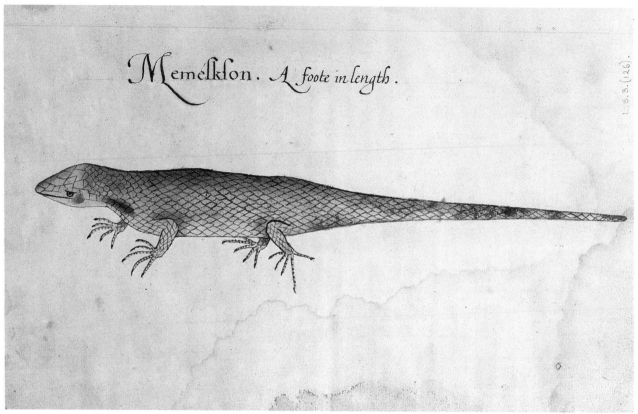

Figure 101. Skink

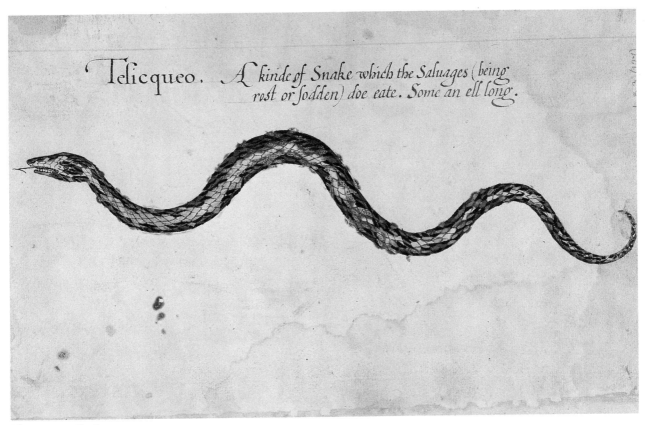

Figure 102. Snake

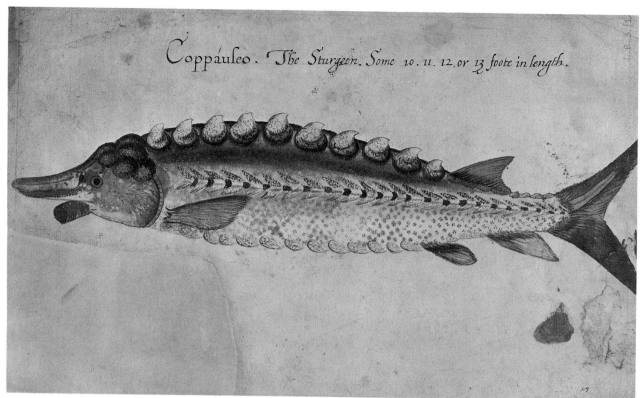

Figure 103. Atlantic Sturgeon

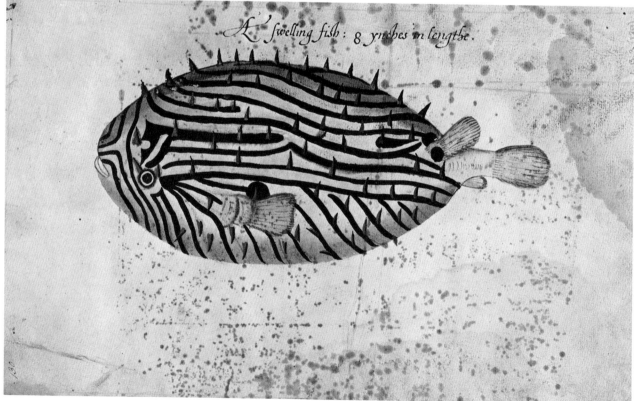

Figure 104. Burrfish

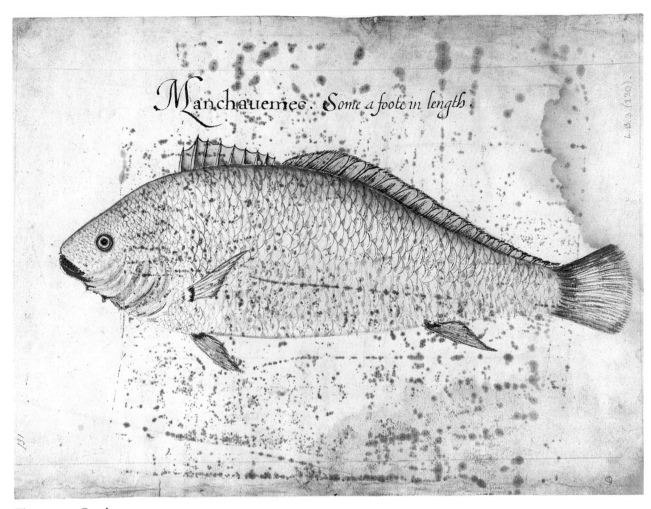

Manchauemec. Some a foote in length

Figure 105. Croaker

w. Raughleys Book by White. Mr Casebys ——— Nat History

page 527D

141 Bald Eagle ————————————————— 8

~~Virginia bird~~ ————————————————— 22

150 Red head Woodpecker ————————— 20

152 Large Woodpecker ——————————— 17

153. Blue bird ——————————————— 47

154 Hairy Woodpecker ————————————— 19

155 ~~Virginia bird~~ The yellow Woodpecker Nat Hist Jam vol. 2d 201

156 Red Wingd ~~Virginia~~ Starling ——— 13 Tab: 25

157. Towhee Bird ———————————————— 34

158 Red bird of Virga ————————————— 38

159 Gold Wingd Woodpecker ——————— 18

160 blue Joly ———————————————— 15

162 Fox colour'd Thrush ————————— 28

151. Purple Jackday ——————————— 12

19 — flying fish ————————————

 Vol 2

16 ~~Squirrel fish~~ Hind 14

18 Old wife

20 Squirrel fish

Figure 106. End Flyleaf

Notes on the Colour Plates

PLATE 1
Autograph Title

The handwriting in brown ink is taken to be that of White himself and is the same as is found on all the original drawings, where there is lettering, except for the coastal profiles (pl. 2). It is an example of good English italic script.

The statement that the voyage was made 'by' Raleigh cannot be taken literally for Raleigh was not present on this or any of the other Roanoke voyages. 'By' here means 'on behalf of'.

The regnal year, 27 Elizabeth, ran from 17 November 1584 to 24 March 1586. Not all the drawings covered by the title can be said to have originated during this period. Some may have had their origin on the reconnaissance voyage of 1584, while the Eskimo drawings can be assigned to 1577, and others possibly to later periods of White's life.

PLATE 2
Coastal Profiles of Dominica and Santa Cruz

The quality of the drawing and inscriptions of these rather rough pilot's island profiles are so uncharacteristic of White that his authorship must be doubted. The penwork is hesitant and clumsy rather than flowing and, unlike White's other drawings, the black lead outlines have not always been carefully followed. The writing too, though italic, is quite different from his and is less cursive and 'professional'. On the other hand, the paper on which the profiles are drawn is consistent with that of the rest of the set and the bar-scale of miles is similar to the one seen on pl. 3, though again the style of the numbering is distinctly different.

Dominica was sighted on the outward voyage on 7 May 1585 and Santa Cruz (St Croix) about 9 May.

PLATE 3
Fortified Encampment, Puerto Rico

The plan of a fortified encampment with entrenchments on the north, east and south sides consisting of a water-ditch and a scarp and counterscarp with a number of bastions some of which protect and mask entrances. At the bottom right-hand corner is a scale inscribed *paesces*, i.e., paces, which, if accurate, and taking a pace to measure five feet, gives the dimensions of the camp as about 1150 by 950 feet. Lying offshore is an English ship, probably the *Tiger*, but possibly the *Elizabeth*, flying the cross of St George from her main and mizzen masts, and perhaps a royal or personal standard from her bowsprit.

The drawing records some of the activities of the English on Puerto Rico between 11 May and 23 May 1585. Their main purpose was to obtain a supply of fresh water and to build a pinnace. The place they chose for their camp has been convincingly identified by Samuel E. Morison as Guayanilla Bay (*The European discovery of America: the northern voyages, AD 1500–1600*, pp. 633–5, 655).

The enclosed area has been cleared near the lines of entrenchments but most of it and the river bank is seen to be quite thickly wooded. At the edges of the trees, particularly on the north and south sides, are a number of structures rounded or rectangular near which there are guards armed with pikes, swords or arquebuses. Lane's quarters are indicated on the north side, 'the General's' (Grenville's) on the south side. The inscriptions record various episodes: the collecting of water by means of the boat with two large barrels on the river, top left; the bringing into the camp of timber on a carriage, lower right; the pinnace, partly built, shown close to the entrance in the centre of the southern entrenchments, with a man using, apparently, a long metal borer to make holes in a spar; Grenville on horseback with twenty-seven men, bottom left, returning from an expedition, 23 May, after which the fort was fired and abandoned the following day.

The drawing, which was folded down the centre at the time of the fire, has offset quite dramatically. The men apparently marching into the sea, at the bottom right-hand corner, are offsets from Grenville's party on the left and there are other instances of offsetting.

The heron, duck and land crabs shown in the pond are most sensitively drawn with the point of a brush.

PLATE 4
Entrenchments, Puerto Rico

The plan of a fortified enclosure on Puerto Rico ('St Johns Ilande') with a wide water-ditch surrounding an

elaborate rectangular line of low fortifications of sand enclosing two conical mounds of salt on a sandy foreshore close to the water's edge. There are triangular bastions in the centre of the walls on both the left-hand and right-hand sides and an arrow-shaped bastion in the centre of the top side. Each bastion covers baffled exits. The walls at the bottom corners curve in and then round and outwards leaving a broad entrance facing the sea. The top bastion narrowly encloses one of the salt mounds. The second mound in the central area is being demolished by men with mattocks. English guards armed with pikes, swords and arquebuses are supervising the work, one with a pike standing on top of the mound. Other men are carrying sacks of salts towards a large boat, drawn up in the entrance, which is being loaded. One armed guard is shown in each bastion. A small three-masted ship with sails furled and flying horizontally-striped flags is anchored offshore.

After Grenville had left the encampment (pl. 3) on 26 May 1585 he sent Ralph Lane with a captured Spanish frigate, shown offshore in the drawing, to fetch salt from a place near Cape Rojo ('Capross'), Puerto Rico. A Spanish pilot directed him to the mounds of salt which Lane quickly enclosed with entrenchments and with twenty-five soldiers and six Spanish prisoners removed to the ship.

The design of the fort has close affinities with Fort Raleigh on Roanoke Island, excavated and reconstructed (1947–50) under the supervision of J.C. Harrington.

PLATE 5
Land Crab

The Land or White Crab, *Cardisoma guanhumi* Latreille. The same crab appears in miniature in pl. 3. This figure was copied, engraved and published by Edward Catesby in his *Natural history of Carolina, Florida and the Bahama Islands* (1731–43 [48]), II, pl. 32, and the drawing is in the Royal Library, Windsor. This illustration was cited by Linnaeus in *Sytema naturae* (10th edn, 1758, I, p. 626), the starting point of the modern binominal system of nomenclature in zoology and botany.

The drawing is particularly bold, having lost only a small amount of colour in 1865.

PLATE 6
Hermit Crab

The Purple-clawed or Land Hermit Crab, *Coenobeta clypeatus* (Herbst), of the West Indies which is unscientifically introduced by White, in his drawings of Indians fishing (pl. 43), into waters close to Roanoke Island. The name 'Caracol' in the inscription is Spanish for a twisted shell. The shells used by the hermit crab may be any suitable empty ones. Those White has drawn are: *Turritella variegata* Linn. (above), and below, *Natica canrena* Linn.

PLATE 7
Fireflies and Gadfly

The fireflies are West Indian specimens, *Pyrophorus noctilucus* (Linn.). The top and right-hand ones show the two luminous spots on the thorax as yellowish in colour. The equivalent spots on the left-hand specimen have been left uncoloured.

The gadfly, *Tabanus* species, is not accurately enough drawn for specific identification or to be able to distinguish whether it is a West Indian or a North Carolina species. The blue colour of the wings is not in any case authentic.

Both the fireflies and the gadfly are duplicated, presumably by White, in Thomas Moffet, 'Insectorum . . . Theatrum' (pl. 77).

PLATE 8
Scorpions

The scorpions are possibly West Indian specimens, *Tityus* genus, but the drawings are not accurate enough for specific identification. The colour of the transverse light bands on the right-hand specimen, no doubt intended to indicate the intersegmental membrane, is exaggerated in contrast with that of the segments.

PLATE 9
Iguana

The reptile is portrayed with conspicuous spiny crest. It is a West Indian species formerly identified as *Cyclura* species but most recently, by Dr Albert Schwartz, as

'overwhelmingly likely' to be *Cyclura cychlura* (Cuvier) which is found widely in the Bahamas where Grenville landed on at least two occasions on the outward passage on June 1585.

PLATE 10
Alligator or Crocodile

The drawing shows certain features common to the alligator and the crocodile which make definite identification impossible. White is more likely to have observed the alligator earlier, in the West Indies, and more frequently than the crocodile. Yet the creature looks more like a crocodile, *Crocodylus acutus* Cuvier, than an alligator, *Alligator mississipiensis* (Daudin). It is not impossible that White, by the time he made the finished drawing, had been influenced by representations of the Egyptian crocodile which were available in Europe. The name *Allagatto* may not have a bearing on the question of identification as it is a corruption of the Spanish *El lagarto* applied indiscriminately to lizard-like reptiles. The inscription is also misleading, since a reptile of the size given would be about two years old.

PLATE 11
Pineapple

The fruit of the pineapple, *Ananas comosus* (Linn.) Merrill. Though the drawing shows conspicuous damp stains it has not strongly offset, the plume only slightly.

Another pineapple appears in a different composition by White in the Sloane copy (fig. 64).

PLATE 12
Mammee Apple

The fruit of the Mammee Apple, *Mammea americana* Linn., of the West Indies. It will be seen that the Sloane copy (fig. 63) includes a cross-section of the fruit. The drawing, like most of the other plant drawings, shows conspicuous water stains.

PLATE 13
Horn Plantain

The fruit of the Horn Plantain, sometimes called the Horse Plantain, of the West Indies, *Musa paradisiaca* Linn. The Spaniards introduced the plantain into the West Indies and a friar, Thomas de Berlanga, is thought to have been responsible for its first introduction on Santo Domingo in 1516. The Spanish name used by White is of obscure origin. His drawings of the banana may be the first by a European though there are much earlier Asian records of the plant.

PLATE 14
Horn Plantains on the Stalk

The fact that there are two drawings of the banana, showing the fruit and the growth of the fruit on the stalk, indicates White's particular interest in the plant. A Spanish prisoner notes that the English took away (from Puerto Rico and Hispaniola) many banana plants and other fruits of which they made drawings. Clearly the intention was to try to cultivate them in the colony they were about to establish in North America.

PLATE 15
Flamingo

The American or Roseate Flamingo, *Phoenicopterus ruber* Linn. This, perhaps the finest of White's bird drawings, may be connected with his passage through the Bahamas. Though much of the crimson and black pigment has been offset the drawing retains a good deal of its delicacy and precision.

PLATE 16
Frigate Bird

Magnificent Frigate Bird, or Man-o'-War Bird, *Fregata magnificens rothschildi* Mathews, which nests in the West Indies and the Gulf Coast, and flies north in summer, reaching the North Carolina coast or beyond. The white body shows it to be a female though the head is too light in colour. Offsetting has removed much of the blue and the black of the wing edges making the bird appear

lighter than the artist intended. The blue colours should be black, glossed with green and purple.

PLATE 17
Tropic Bird

Red-billed Tropic Bird, *Phaethon aetherius mesonauta* Peters, of the West Indies, though the legs should be yellowish. The wings have lost some grey and brown by offsetting and a good deal of blue has been removed from the right side of the head and body.

PLATE 18
Brown Booby

Brown Booby, *Sula leucogaster leucogaster* (Boddaert), of the West Indies, an immature specimen.

PLATE 19
Noddy Tern

Common Noddy Tern, *Anoüs stolidus stolidus* Linn., of the Atlantic coast of the southern United States. Much of the black, especially from the tail, has been removed by offsetting together with some brown.

PLATE 20
Lookdown or Moonfish

Lookdown or Moonfish, *Selene vomer* (Linn.). The absence of the first dorsal and ventral fins may be explained by their small size and the artist's inability to make them stay erect. The pale gold used on parts of the head and back and underparts of the fish has now partly oxidized showing grey and black as has the gold on the pectoral and caudal fins.

PLATE 21
Lookdown or Moonfish

The name 'Crocobado' given to the same Lookdown or Moonfish, *Selene vomer* (though probably a larger specimen), as was 'Polometa' in the last plate, is mysterious

and does not seem to have a Spanish origin. The appearance of the fish with the gill cavity exposed has doubtless been caused by the top of the snout having been caught up by a hook, also leaving the mouth open. Again, the first dorsal fin is absent and the first ventral merely suggested, but the drawing is unfinished leaving the gills, the iris of the eye and the ventral fin uncoloured.

PLATE 22
Grouper

Certainly a grouper, probably the Rock Hind, *Epinephelus ascensionis* (Osbeck), but its over-bright colour and the absence of a projecting lower jaw, among other things, make it untypical of the species. The name 'Garopa' comes from the Portuguese *garoupa*.

PLATE 23
Grouper

The species of this grouper is uncertain but is most likely to be the Yellow-fin Grouper, *Mycteroperca venenosa* (Linn.), though the colour is too brown, the spots on the body too small and the fin blotches untypical of the species. It is less likely to be the Red Grouper, *Epinephelus morio* (Cuvier and Valenciennes) though the general colouring is nearer, but the reddish shades on the head and breast are absent along with other colour features. The Spanish 'Mero' is used for several different fish, the French *Mérou* for groupers only.

PLATE 24
Grunt

Blue-striped Grunt, *Haemulon sciurus* (Shaw), though the stripes are too broad and regular and there are no spines on the caudal and anal fins. Generally too the basic colour is insufficiently yellow. The 'f' of 'pefe' should be without the cross stroke, indicating the modern 's'. *Pece pica* in Spanish means lance-fish, pike-fish.

PLATE 25
Soldier-Fish

Soldier-fish or Squirrel-fish, *Holocentrus ascensionis* (Osbeck), though a typical specimen of the species would be redder and the lower jaw should project. The Spanish 'oio de buey' means ox-eye. The drawing has lost little colour in offsetting and gives a good idea of its original appearance.

PLATE 26
Dolphin

The fish, not the mammal, *Coryphaena hippurus* Linn., which reaches a length of six feet. 'Duratho' is a corruption of the Spanish *Dorado*, another name for the species. An early engraving of the drawing by Baptista Boazio appears at the bottom left-hand corner of the map of San Augustín, with an accurate description, in Richard Field's edition of Walter Bigges, *A summarie and true discourse of Sir Frances Drakes West Indian voyage* (London, 1589).

PLATE 27
Flying-Fish

Flying-Fish, *Exocoetus volitans* Linn. There is a degree of distortion as the artist has attempted to give both the top and side impression of the fish in the same drawing. The white and silver, particularly on the extended pectoral fins, have oxidised to a greyish-black colour and there is some flaking of the blue pigment on the upper parts of the fish which have offset strongly. A rather crude engraving of this drawing by Baptista Boazio appears on his map of Santiago in Walter Bigges, *Sir Frances Drakes West Indian voyage* (1589). *Pez volador* is the Spanish for flying-fish.

PLATE 28
Remora, Dorsal View

Remora or Shark Sucker, probably *Remora remora* (Linn.), seen from the side and above, giving a clear view of the sucking disc on top of the head. The Spanish *rebeza*, now superceded by *remora*, means thick lip.

PLATE 29
Remora, Ventral View

Probably *Remora remora* (Linn.) and perhaps the same specimen as shown in pl. 28 but drawn from the side and below. A moderate amount of pigment has been lost in the offsetting but the damage to the tail was perhaps caused by water before the known damage at Sotheby's in 1865.

PLATE 30
Trigger-Fish

Queen Trigger-fish, *Balistes vetula* Linn., a good representation, though much of the bright blue colour has been lost from the bands round the mouth and tail fins and only some of it can be accounted for by offsetting in 1865. The inscription should read 'Pese porco.' *Péce puerco* means in Spanish pig-fish. *Pez puerco* was the name correctly given to another group of this species, *Balistes polylepis* Steindachner. White's likeness of the fish was engraved by Baptista Boazio and appears in his general map in Richard Field's edition of Walter Bigges, *A summarie and true discourse of Sir Frances Drakes West Indian voyage* (1589). The same fish also appears in White's general map (pl. 59).

PLATE 31
Portuguese Man-o'-War

Portuguese Man-o'-War, *Physalia physalis*, formerly described as a jelly-fish with the name *Caravella caravella* derived from its supposed likeness to a Portuguese fighting ship, its 'hull' rising to bow-like projections at each side with a fan-like 'sail'. It is now known to be an integrated composite of various separate organisms. The small number of tentacles shown on the drawing suggest a very young specimen.

PLATE 32
Indian Village of Pomeiooc

The village was discovered, according to the *Tiger* journal, on 17 July 1585, and is shown on White's map of Raleigh's Virginia (pl. 60), just south west of the lake

named 'Paquippe' (Mattamuskeet Lake). It is enclosed with a palisade of light poles with two entrances, one at the bottom, left, the other at the top, left. Evidence suggests that White has deliberately exaggerated the space between the poles, which are about the right height, to allow a clearer view of some houses. There are eighteen houses of pole and mat construction, some with open ends and sides, several of them showing interior platforms, along the sides or across the ends, which were used primarily for sleeping. The largest house is identified by Harriot in the engraving (De Bry, pl. XIX [fig. 23]) as that of the 'King', the building with the cupola as the temple (see also De Bry, pl. XXII [fig. 26]). The houses, again according to Harriot, were built for 'The kinge and his nobles' and were constructed of small poles bent and fastened together at the top. The method of lashing is shown in De Bry, pl. XXII (fig. 26). Sometimes they were covered with rush mats, more usually with bark. The buildings can be classified as longhouses, that is they are markedly longer than they are broad, though a few, particularly in the engraving, approach the domed, oval or round mat-covered houses known in New England and the Great Lakes region, and are close to those described for the Powhatan.

A man is seen chopping timber with an axe, just left of and above the fire in the centre, which is too indistinct to allow us to say whether it is an Indian stone axe or an English trade axe. The dog shown nearer the top is interesting as an example of the type of Indian domesticated dog before inbreeding began with European dogs.

PLATE 33
Indian Woman and Young Girl

The woman, described by both White and Harriot as a chief's wife or chief lady of Pomeiooc, wears an apron-skirt of fringed skin, edged at the top and bottom with a single row of white beads. Her hair, fringed at the front, is worn long behind and caught up at the nape of the neck. Her headband is probably of woven beadwork. It is not clear whether the close-fitting necklace is real or suggested by painting or tattooing, but the long three-strand necklace is clearly made up of beads, perhaps shell rather than copper, pearl or bone (in a woven strip?). The marks or decorations on her face and upper arms are painted or tattooed. Harriot, for the engraving (De

Bry, pl. VIII [fig. 12]), says her skin is 'pownced' or tattooed. She is holding a large gourd vessel for carrying water.

The girl, ten years old or less, also wears her hair in a fringe in front but free at the sides and back. Her slight (summer) 'clothing' is of the type worn by girls before puberty, consisting of only a moss pad at the crutch supported by leather strings. She also wears a necklace, apparently of at least three strands of beads with a pendant, which she clutches in her right hand. The doll she holds in her left hand is clearly English and dressed in Elizabethan female clothing.

PLATE 34
Old Indian Man

The old man of Pomeiooc, to judge from the engraving (De Bry, pl. IX [fig. 13]), wears his hair drawn flat at the sides and caught up in a knot at the back, leaving a roach down the middle of the head. Facial hair, here sparse, is mentioned as characteristic of older men; younger men plucked their beards. His fringed mantle is turned down at the top to allow it to pass under the right arm, showing the hairy side of the deerskin which normally in winter would be worn against the skin. A neat seam is visible running down the left side of the mantle.

The partial oxidization of white heightening, painted along the edges of the feet, hands and shoulder, accounts for what looks like smudging in these areas.

PLATE 35
Indian Woman and Baby of Pomeiooc

Though White describes the woman as a chief's wife of Pomeiooc, Harriot in the caption for the engraving (De Bry, pl. X [fig. 14]) states that she is from Dasemunkepeuc. Her hair, fringed at the front, freely falling at the sides and back, looks like a grey cap where water damage has removed the surface wash. The decoration of the upper arms, similar to that of the woman in pl. 33, may be painted or tattooed. She wears a double apron-skirt. Harriot says that the method shown of carrying children was typical, however unnatural it may look. It is strange that White does not in fact illustrate, or Harriot mention, the cradleboard used generally among the In-

dians of the south-east and north-east for holding and carrying younger babies. Perhaps the position shown here is a variant, or misapprehension of the hip-straggling method used by modern Florida Seminole mothers where the cradleboard is unknown.

PLATE 36
Village of Secoton

An example of the type of open village, in contrast to the enclosed village like Pomeiooc (pl. 32), Secoton, the chief town of the Secotan Indians, was discovered on 15 July 1585. The colonists, according to the *Tiger* journal, 'were well intertayned there of the Sauages'.

The village has thirteen houses of light pole and mat construction, similar to those of Pomeiooc, and grouped mainly along a central thoroughfare. Here, or close by, the Indians are engaged in various activities, some of which are the subjects of separate drawings: the figures dancing round posts in a circle, bottom right (pl. 39); the fire, to the left, inscribed *the place of solemne prayer* (pl. 40); figures squatting to eat, above, in the centre (pl. 41); and the charnel house inscribed *The house wherein the Tombe of their Herounds standeth*, bottom left (pl. 38). The drawing is in fact a 'composite', intended to give information on a number of aspects of Indian life in one composition. The most interesting subject not treated by White in separate drawings which have survived, but expanded in the engraving (De Bry, pl. XX [fig. 24]), is that of Indian crops and the way maize is grown. The drawing, or first sketches for it, would probably have been made 15–16 July. At about that time the first crop of three sowings, planted in May, would be due for harvesting—*Their rype corne*, in the top field, upper right-hand corner; and the crop planted in June would have about a month to go—*Their greene corne*, in the second field; and the crop sown in July had begun to show—*Corne newly sprong*, in the third field. The ripe corn, according to Harriot, stood ten feet high. The small hut, mounted on a platform in the top field, may shelter a seated figure to scare birds.

PLATE 37
Indian Woman of Secoton

The Secoton chief's wife wears her hair with a fringe in front and hanging in wisps at the side and back with a headband of some twisted material. Her double apronskirt of fringed skin is ornamented with a double row of beads or pearls. The tassels of the fringe are heightened with white and show traces of gold. She is elaborately painted or tattooed on her cheeks, forehead, chin, upper and lower arms and on the calves and instep. There is also a simulated necklace and a suggestion of an ear ornament. Harriot says her facial and body decoration are tattooed, the neck ornament painted or tattooed.

PLATE 38
Indian Charnel House

The building is the clearest example in White's drawings of pole and mat construction, with a raised platform, perhaps six feet above the ground, on which the emaciated bodies of Indian chiefs are laid out. White's inscription succinctly describes the process of preserving them. Accordingly, what we see are skeletons, from which the flesh has been removed and dried, recovered with their own skin and stuffed with leather (deerskin), the mummified heads retaining their hair which is drawn up to a point or knot. The sun-dried flesh is wrapped in the four large matting bundles seen at the feet of the bodies.

The matting folded back over the roof seems to have been incorrectly drawn for the evidence of museum specimens and descriptions goes to show that the rushes (*Typha* species) were laid side by side, their length determining the width of the mat, and sewn or bound together with fibre at intervals of about six inches. Clearly the matting of the roof shows the rushes running the indefinite length, not the definite width, of the material. If made this way it could not easily be folded back, as shown, or the rushes joined lengthwise.

The idol 'Kywash', 'an image of wood keeping the dead', dressed in black, with what appears to be a round, brimmed, pointed hat, is the subject of a separate drawing, now lost, from which De Bry pl. XXI (fig. 25) was made. Though in the engraving the posture of the figure is much the same, details of dress and headdress differ somewhat mysteriously.

The space beneath the platform, where the skins are spread out and a fire burns, was used by a priest who 'hath charge of the corpses' and who is seen in the engraving (De Bry, pl. XXII [fig. 26]).

PLATE 39
Indians Dancing

The dancers, ten men and seven women, are likely to be moving round the circle of posts in an anti-clockwise direction. Some are wearing breech-clouts (two men), some apron-skirts (men and women), at least one (a woman) a fringed skin mantle, and a number have leather pouches hanging from their waists. The men have their heads shaved, except for a central roach, and wear feathers in their hair. Many of the dancers are holding gourd rattles and many carry leafy twigs. In addition to the tattooed or painted decorations two men, one to the left of the bottom left-hand post and the other to the right of the bottom right-hand post have markings on their backs, the former's resembling the ones seen in De Bry, pl. XXIII (fig. 27), identified as those of Wingina, chief of Roanoke.

It is likely that the dance is a green corn or harvest ritual, as such ceremonies were widespread throughout the Indian tribes of eastern North America. The expected date of these would be about mid-July, about the time the colonists discovered Secoton and when presumably White made this and other Secoton drawings. The only other evidence of the circle of posts with human faces is the illustration in Robert Beverley's *History and present state of Virginia* (1705) taken directly from White though the association of carved posts with some sort of religious structure is more widespread, the foremost example of which is the Big House of the Delaware. J.R. Swanton, in his *Indians of the southeastern United States* (1946), suggests that the posts represent minor deities. The significance of the three women who clasp each other in the centre of the circle – Harriot's 'three of the fayrest Virgins' – is not known.

The large drawing was folded so that various details, most strongly the red gourd rattles, have offset on the other side of the central fold.

PLATE 40
Indians round a Fire

Six men and four women are seated or kneeling round a spoke-shaped log fire and singing to the accompaniment of gourd or small pumpkin rattles. Four of the men have feathers in their hair and all have shaved heads with a central roach except for the man (?) behind the flames, who has long untrimmed hair. One man wears a breech-clout, one is entirely naked and two wear skin mantles draped over one shoulder. Two women wear apron-skirts and one seems to be naked except for a cord round her waist.

Harriot thought that this was a ceremony of thanksgiving, perhaps occurring round the fires shown in Secoton village (pl. 36). The spoke-shaped arrangement of logs is still common among the Seminole of Florida, and the fire is fed by moving the logs in as they burn.

PLATE 41
Indian Man and Woman Eating

The man's and woman's sitting posture is nearer squatting than the way Europeans would sit. De Bry, realising that his readers would find this posture difficult to understand, has altered it in his plate XVI (fig. 20). The deerskin mantles worn by both man and woman are closely similar. The way their hair is worn is here more clearly shown than elsewhere and is typical – the man's with the central roach and feather, the woman's with the fringe in front and tied at the neck behind. The ear ornament of the man – a long piece of skin, worn through a hole in the lobe, with ends of bone or shell, and the woman's three-strand necklace are also very clearly drawn. The large circular dish contains hominy, maize kernels swollen by soaking and boiling. The mat, as with that shown in pl. 38, appears to be inaccurately drawn as the rushes should lie across it and the stitching along its length.

PLATE 42
Indian Priest

According to Harriot this represents a priest of Secoton with special clothing and ornamentation. He is wearing a rabbit-skin cape and leather ear ornaments and he

seems to have some paint on his face. The index-finger pointing down may not be an Indian gesture but could be a stylistic detail imported by White from European Mannerism. As little colour has been transferred in the offsetting, the drawing comes nearer than most to its original appearance.

PLATE 43
Indians Fishing

This is another 'composite' drawing showing Indian methods of fishing by day, with the dipnet and spear, and by night, with a fire in the canoe. It also shows the use of fish-weirs to trap fish. In addition it gives a certain amount of information about life in the shallows between the mainland and the Outer Banks where a catfish, a hermit crab, burrfish, king crabs (the earliest known of this arachnid), hammerhead sharks, skate or ray and perhaps a sturgeon can be distinguished. A pelican, two swans and a flight of duck are seen in the sky above the mainland.

White no doubt made separate studies of each of the creatures included in this drawing, some of which have survived. He, unscientifically to our way of thinking, has introduced a West Indian species of hermit crab (see pl. 6) into North Carolinian waters and some large fish which would not normally have been found in the shallows.

PLATE 44
Cooking in a Pot

Apart from the ear of maize, it is not clear what is cooking in the pot. Harriot says that fruit, flesh and fish were boiled together. The type of large pot here depicted has been matched archaeologically for coastal Virginia and North Carolina. Shards of several pots have been excavated and reconstructed at Fort Raleigh. However, the base should be slightly convex rather than concave as shown by White. Indian pots, made by the women, according to Harriot, would not of course have been thrown on a wheel but would have been built up in coils by hand. Taking the horizontal markings of the smoothed-over coils visible on the pot as an inch or an inch and a half apart, as found on excavated shards, the

diameter of the mouth of the pot would be eight to twelve inches.

PLATE 45
Cooking Fish

Barbecue frames of the type shown here were widely used by North American Indians for drying or broiling fish or meat but Harriot emphasises that the Carolina Algonquians broiled their fish and did not smoke or dry them. The fish shown cooking are possibly shad, *Alosa sapidissima*, probably the same fish as seen in the canoe in the fishing scene (pl. 43). The greenish-yellow colours on this sheet are water-stains from another drawing, perhaps part of the damage suffered by the volume of drawings in 1865.

PLATE 46
Indian Elder or Chief

Though the inscription identifies the subject simply as a chief, Harriot in the engraving (De Bry, pl. VII [fig. 11]), calls him a chief of the Roanoke Indians, the immediate neighbours of the English settlers. Harriot also notes that the chief men fold their arms as they walk or talk to one another as a sign of wisdom. The rectangular gorget is likely to have been made from native copper rather than European smelted sheet copper.

PLATE 47
Indian Woman

The inscriptions on this drawing, the engraving (De Bry, pl. VI [fig. 10]) and the Sloane copy (fig. 37) all give different identifications, suggesting that by the time White made his finished drawings his memory was, at least for this figure, confused. The distinctive female body ornamentation is, as Harriot tends to suggest, very likely to have been tattooed, rather than painted. The curious anatomical error made by White in giving the woman two right feet is difficult to explain. Perhaps the preliminary drawing was unfinished as regards the feet and the artist was misled by the crossed right leg into thinking momentarily that it was the left, even though he had already drawn that foot correctly.

PLATE 48
Indian in Body Paint

The inscription and the appearance of the figure itself indicate that the elaborate body decoration is painted, not tattooed, for some special occasion. Even the pose is indicative of some important event, the only one which can be said to be somewhat artificial, and is stylistically close to that found in the Mannerist portrait of contemporary Europe. The ornaments are also somewhat elaborate and the necklace and bracelets are of pearls or copper beads. The tail worn behind to support the quiver (see De Bry, pl. XXIII [fig. 27]) is probably a puma tail. The six foot bow is fairly typical of surviving eastern Indian bows, and the rush quiver is consistent with rare references for New England and elsewhere in the early seventeenth century. The bracer or wrist-guard is unique for the Carolina Algonquians though known for Virginia.

PLATE 49
Indian Conjuror

Harriot describes the 'coniurers or iuglers' in terms which suggest the use of trance or spirit possession and distinguishes them from the priests though the precise differences are not made plain. The small bird worn on the side of the head is a badge of office. Here is the clearest drawing of the pouch as commonly worn by Indian men at the waist girdle to hold knives, tobacco, pipes and all kinds of personal belongings. A comparable pouch from Virginia survives in the Tradescant Collection, Ashmolean Museum, Oxford.

PLATE 50
Milkweed

Identified as *Asclepias syriaca* Linn. but this species is not now found in the area of the Outer Banks though a number of other species of *Asclepias* are. Harriot makes no reference to the plant which is known for its medicinal properties as a diuretic and expectorant. John Gerard describes it at length in his *Herball* (1597) as 'Indian Swallow woort', emphasising the downy covering of its seeds which he calls 'most pure silke'. He publishes a woodcut illustration which must have been taken from another version of the drawing for he does not mention, as he certainly would, its curative properties as related in the inscription. He may have received his drawing from Raleigh. He also makes a reference to the presumed survival of the Lost Colony – 'Norembega, and now called Virginia . . . where are dwelling at this present Englishmen, if neither vntimely death by murdering, or pestilence, corrupt aire, bloody flixes, or some other mortall sicknes hath not destroied them.'

PLATE 51
Sabatia

Sabatia stellaris Pursh. Known also as Rosegentian, Sea Pink and Marsh Pink in North Carolina and widely found in salt marshes and sandy coastal places along the Atlantic seaboard of North America from Massachusetts to Florida. White has drawn the markings at the base of the corolla-lobes with considerable accuracy as too the habit of the single stem. The pinkish-mauve of the flowers has oxidized to a markedly darker shade towards the outer edges. As with the previous drawing there are yellowish-green water-stains down the centre of the sheet.

PLATE 52
Head of a Brown Pelican

Eastern Brown Pelican, *Pelecanus occidentalis occidentalis* Linn. The general effect is too grey and the area near the bill should be lighter. A distant view of the bird is found in the fishing scene (pl. 43). Much of the grey and blue pigment has been detached by offsetting.

The word *Tanboril*, bottom right, is part of the inscription for the drawing, reproduced at pl. 54, which has been separated.

PLATE 53
Burrfish

Also called the Spiny Box-fish, *Chilomycterus schoepfi* (Walbaum). The caudal fin should be round, not forked, and the general effect is perhaps too greyish.

PLATE 54
Puffer

The name *Tanboril* (see pl. 52) is missing from the inscription. The drawing may represent the Smooth Puffer, *Lagocephalus laevigatus* (Linn.), though the caudal fin is too forked for this species.

PLATE 55
Loggerhead Turtle

Atlantic Loggerhead Turtle (*Caretta caretta caretta* Linn.), apparently a male specimen. This illustration produced the earliest known copy of a John White drawing by the artist of the John Mountgomery manuscript, 'A treatice concerning the nauie of England' (Harvard University Library, J. P. A. Lyell collection, MS Typ 16), probably made before 1589.

PLATE 56
Common Box Tortoise

Terrapene carolina carolina (Linn). Harriot also stresses the value of tortoises 'both of lande and sea kinde' and their eggs as food.

PLATE 57
Diamond-back Terrapin

Probably the Southern Diamond-back Terrapin, *Malaclemys terrapin centrata* (Latreille) but these turtles have only five toes, not six as shown in the drawing.

PLATE 58
Swallow-tail Butterfly

Papilio glaucus Linn. White made another version of this drawing which he gave to Thomas Penny (pl. 77).

PLATE 59
Map of Eastern North America: Florida to Chesapeake Bay

The make-up of the map is discussed on pp. 33–4. Norumbega (New England) appears as an island or promontory in the top right-hand corner, Bermuda is just indicated at the edge of the sheet, centre, and the Bahama Islands, much exaggerated in size, appear below, on the left. It will be seen how meaningless White's scale of latitudes has become. On the mainland, within the inscription 'LA VIRGENIA PARS', are the arms and crest of Sir Walter Raleigh, and the coastal area of his Virginia is a small-scale version of the map reproduced at plate 60. The Florida promontory is profusely inscribed with French place names derived, with the coastal outline, from Jacques Le Moyne. The decorative features of the map, with its 'garnishing' of ships and marine fauna (including the dolphin fish, flying-fish and the squirrel-fish which appear as separate studies) indicate the influence of Flemish map-engravers such as Jodocus Hondius, the engraver of the Molyneux globes (1592). The map has been folded down the centre so that many details have offset correspondingly. The section to the right of the scale of latitudes gives some idea of the freedom and liveliness of White's draughtmanship and colouring little affected by water damage. More use of the pen is found on this map than on any other drawing.

PLATE 60
Map of Raleigh's Virginia

The map covers the coastline of North America from south of modern Cape Lookout to the north side of the entrance to Chesapeake Bay. A scale of leagues (1 league = about 3 miles or 1/20 of a degree) appears in the bottom right-hand corner, the royal arms on the mainland between Chesapeake Bay and Albemarle Sound and those of Sir Walter Raleigh further south. Though the map is unprecedentedly accurate in coastal configuration, hydrographic and topographical information are surprisingly absent. It is also devoid of pictorial elements except for the English ships and Indian canoes. White has amended the map by means of two patches visible at the head of Albemarle Sound and, the large one, along the shore of Pamlico Sound. The map is discussed on pp. 32–3.

The sheet, as bound in the original volume, was folded down nearly a quarter of the way from the top. As a result there has been offsetting on both sides of the fold, most conspicuously the windrose and the royal arms.

PLATE 61
Indian Man of Florida

One of two Indian figures which owe nothing to White's powers of observation but which are copied direct from Jacques Le Moyne de Morgues. The man is an Eastern Timucua from the St John's River area of Florida. The designs on his body are almost certainly tattooed, the stains on his face painted. The pendants hanging from his belt are likely to be stone or shell, the animal tail tied into the hair drawn up on the top of the head, a raccoon's. The small oval plaques threaded round his knees and elbows and the gorget hanging from his neck may be of copper supported by dyed buckskin thongs. The ear ornaments come nearest to archaeologically-known wooden earplugs covered with copper though the colour is silvery. The bow has been only slightly Europeanized but the head of the arrow is exaggerated in size. The quiver, probably of dyed buckskin, is perhaps too strongly coloured while the wrist-bracer seems unduly elaborate.

PLATE 62
Indian Woman of Florida

Also copied from Jacques Le Moyne de Morgues and again portraying an Eastern Timucua Indian, a woman, of north-east Florida. Besides the painting and tattooing similar to the man's, there is a line of tattoo marks running down the chin from the lower lip. The woman's ear ornaments are similar in shape to the man's but are reddish-gold in colour. She wears a simulated necklace but also a real one of alternating large and small metallic beads, perhaps made of gold obtained from European sources. The skimpy garment hanging from a red and white band is of Spanish moss, mentioned in early accounts of Indian clothing, but is too blue in colour. The bowl or pot is matched archaeologically for Florida if

not precisely from the north-east area. The multi-coloured ears of maize are realistic.

Though the style of this and the previous drawing is characteristically White's the constituent details, apart from some exaggerations, mainly of colour, show Le Moyne to have been a skilful ethnographic artist, particularly in portraying the Indian cast of feature, more so than is evident in his one surviving Indian miniature in the New York Public Library and in De Bry's engravings of his work.

PLATE 63
Eskimo (Inuit) Man

A portrait for which the preparatory drawing was made during Frobisher's second expedition to southern Baffin Island in 1577, or shortly afterwards in Bristol. His jacket, trousers and boots are of sealskin and show certain characteristics representative of the old Thule culture which has long since disappeared from Baffin Island. This and the portrait of the Eskimo woman and baby (pl. 64) are discussed on pp. 28–30.

PLATE 64
Eskimo (Inuit) Woman and Baby

The woman is seen carrying the baby on her back in her hood. She, like the man, was captured on Frobisher's second voyage, 1577, to southern Baffin Island and brought back to Bristol. She was not related to him but like him died within a short time of arriving in England. The baby only briefly outlived her.

A curious feature of both the woman's and the man's portrait is that the navel is indicated beneath the thick sealskin jacket. This is a Mannerist device often found in sculpture and figure drawing of the period in Europe and derived from Roman work where the body contours were visible under light drapery.

PLATE 65
Pictish Man Holding a Human Head

This flamboyant figure represents White's attempt to reconstruct the appearance of the savage ancestors of the English, or at least their neighbours the Picts, a name given by the later Roman writers to the people living beyond the frontiers of Roman Britain, in the Scottish Lowlands.

Though the idea of the torque, girdle and shield probably derives from the late classical writers the feeling of the drawing is entirely sixteenth century. The pose of the figure is Mannerist and many of the elements of body decoration are inspired by late Renaissance ideas such as the lorica with its muscular contours on the torso, the owl's head replacing the gorgon's head and animal masks on the shoulders simulating pauldrons. The monstrous head on the belly may be close in spirit to those found in Gothic paintings of devils. Unquestionably White is giving a sort of European parallel to the painted and tattooed decoration he found among the Algonquian Indians, but he attempts to make the portrait more convincing by adding weapons such as the shield and sword which he either derived from older illustrated works or drew from contemporary examples he could observe.

PLATE 66
Pictish Man

More clearly than in the preceding figure this Pict echoes the body ornament which White observed among the Algonquians, particularly the simulated bracelet and necklace and the decoration of the calves and navel. Even the patttern on the thighs may have been suggested by the fringe of the Indian apron-skirt.

PLATE 67
Pictish Woman

The body decoration and ornaments worn by the woman are similar to those shown on the two male Picts. The star and crescent is surely derived from Turkish sources but the curiously small spears and darts seem to have no prototype, except perhaps in Saxon manuscripts.

PLATE 68
Ancient British Man

White apparently distinguishes the naked barbaric ancestor from the clothed, less savage forebear, more open to civilizing influences. The sword carried by the man is in fact an English type of the fifteenth or sixteenth century.

PLATE 69
Ancient British Woman

She is the counterpart of the previous male figure, stained, like him, with a blue dye and like him wearing a single garment which cannot be identified as belonging to any definite period. Her sword is another variation on the scimitar as are the ones carried by the Pict men and woman – a type often found in later medieval and sixteenth-century illuminations and paintings.

PLATE 70
Hoopoe

Upopa epops Linn., a migrant in England, where White almost certainly drew it, and where it is a regular visitor to the south of the country, though in small numbers. That he should have made two finished studies of Old World birds (see also pl. 71) alongside his New World studies is characteristic of his concern to 'collect' widely distributed species just as much as he was concerned with races of widely different origins whether of the New World or the Old.

PLATE 71
Roller

The Common Roller, *Coracias garrulus* Linn., only occasionally found as a vagrant species in England but widely distributed over southern Europe, western Asia and north-west Africa. Unless this is a copy White is again likely to have observed the bird in England.

PLATE 72
Tartar or Uzbek Man

This and the four following figures are clearly not drawn from the life as were White's Algonquian Indians, nor are they imaginative reconstructions like his Picts and Ancient Britons. Their flatness shows them to be copies, probably from engravings. The cloak shown here is perhaps Uzbek and the tall hat is rather like those seen in contemporary representations of Tartars. There is no evidence that White travelled to the East.

PLATE 73
Turkish (?) Man

The source for this drawing is unknown.

PLATE 74
Turkish Woman

Nicolas de Nicolay in *Les quatres premiers livres des navigations et perigrinations orientales* (1568) includes a plate sufficiently close to this drawing to suggest a common prototype, entitled 'Femme Turque vestue a la Moresque'.

PLATE 75
Turkish Woman

Another plate in Nicolay, entitled 'Femme Turque allant par la ville' is somewhat similar to this drawing though the headdress is quite different. An English edition of Nicolay was published in 1585.

PLATE 76
Greek (?) Woman

The stance of the figure and the tunic have a remote connection with the 'Fille de Joye Turque' of Nicolay.

PLATE 77
(a) Swallow-tail Butterfly

The butterfly, *Papilio glaucus* Linn., is a replica of pl. 58, though less sensitively drawn. It is pasted into the manuscript of Thomas Moffet's 'Insectorum . . . Theatrum' (British Library, Sloane MS 4014) as are the other insects in this plate. The latin inscription, written by Thomas Penny, can be literally translated, 'the painter White brought this back to me from American Virginia. 1587.' This is the only instance of White's name appearing on a drawing. The date may refer to White's return to England as governor of the second colony in 1587, or the date he gave Penny the drawing, or both, the last seeming the most likely interpretation.

(b) Fireflies

These are replicas, more or less, of two of the fireflies, *Pyrophorus noctilucus* (Linn.), in pl. 7, though again the quality of the drawing is much cruder. The vital passage of manuscript relating to this insect is found in the last three lines, 'Hanc Cicindelam . . . accepi' which can be literally translated, 'This firefly, together with the picture, I [Penny] received from White, most skilful painter, who very deligently observed it in Hispaniola and Virginia alike.'

(c) Gadfly

The fly, *Tabanus* species, is brighter in colour and with a smaller head and thorax than in pl. 7. A passage in Moffet's manuscript, not reproduced in the plate, refers to it when he says that Penny describes two rare species of gadfly of which one was sent to him by White from 'Virginia of the Indians'. A description of the 'Virginian' fly then follows.

Moffet also says that White gave Penny a cicada from 'Virginia' but the drawing of the cicada in the manuscript is unlike White's work.

Notes on the Monochrome Plates

FIGURE 1

Main Title-Page

The engraved title-page to the English edition of Theodor de Bry's *America*, part I. The author, Thomas Harriot, is here described as 'servant' to Sir Walter Raleigh. De Bry has adapted five Indian figures, each the subject of a separate plate, and incorporated them into his architectural design.

FIGURE 2

Dedication to Sir Walter Raleigh

De Bry's general dedicatory epistle to all three sections of the volume. It is clear that neither Harriot nor Hakluyt has attempted to correct De Bry's English which is entirely his own, yet he makes clear enough his aim to do justice to White's figures by the engraving. The arms on page 3, with the motto 'Amore et Virtute', are those of Sir Walter Raleigh.

FIGURE 3

Title-Page to the Indian Plates

In this second title-page White's name is mentioned for the first time. The date 1588 implies that De Bry knew of White's voyage of that year and had secured the 'Virginia' drawings before the latter's departure in April. De Bry makes it clear that Thomas Harriot wrote his notes to the plates in Latin and that Richard Hakluyt translated them for the English edition.

FIGURE 4

Epistle to the Gentle Reader

Here De Bry speaks of his willingness to publish White's drawings and of Hakluyt's part in encouraging the work. He also mentions his sons' part in the engraving but we do not know what work they undertook. Finally, he speaks of 'dyvers secret marks' to prevent counterfeiting of the designs but no such marks have been identified.

FIGURE 5

Map of Raleigh's Virginia

In the left-hand panel, below the royal arms, White ('With') is given as the author of the map, De Bry as engraver and publisher. The Latin wording in the right-hand cartouche says, in effect, that the part of America, now called Virginia, was first discovered by the English at the expense of Sir Walter Raleigh in 1585, in the twenty-seventh year of Queen Elizabeth's reign, and that the account of the colony given in this book is accompanied by images of the inhabitants.

There are considerable differences between the engraved map and White's manuscript map of 'Virginia' (pl. 60). It is oriented to the west, the proportions between the banks, sounds and mainland have been altered, the map has been extended by nearly a hundred miles inland and there are revisions of names and some additions, making this a later map. But the immediately noticeable difference is the use of symbols, such as the circular palisade for an Indian village, whether open or enclosed, conventional signs for both evergreen and deciduous trees and for mountains, and 'garnishing' of Indian figures.

FIGURE 6

Arrival of the English

The plate is engraved by 'T.B.', Theodor de Bry. Though the drawing has not survived, the engraving is close to the sketch-map (p. 10). It shows part of Pamlico Sound, Roanoke Island, the mouth of Albermarle Sound and the Alligator River and part of Currituck Sound, with the Carolina Outer Banks divided into six islands. The area corresponds to the right-hand section of the sketch-map from which a few features have been taken – such as the site of the village of Pasquenoke and the grapevines in the area of Weapemeoc.

The Indian village 'Roanoac', on Roanoke Island, appears for the only time in White's maps. Unfortunately, he was less interested in locating the English settlement. Whereas the sketch-map is the first rough attempt to map the area, this map represents a more advanced stage in compiling the field-sketches made by Harriot and White.

FIGURE 7
Indian in Body Paint

The engraving is by 'T.B.', Theodor de Bry. The figure in pl. 48 is reversed and duplicated to give a rear view. The man's stance has been exaggerated in typically Mannerist fashion. The back view shows how the tail is used to support the quiver. The figures are set against a landscape background where Indians are seen hunting deer, in keeping with the content of the inscription on the original drawing.

FIGURE 8
Indian Woman of Secoton

The plate is engraved by 'T.B.', Theodor de Bry. The figure in pl. 37 is duplicated to give a rear view and is set against a landscape of shoals and Indians reminiscent of the fishing-scene (pl. 43). The front view of the woman is extremely close to the original, even to the details of tattooing and body painting. The figures taken together provide the clearest depiction of the double apron-skirt. The engraving defines the ear ornament as four beads on a pendant attached to the lobe. The feet have been much reduced in size.

FIGURE 9
Indian Priest

The engraving is by 'G. Veen', Gysbert van Veen, and the figure in pl. 42 is reversed, duplicated to give a rear view, and set against a landscape background. Though the left-hand figure is close to the original the features are less convincingly Indian and the feet and hands are reduced in size. Harriot adds the information that the priest is from Secoton.

FIGURE 10
Indian Woman

The engraving is by 'G. Veen', Gysbert van Veen. The figure is as in pl. 47, reversed and duplicated to give a rear view, and set against a landscape background. Though the left-hand figure is close to the original, the face (which is less tattooed) and hair have been Euro-

peanized, and the feet, this time correctly drawn, reduced in size. Here Harriot gives the information that the woman is from Secoton.

FIGURE 11
Indian Elder or Chief

The engraving is by 'T.B.', Theodor de Bry. The figure in pl. 46 is reversed, duplicated to give a rear view, and is set against a landscape background. Whereas the original figure wears a single apron-skirt, the double garment is worn here, in Dr Sturtevant's view perhaps mistakenly. Again the Indian features have been somewhat Europeanized.

FIGURE 12
Indian Woman and Young Girl

The engraving is by 'T.B.', Theodor de Bry. The woman's stance is slightly modified from that in pl. 33, her left foot being behind her right and the girl is running towards her from the right holding in her right hand an English rattle and the doll in her left. The figures are set against a landscape background. There are also minor differences in detail in the figures: the woman has no headband; there are no tattoo marks on her chin but they appear on her calves; the small necklace is simulated; and the girl's necklace is two-string without a pendant.

FIGURE 13
Old Indian Man

The engraving is by 'T.B.', Theodor de Bry, and is set against a landscape with the village of Pomeiooc. The figure differs from that of pl. 34 in only minor details: no seam is visible in the mantle and the man is now wearing moccasins. This is a clear example of how much has been lost in the engraving. The face and hair have been tidied-up so that its most convincing aging quality has been entirely lost as has the texture of the deerskin mantle.

FIGURE 14
Indian Woman and Baby

The engraving is by 'T.B.', Theodor de Bry, the figure in pl. 35 reversed and duplicated to give a rear view and set in a landscape. The woman is here identified as from Dasemunkepeuc, a village on the mainland opposite Roanoke Island, rather than from the more distant Pomeiooc. The woman is seen to have a two-strand simulated necklace, tattoo marks on her cheek and pendant ear ornaments.

FIGURE 15
Indian Conjuror

The engraving is by 'G. Veen', Gysbert van Veen. The figure of pl. 49 has been considerably reduced in size and set against a landscape background. Harriot more suggestively calls him here a conjuror (see note to pl. 49). Though the pouch and animal skin have been most accurately reproduced, the flexed fingers, the facial expression and the bird worn at the side of the head are notably less convincing.

FIGURE 16
Indians Making Canoes

The engraving is by 'T.B.', Theodor de Bry. The original drawing has not survived. Harriot here explains in detail, and White has carefully illustrated, the method of making a dug-out canoe. Elsewhere Harriot's specifies for this purpose the use of a tall, straight tree called *rakiock*, perhaps the White or Swamp Cypress, *Taxodium distichum*, and says that canoes were made 'onely with the helpe of fire, hatchets of stones and shels.'

FIGURE 17
Indians Fishing

The engraving is by 'T.B.', Theodor de Bry. The canoe is as in pl. 43 but the crouching figure on the right is a woman and one of the fish in the canoe may be identified as a gar. The creatures in the water are more numerous and varied and now include sting-rays, a loggerhead turtle, a land crab and snake-like amphibians. There are many more fish beyond the canoe and more canoes and Indians fishing. The fish-weir in the left background is of a different type but none of the fish in it, in contrast to those seen there in the original, can be definitely identified. Two other fish-weirs are visible in the distance. The birds flying in the sky have lost their identity. The king crabs seen at the water's edge, right, according to Harriot, supply, with their spiny tails, points for the spears used by the Indians to hunt fish.

FIGURE 18
Cooking Fish

The engraving is by 'T.B.', Theodor de Bry. The barbecue of pl. 45 has been reversed and two Indian men have been added. The grill here has only five cross-pieces and the smoke and flames have been accentuated. The long fork is more likely to have been a natural pole forked at the end, for the tool pictured here has no parallel in eastern North America. Though the pack-basket is similar to the type known throughout eastern America, the wicker-work technique appears to be European rather than Indian. A gar and hammerhead shark can be made out among the fish in the basket.

FIGURE 19
Cooking in a Pot

The engraving is by 'G. Veen', Gysbert van Veen, who has added two Indians to the fire and cooking pot of pl. 44. This illustration shows the only example of an Indian woman wearing a breech-clout, probably an error on the part of the engraver. The fan used by the man has no counterpart except in Florida and its appearance is suspiciously like ones appearing in Le Moyne's illustrations of Florida, e.g., pl. XXIV of De Bry, *America*, part II (1591) – one of several possible confusions by De Bry between White's and Le Moyne's work of which he held a good quantity together at one time. The large spoon held by the woman, on the other hand, agrees in shape and size with wooden spoons known archaeologically throughout eastern North America.

FIGURE 20
Indian Man and Woman Eating

The engraving is by 'T.B.', Theodor de Bry, who has conspicuously altered the squatting posture of the two Indians in pl. 41 to an acceptable European sitting position. A number of objects now appear on the mat – a pouch, a tobacco pipe (the only certain example in White's work), a gourd water-vessel, walnuts, four husked ears of maize and a scallop or clam shell. White must certainly have provided De Bry with a drawing showing these objects to give some idea of the Indians' diet whereas pl. 41, like so many others in the surviving set, records the basic subject without elaboration. Again the engraver has failed to reproduce the characteristic Indian cast of feature, as White has so successfully expressed it, and has Europeanized it perhaps to make it more attractive to his European readership.

FIGURE 21
Indians round a Fire

The engraving is by 'T.B.', Theodor de Bry, is in reverse of pl. 40 and is set in the usual landscape. Two standing figures have been added to the left of the circle, and the Indian behind the fire is here hidden by smoke and flames. Differences in detail are otherwise minor but there are no naked Indians and the smoke and flames, as the figures, have been accentuated.

FIGURE 22
Indians Dancing

The unsigned engraving is in reverse of pl. 39. There are many minor differences from the original mainly in costume or decorative details. The most noticeable is the woman on the extreme left of the circle who now has her back to the viewer and is looking back over her right shoulder, holding a bundle of twigs at the small of her back. She is wearing moccasins. And the man to the left of the fan post now wears a puma (?) tail hanging behind from his waist. The women's hair, particularly that of the three in the centre of the circle, has been thickened and to some extent curled in an un-Indianlike way.

FIGURE 23
Indian Village of Pomeiooc

The engraving is by 'T.B.', Theodor de Bry. In general it conforms closely to pl. 32 apart from a number of minor differences, but the rear entrance to the palisade is not shown, its poles are taller, thicker, more regular, and the house with the cupola on the right now has a hexagonal ground-plan. A landscape background has been added of trees, part of a field of corn on the left, sunflowers and a small pond on the right from which three Indians are taking water. There is a ridge in the foreground with stylized plants growing on it.

FIGURE 24
Indian Village of Secoton

The engraving is by 'T.B.', Theodor de Bry. Though the houses are much as in pl. 36, with two added at the top, the composition includes much more detail in the empty areas of the original. These show additional crops: tobacco, top centre and lower left, above the small hut; sunflowers, just above the last; and pumpkins bordering the field of sprouting corn. In the top field the ripe ears of maize are wrongly shown without husks. Round the dance circle, bottom right, there are only six posts rather than seven in the drawing. Apart from other small differences of detail what is not altogether clear in the drawing is often precisely engraved: the carved heads at the top of the posts round which the Indians are dancing; similar heads topping the smaller posts within which a fire is burning, further left; the figure in the hut, top right, to scare birds. The trees are more luxuriant and among them, top left, are Indians hunting deer. The Indian figures are generally larger and more precisely outlined, their feather headdresses more definite.

Harriot judges the open village, with its houses more informally arranged within trees and with gardens growing crops, more attractive than the enclosed village. He mentions tobacco as a garden crop. A small fenced garden with an unidentifiable crop is shown just above the pumpkin border. The excellently drawn sunflowers have been identified as *Helianthus annuus macrocarpus* (DC.) Cockerell, widely cultivated for its seeds in aboriginal North America. Harriot says that the Carolina Algonquians planted sunflowers among the maize and used the

seeds in bread and soup. The tobacco shown would have been the indigenous *Nicotiana rustica* Linn. rather than *N. tabacum* Linn. introduced in colonial times. The pumpkins have been identified as *Cucurbita pepo* Linn.

FIGURE 25
Indian Idol

The engraving is unsigned and there is no corresponding drawing. It represents an idol seated in a circular hut of matting and is presumably taken from a detailed drawing of the image seen in the charnel house (pl. 38). It has the same tight-fitting bodice and the zig-zag or ringed ornament of the legs, but the hair tied in a knot above the head and other details of dress are quite different. Harriot comments that its head 'is like the heades of the people of Florida' and the hairstyle is in fact indistinguishable from that of the Timucua Indians of Florida as drawn by Le Moyne and engraved by De Bry in *America*, part II. It may well be that the engraver had thought of the pointed head, or hat, of the image as sufficiently like the hairstyle of the Timucua (as observed by Le Moyne and of which De Bry held plenty of examples in the latter's drawings at the time) as to justify a direct borrowing. Other aspects of the engraving are suspicious: the round hut which would have no place in the charnel house, the high decorated tops of the moccasins, the beads round the thighs, all unparalleled in the region, and the naturalistic treatment of the image which has nothing in common with archaeological examples or Indian work in general.

FIGURE 26
Indian Charnel House

The engraving is unsigned and in reverse of pl. 38. The structure is now enclosed in a tall hut with an arched roof – clearly the one seen at the bottom left-hand corner of the village of Secoton (pl. 36). The platform on which the bodies are laid is supported by ten posts, not eleven as in the original drawing, and there are now nine bodies, instead of ten, with roached hairdress rather than the hair drawn up as White drew it in the surviving drawing. A rather different image is shown with hair, or headdress, somewhere between that of the original and

that in fig. 25. The image's dress, what one can see of it, reflects that shown in the latter.

FIGURE 27
Indian Markings

The engraving is by 'T.B.', Theodor de Bry, and no original drawing has survived. The figure is very close, though in reverse, to the one seen from behind in fig. 7, but the way the quiver is supported by the puma (?) tail is more clearly shown than in that plate.

Harriot says that most Indians of the region had 'marks rased on their backs' for identification and that the marks he is illustrating refer to their places of origin, though the marks themselves are identified as belonging to named chiefs or highly ranked individuals. Robert Beverley, in his *History and present state of Virginia* (1705), reproduced all the symbols in an engraving derived from this De Bry plate and describes them as marks painted on the shoulder-blades of travellers in order 'to shew the Nation they are of'. 'The usual mark is one, two or three Arrows; one Nation points these Arrows upwards, another downwards, a third sideways, and others again use other distinctions.' Scholars have not been in agreement as to whether these are tribal marks, marks of totemic clans, or indications of high rank. Dr Sturtevant is inclined to see them as indicating local affiliation or individual leading men. But if indicating the wearer's town, how are two different symbols for Secoton and three for the two towns of Pomeiooc and Aquascogoc to be explained? There is also the problem of the meaning of Harriot's expression 'rased'. Literally it implies cicatrization but use of this method of decorating the body is not known in eastern North America. Tattooing might be a better explanation. Beverley, as already quoted, thought that the patterns were painted on.

FIGURE 28
Third Title-Page

De Bry here observes that the painter from whom he had the pictures of 'the Inhabitants of Virginia' gave him too the five following figures. This can only mean that John White was also the author of the Picts. But it is clear that one of the engravings (fig. 31) was taken from

a miniature painting by Jacques Le Moyne de Morgues. The others do not correspond well, or at all, to White's Picts, so that it is possible that Le Moyne may have been the originator of all five figures. The problem is discussed on p. 18.

De Bry also says that the painter found the figures in an 'Oolld English cronicle'. This could well be so since the similarity of these figures and White's is so marked as to be explained by the possibility of Le Moyne and White adapting them from the same source, an illuminated English history perhaps.

De Bry's last observation certainly rings true that the Indians of 'Virginia' and the English race had a similarly savage beginning.

FIGURE 29
Pictish Man Holding a Human Head

The engraving is by 'T.B.', Theodor de Bry. It comes with fig. 30 closest of all the set to a drawing by White (pl. 65), though there are a number of differences, mostly minor, – the Pict holds a spear in his right hand as well as a head and the figure is set in a hilly river landscape with another human head lying in the foreground.

FIGURE 30
Pictish Woman

The engraving is by 'T.B.', Theodor de Bry, and comes fairly close to pl. 67 but the body is turned more fully to the front. The hair is quite distinct being more curling, less visible above the shoulders and more profuse below. The torque and girdle appear more like cord and a chain is shown supporting the sword. The feet are smaller. The figure is set against a river landscape with towers.

FIGURE 31
Young Pictish Woman

The engraving by 'T.B.', Theodor de Bry, has no counterpart among White's drawings but is taken from a miniature by Jacques Le Moyne de Morgues (see p. 18), with which it corresponds almost exactly, apart only from the very small-scale, finely painted flowers on her

body which the engraver would have found most difficult to reproduce and for which he provides a more generalized approximation. The landscape has also been accurately reproduced. Le Moyne's invention of this figure is the basis for the theory that he may have been the first author of the other four plates.

FIGURE 32
British Man

The engraving is by 'T.B.', Theodor de Bry. The drawing by White (pl. 68) has a general similarity but there are many differences. The figure is reversed, wears a sword, as well as a small shield, and in his right hand carries a spear in place of the sword. His arm posture is different but the 'jerkin', belt, round shield, and to a lesser extent the stance, are much the same. He is set in a river landscape.

FIGURE 33
British Woman

The engraving is by 'T.B.', Theodor de Bry. Again there is only a general similarity between this figure and White's (pl. 69). The difference is mainly of posture. The woman is on the alert, White's definitely at ease. Though their dress is the same, De Bry's figure wears the sword at her side, not at the back, and her hair is longer, curling where White's is straight, and more luxuriant. The spear has a ball at the base. She is set in a landscape with trees and houses.

FIGURE 34
Sloane Volume: Inscribed Titles

The volume contains early seventeenth-century copies by several different hands of twenty-seven of White's Indian, Eskimo and natural history subjects of which original versions (not used by the copyists) survive and are reproduced in facsimile in plates 1–76. In addition there are two Eskimo, five Brazilian, three miscellaneous costume subjects and a group of forty-four drawings of birds, fish and reptiles executed by White in 'Virginia' of which no original versions survive. The volume also

contains fifty-seven pages of flower drawings which have no known connection with White's work and are not reproduced here. The volume appears to have been in existence by, and possibly some time before, 1614 (see p. 21).

The earliest inscription, dated 11 April 1673, ends with the words 'lent to my soon White' which can be held to mean 'lent to my son whit [White]', the 'son' being perhaps a grandson or great-nephew of the artist (see p. 21). The longer inscription is in the hand of Dr Hans Sloane who was finally successful in obtaining the volume from the family. Here he makes it clear that he believes it to contain the original drawings by White from which De Bry executed his engravings.

FIGURE 35
Indian Village of Pomeiooc

The drawing is much larger than the original reproduced at pl. 32 and is clearly from a different version of the subject. The ponds in the right-hand corner and the fields of grown corn link it more closely to the lost variant used by De Bry for his engraving (fig. 23) but in other ways it is quite distinct. There are nineteen houses, not eighteen as in the original and the engraving. The most striking difference from these others is the larger apparently hexagonal house immediately behind the fire with a curving roof rising to a central point which is shown open with a man and a woman seen inside, perhaps the chief and his wife. The man with the dog and the man carrying wood are not represented while a naked figure carrying a baby is added to the right foreground. One curious feature, most of the houses have matting laid over the constructional matting which hangs over the ends. Such a feature is apparent on one and perhaps two houses on the engraving and not definitely on any in pl. 32. More penwork is apparent in the drawing than in the surviving original.

FIGURE 36
Indian Woman of Secoton

The woman is close to the figure in pl. 37 but the face, parts of the arms and feet are disfigured by white bodycolour which has oxidized. There are no bead trimmings on the skirt and there is no overhanging top fringe. The

tattooing throughout is sharply defined in darker blue and the colouring generally is somewhat different, particularly the skirt which is brownish-grey and the skin colour which is rather more pink.

FIGURE 37
Indian Woman of 'Aquascogoc'

Each version we have of this figure is differently identified and it seems clear that White's memory was confused. The figure is much more crudely drawn than that reproduced at pl. 47 and again there is much use of white bodycolour which has oxidized. The general colour is darker brown and – a typical copyist's misunderstanding – a thick line replaces the rows of tattooed dots on the cheekbone. The facial markings in general have been exaggerated and there are differences in the ornamentation of the legs. Strangely, the error of the surviving original is repeated here: the woman has two right feet!

FIGURE 38
Indian in Body Paint

The man is standing much as in pl. 48 but one main purpose of the original has been lost, to show how an Indian chief was painted for war or ceremonial occasions, as the elaborate body and face paint is entirely absent. As for the costume, the apron-skirt is double rather than single, the wristlet, wrist-guard and the tail are missing, and an extra feather is worn on the head. Other details of ornament differ. The figure is also thinner, the colouring much lighter and the face has been Europeanized.

FIGURE 39
Old Indian Man

Though the stance and dress are much as in pl. 34 the man has been substantially modified, particularly in facial expression and physique. He is wearing a feather on his forehead, another which is just visible beyond the right side of his face and a three-strand necklace – all additions to the plain figure in the original drawing. The colouring generally is lighter and almost nothing of the

FIGURE 40
Eskimo (Inuit) Man

The drawing is in reverse of pl. 63 but the left hand now carries a double paddle (the top paddle cut off short). The man's sealskin clothing is similar but the hood-yoke is represented by a triangular throat-piece of the jacket which flares out at the hips with no suggestion of the navel as in the original. The face appears more marked and the bow is larger than in the original with additional bands of sinew in chevron pattern towards the lower end. The arrow lying in the foreground is, like the paddle, reddish in colour with a steely grey head, probably intended to indicate metal. The outline drawing is in pen and brown ink, a technique rarely used by White.

FIGURE 41
Eskimo (Inuit) Man Seen from Behind

No original drawing of this exists. The man is presumably the same as that seen from the front in fig. 40 but the bow and paddle have changed hands and the beard is more prominent. The sealskin hood, which is trimmed with lighter fur and sewn down the middle, separates at the neck and the two ends are sewn onto the back of the jacket. The jacket is trimmed at the lower edge and wrists with narrow bands of black and white fur and the sleeves are sewn into the jacket. The cut of the jacket's tail – a feature of the old Thule culture not now present in Baffin Island – is best shown here. The trousers are tucked into long boots of dehaired skin, turned over at the top to show the fur stockings. This is more clearly seen here than in fig. 40. The paddle is of reddish wood, about eight feet long, with two moulded rings (of bone?) separating the middle section.

FIGURE 42
Eskimo (Inuit) Woman and Baby

The figure approximates to pl. 64 but the head is facing farther to the left. The child's head is more conspicuous

in the hood and its right hand appears over the edge. The faces of both woman and child have been Europeanized and are much lighter in colour. The hood is without flaps, the jacket without a front opening and the strings from neck to waist are lacking while the cord round the body is lower and more visible. The sleeves are here set into the jacket which does not plunge so steeply in front. The tail is longer, appearing to reach the ground. A simple pair of stockings only is indicated. The general colour of the clothing is yellowish-brown. Again much penwork is visible in the drawing.

FIGURE 43
Englishmen in a Skirmish with Eskimos (Inuit)

The landscape has been cited (p. 8) as evidence of White's presence with Frobisher on his second voyage, 1577, to Baffin Island but no original drawing has survived. The copy however shows affinities with White's style and appears with other copies certainly derived from his work. Moreover, the details, for a copy, are convincingly drawn, in particular the kayak in the foreground, the weapons, dress and tents of the Eskimos. The large flag flying at the stern of the English boat displays the cross of St George and the royal arms, centred. The skin kayak is perhaps fifteen feet long with a circular cockpit reinforced by a broad band of darker skin. The low rectangular Eskimo tents, with end supports joined to form a ridge, are covered with skins and their stone bases are visible. The drawing preserves sufficient atmosphere and well-observed detail to indicate how convincing the original must have been.

FIGURE 44
Indians of Brazil Mourning over a Dead Man

This and the following four subjects, in pen and brown ink and watercolours, are copies of drawings by White from an earlier source. They are closely related to woodcuts in Jean de Léry's *Histoire d'un voyage fait en la terre du Bresil* (1578) but are not copied from them. White's drawings and the woodcuts would seem to be derived from a common, presumably printed, source. They are further examples of White's interest in compiling a 'theatre' of races.

Five naked Tupinamba Indians of Brazil, four women and a man, are mourning the death of an Indian man. The dead man in the hammock has a labret below his lower lip and the front of his head is shaven. The man at the back also wears a labret in the same way, his head is shaven in front and he holds a gourd rattle. The composition is close to that of the woodcut on p. 335 of De Lery's *Histoire*.

FIGURE 45
Indians of Brazil Welcoming a Frenchman

A bearded Frenchman, half sitting in a hammock, is wearing a brownish coloured jerkin over a blue doublet, greenish-yellow breeches and grey shoes. He and the naked Tupinamba woman to the left are hiding their faces in their hands as part of the welcome ceremony. The woman's hair in two tails is bound with blue ribbon (?). The naked Tupinamba man behind the hammock, his head shaven and wearing a labret beneath his lower lip, is holding an arrow in his left hand, with the head against his chest, while he brings the blade of a knife against the shaft with his right. The vessel in the lower right-hand corner containing liquid is apparently earthenware. The composition is related to that of the woodcut on p. 315 of De Lery's *Histoire*.

FIGURE 46
Cannibal Indian of Brazil

A naked Tupinamba Indian grasps a wooden club above a severed Indian head lying on the ground. His head is shaven in front, he wears a labret below his lower lip and his brown body is decorated with long, dark, parallel scars on the chest, upper and lower arms, thighs and calves, running along the limbs. The club is coloured red and five feathers of various colours are attached to the lower end by a ring. The composition is close to that of the woodcut on p. 249 of De Lery's *Histoire*.

FIGURE 47
Brazilian Indian Man, Woman and Child

The naked Tupinamba man, his skin unevenly coloured dark brown to suggest staining, holds four arrows fletched with feathers of various colours, the shafts red. The bow is also coloured red. His necklace, made of bone or shell, is supported by a single cord. His head is shaven in front and a labret is visible beneath his lower lip. The naked woman, a lighter colour, supports the baby by means of a cotton sling at her left hip. A growing pineapple is shown in the foreground, lower left, and a reddish plate holding two oval, pale brown fruits, lower right. The composition is the same as in the woodcut on p. 121 of De Lery's *Histoire* but there is a hammock slung across the middle, behind the figures.

FIGURE 48
Brazilian Indians Dancing

The naked Tupinamba man is stained dark brown on parts of his body. At his buttocks he wears a spread of variously coloured ostrich feathers attached to a red thong passing over his shoulder. Thongs of the same colour are tied round his calves from which hang pale, rattling, bell-shaped shells or pods. The naked woman, lighter in colour, wears a diadem of single feathers, alternately red and pale in colour. The rattle she holds is decorated with two red features at the top, separated by another of some metallic colour which has oxidized and shows signs of water damage. The parrot is green, blue and red. The composition is close to that of the woodcut on p. 275 of De Lery's *Histoire*.

FIGURE 49
Roman Soldier

The figure seems to have been taken from a woodcut on p. 16 of Guillaume du Choul's *Discours sur la castrametation et discipline militaire des anciens Romains* (Lyon, 1567), entitled 'Archers avantcoureurs'. The soldier's helmet is a metallic bluish-grey, his cuirass blue, while his tunic is shaded from light yellow to brown. The yellowish sandals are bound to the lower legs with blue thongs. A red leather strap supports his quiver and a similar belt holds

a short sword with a black scabbard, a yellowish hilt with criss-cross pattern in black, bluish quillons and pommel. The bow is blue, the arrow yellowish-brown with black barbed head.

FIGURE 50
Doge of Genoa

White must have copied the figure from an unidentified costume book. There is a general similarity to the engraving in Abraham de Bruyn's *Omnium pene Europae, Asiae, Aphricae arque Americae gentium habitus* ([Antwerp], 1581), pl. 30, but no direct connection. Each may be derived from a common prototype.

The Doge's coronet enclosing a black cap lined with ermine is purplish (silver oxidized?) at the top. He wears an ermine cape and a long coat of brown brocade, patterned with black and gold. The raised left forearm shows the bluish sleeve of an undergarment. His stockings are dark purplish-grey and his shoes are black. The date 1575 could indicate the year when White drew the original. If so it is the earliest date associated with his work.

FIGURE 51
Medieval Man

The man's dress and hairstyle suggest an English fifteenth-century original, perhaps a mural painting or an illuminated manuscript in the manner of Herman Scheere or his school, at the beginning of the fifteenth century.

The man's gown is deep purplish-brown, the folds are indicated in black. The bag sleeves are gathered into narrow fur-lined (?) cuffs. He appears to be wearing a hood with a red border. His hair is brown, his feet shod in dark material with a seam down the centre. The drawing has suffered water damage and part of the surface is heavily stained with dark red and brown, perhaps offsets.

FIGURE 52
(a) Iguana

This and the following group of drawings (figs. 53–66) almost all correspond to surviving originals by White though they are not copied from them. They are by a different hand from that of the copyist of most of the early sheets of the Sloane volume and one consistent in style and type of inscription.

The iguana, *Cyclura cychlura* (Cuvier) is close to the original reproduced at plate 9 but differs mostly in colour being much greener. The rings and scales of the tail are more crudely emphasized and browner. No attempt has been made to indicate the body scales where the colour is greenish-yellow.

(b) Alligator or Crocodile

Alligator mississipiensis (Daudin) or *Crocodylus acutus* Cuvier. See pl. 10 to which it is close but set at more of an angle with the edge of the sheet and greener in colour.

FIGURE 53
(a) Swallow-tail Butterfly

The butterfly, *Papilio glaucus* Linn., is slightly smaller than that shown in pls. 58 and 77(a), and darker in the ground colour and forewings. Though some details are nearer one original, some nearer the other, it is generally close to pl. 58.

(b) Puffer

Possibly the Smooth Puffer, *Lagocephalus laevigatus* (Linn.), as in pl. 54, but the copy is somewhat larger, faces right, and is greyer and darker in colour. The markings are not identical, the eye is larger and the nostril is more sharply defined.

FIGURE 54
(a) Remora, Ventral View

The fish, *Remora* species, is considerably larger than as shown in pl. 29, otherwise similar. The colour is a uniform greenish-brown, with whitish-blue bodycolour heightening the pectoral and ventral fins and outlining

the gill cavity and the eye. The rays of the fins are more conspicuous.

(b) Remora, Dorsal View

The same fish, seen from above and the side. No corresponding original drawing survives and this copy is in reverse of pl. 28. The colour is a uniform greenish-brown, heightened with white or blue at the base of the pectoral fins, on the back, the disc, the eye and the teeth. The projecting lower jaw and teeth are also emphasized. The disc is bluish-black and the number of laminae is sixteen.

FIGURE 55
Land Crab

The crab, *Cardisoma guanhumi* Latreille, is shown as in pl. 5 but facing right. Its colour is much browner though in size it is about the same except that the feet and claws are rather longer. The details, as in most copies, are less clear. The edge of the shell has been formalized as have the eyes, eye-sockets and forepart of the shell.

FIGURE 56
(a) Grunt

The size of the fish, *Haemulon sciurus* Shaw, is a good deal larger than it appears in pl. 24. The colours are stronger and the blue body stripes are crudely prolonged over the head.

(b) Hermit Crabs

The two crabs, *Coenobeta clypeatus* (Herbst), are shown here side by side and redder and browner than in pl. 6, though about the same size. The copy is close to the surviving original but the markings on the round shell are more precise.

FIGURE 57
(a) Burrfish

The fish, *Chilomycterus schoepfi* Walbaum, is rather large and more brightly coloured than in pl. 53, with a greater use of reddish-brown, while the lower edge of the copy is yellowish-brown.

(b) Grouper

The fish, probably *Epinephelus ascensionis* (Osbeck), is substantially larger than in the surviving original (pl. 22) but is close in shape and colouring, though the spots on the body are all black, the mouth dull crimson and the iris crimson and black. The fold of skin behind the mouth is exaggerated and there is no silver on the lower parts which are bluish-white.

FIGURE 58
Portuguese Man-o'-War

The physalia, *Physalia physalis*, is shorter and shallower than in pl. 31 but with longer and more substantial tentacles. The crimson on the 'hull' is stronger and there are strong blue touches at the tip. The vein-like markings are stronger bluish-grey, the crimson colour of the 'sail' deeper and the bluish-grey of the tentacles more pronounced.

FIGURE 59
(a) Trigger-Fish

The copy of the fish, *Balistes vetula* Linn., is close to the surviving original (pl. 30) but the general colour is olive-brown rather than bluish-grey, while the silvery effect of the original is lost. The blue bands from and above the mouth are in stronger body-colour as are the fins.

(b) Lookdown or Moonfish

The copy of the fish, *Selene vomer* Linn., is extremely close to the original (pl. 21), though some lines are more definite. The colour is a rather darker brownish-grey, and brown is used on the fin spines and back.

FIGURE 60
(a) Dolphin

The fish, *Coryphæna hippurus* Linn., is in reverse of that reproduced at pl. 26, the body is deeper in proportion and the front of the head is not nearly so vertical. The

upper part of the body is much greener and the reticulated pattern finishes in a more definite lateral line, picked out in black. The blue bodycolour used on the fins for the original is replaced by a duller dark blue. The caudal fin is less lunate and the face has more green and blue and less crimson.

(b) Remora, Dorsal View

The fish, *Remora* species, is longer than in pl. 28, the colour stronger on the back, disc and fins, and more blue appears behind the eye, on the anal fin and on the tail. The snout, back and dorsal fin are dark greenish-brown with black spots and the caudal fin is dark grey. On the white underparts no stripes are indicated. The disc has more laminae which are more clearly defined, producing a convex effect.

FIGURE 61
Flying-Fish

The fish, *Exocoetus volitans*, is shown larger than in pl. 27 but is generally close in detail and colouring though the blue bodycolour on the back is somewhat darker. The silver on the side of the body has oxidized and is not found on the pectoral fins, the rays of which are drawn in bluish watercolour.

FIGURE 62
(a) Grouper

The fish, *Mycteroperca venenosa* (Linn.), is rather larger than as represented in pl. 23, but is close in outline and colouring, though the brown of the back is darker. The gold of the underparts is absent which are now a pale brownish-yellow and the eye is touched with crimson and brown only.

(b) Soldier-Fish

The fish, *Holocentrus ascensionis* (Osbeck), is much larger than as represented in pl. 25. The general colour is crimson. The lines on the head are greatly emphasized and the eye, which has a reddish iris, is much enlarged. Both the dorsal fins have been exaggerated.

FIGURE 63
Mammee Apple

The copy of the fruit, *Mammea americana* Linn., has been somewhat enlarged from that represented in pl. 12 and much simplified, executed wholly in shades of brown, deeper in colour than in the surviving original, with larger spots. The blotch towards the right-hand side is no doubt accidental. A cross-section of the fruit is added with creamy-yellow flesh and dark brown seed cavities.

FIGURE 64
Pineapple

The fruit, *Ananas comosus* (Linn.) Merrill, has a more prominent tuft than in the original (pl. 11), with strongly serrated leaves coloured green and yellow, brown and red at the tops. The segments of the fruit are much more strongly indicated by cream lines edged with deep brown, with pink and white heightening at the apexes. The stalk in section is pale pink, touched with darker pink.

FIGURE 65
Horn Plantain

The banana, *Musa paradisiaca* Linn., is very close to the fruit represented in pl. 13, even to the touches of reddish-brown on the skin on the lower part of the left-hand specimen, though the veining of the flesh on the other is less elaborate. The general colour is a strong yellowish-green.

FIGURE 66
Milkweed

The plant, *Asclepias syriaca* Linn., shows various differences from the specimen represented in pl. 50, having only four pairs of leaves on the main stalk. The leaves and pods are larger, the former, except in one instance, without apexes. The seeds are more clearly indicated. The root is larger and thicker and the leaves are washed light yellowish-green for the underside, left, and a stronger yellowish-green for the upperside, right. The seeds

are pale yellow and the down in the pod white. The rootstock is brown.

FIGURE 67
Bald Eagle

This and the rest of the birds of 'Virginia' are copies by another hand, also responsible for most of the fishes in the latter part of the Sloane volume. The strong pen outlines, with a tendency to stylization, are characteristic of this copyist. There are henceforth no original drawings known for comparison.

The copy probably represents the southern race of the Bald Eagle, *Haliaetus leucocephalus leucocephalus*. The bill is yellow, as is the eye; the head, neck and tail whitish; the underparts are light brown and the wings dark brown; the lower end of the legs and the feet are yellow, the claws black.

FIGURE 68
Sandhill Crane

Grus canadensis (Linn.), but identification of the race is not possible from the copy. The bird's plumage is bluish-grey, without the expected rusty red and brown and the black hairs on the short bald head. The tail plumage is conventionalized. Edward Topsell used a crude version of this copy in 'The Fowles of Heauen' (Huntington Library, Ellesmere MS 1142) f. 206 *v*.

FIGURE 69
Common Loon

Gavia immer (Brünnich). The pale colours of the neck and head and the light coloured back, with absence of spots, suggest an immature specimen, but this is not a good drawing of the species.

FIGURE 70
Surf Scoter

Melanitta perspicillata (Linn.). The bill is yellow at the tip, and on top, white beneath, with a black spot at the side. The head, wings and body are black with four

vague brownish spots across the face and greyish-white patches on the forehead and nape. The feathers have been picked out in white.

FIGURE 71
Red-Breasted Merganser

Mergus serrator serrator Linn. The bill is red, as is the iris, the head crest and upper neck green or greenish-black. The lower neck is white, touched with grey, the lower breast is grey, strongly flecked with brown, the underparts less strongly, while the tail is brown. The flanks are mottled black and white, the wing coverts are brown with white patches, and the primaries and upper tail coverts are black and brown. The red breast, characteristic of the species, is not clearly indicated, and the brown of the wings is nearer that of the female though the head is that of the male.

FIGURE 72
Bufflehead Duck

Bucephala albeola (Linn.). The beak is bluish, with a blue spot at the tip. The forehead, face and chin are greenish-black and a white patch extends round the nape. There are purplish and green bands encircling the neck lower down. The breast, underparts and tail are white, the lesser and middle coverts white, the greater coverts brown and the rest of the wings black, outlined in white, as are the back and tail feathers.

FIGURE 73
Common Loon

Gavia immer (Brünnich), an adult specimen of the bird shown at fig. 69. The beak is black, the iris yellow, and the eye is encircled with a brownish patch which reaches the chin, the rest of the head greenish-black except for a patch of white on the throat. A band of white encircles the neck with another of bluish-black below. The breast, underparts and tail are white, with touches of black and grey. Green, brown and black on the wings give an iridescent effect, probably also intended by means of the same colours on the head and neck.

FIGURE 74
Trumpeter Swan

Olor buccinator Richardson, now extinct in eastern North America. The beak is black, heightened with white, and a narrow black area on the forehead extends round the eyes. The plumage is white, flecked with grey. Two swans are shown in the fishing-scene (pl. 43).

FIGURE 75
Gull

Probably an immature specimen of the Herring Gull, *Larus argentatus smithsonianus*. The bill is pinkish-grey, the head, neck, mantle and underparts are white picked out in bluish-grey, the tail is brown, as are the wings except for the white secondaries.

FIGURE 76
Red-Headed Woodpecker

Melanerpes erythrocephalus Linn. The tail is reddish-brown, the head and throat scarlet and crimson. Below is a black collar which is represented too wide. The nape, wings (except for the white ends to the coverts) and tail are greyish-black, the breast and underparts white, strengthened with grey. The legs and feet are greyish-black. As drawn the pose is unnatural; the bird should clinging vertically to a branch.

FIGURE 77
Common Grackle

Quiscalus quiscula (Linn.). Identification of the race is not possible from the copy. The bill is greyish-black, the plumage, legs and feet purplish-black, with green reflections round the yellow eye, on the tail and, to a lesser extent, on the wings and underparts.

FIGURE 78
Pileated Woodpecker

Southern Pileated Woodpecker, *Ceaphleus pileatus pileatus* (Linn.). The crest and molar region are scarlet, the lores brown, the iris yellow, the crown, ear coverts and side of neck greyish-white, with a patch of the same colour on the throat. The rest of the body is black, with a whitish sheen, and the edges of the coverts are greyish-white.

FIGURE 79
(a) Bluebird (?)

This can hardly be other than the Eastern Bluebird, *Sialia sialis sialis* (Linn.), though the representation is inaccurate in various respects: the shape of the bill and head, length of the tail and the too light colour of the breast. The beak is grey, the head, neck, wings and tail blue, the tips of the wing coverts and primaries black. The eye is surrounded by a lighter pinkish patch. The throat and breast are rose-pink, paling towards the wings, the underparts white, picked out in blue, and the legs and feet grey.

Edward Topsell used another version of this copy in 'The Fowles of Heauen' (Huntington Library, Ellesmere MS 1142), f. 31 *v*.

(b) Towhee (?)

The bird is not certainly identifiable but may have been intended for a female Red-Eyed Towhee, *Pipilo erythrophthalmus erythrophthalmus* Linn. The bird is shown perched on an ear of multi-coloured corn. Its bill and eye are grey; the head, neck, wings and tail are brown and the sides pink; the breast and underparts are grey-white touched with brown; the legs and feet are brown. The pink on the sides should be duller and there should be white on the wings and tail. The characteristic red of the iris is absent.

Edward Topsell used another version of this copy, inscribed *Aushouetta*, in 'The Fowles of Heauen' (Huntington Library, Ellesmere MS 1142), f. 31 *v*.

FIGURE 80
(a) Blue-Grey Gnatcatcher

Polioptila caerulea caerulea (Linn.), probably a female, but there are various inaccuracies. The bird as shown has a grey bill, the head and throat are brownish with a lighter patch round the eye. The mantle is greyish-blue

and the tail grey to greyish-brown. The breast and underparts are white, picked out with grey. The legs and feet are dark grey. For a gnatcatcher the proportions are faulty. The head should be blue-grey, the white of the eye is not clearly defined, and the outer tail-feathers should be white.

(b) Downy Woodpecker

Eastern Downy Woodpecker, *Dendrocopas pubescens pubescens* (Linn.), though there are inaccuracies of detail. The bird's bill is greyish-white, the forehead and crown scarlet, the rest of his head black with a white eye-ring, and white stripes on the nape and side of the neck. The mantle and wings are black with white spots, the tail black. The underparts are light brown, picked out with darker brown, and the legs and feet are grey. The bird should have a black forehead, with only a small patch of red in the crown, while the underparts are white. The pose as drawn is far from natural.

FIGURE 81
(a) Brown Thrasher

Probably the female Eastern Brown Thrasher, *Toxostoma rufum rufum* (Linn.). The beak is yellowish, with grey at the tip and edges; the head heightened with silver-brown; the eye ringed with white, with a white patch below; the neck light-brown, shading to white; the mantle greyish; the underparts are white, flecked with brown and grey and partly washed with grey; the wings and tail brown. The bird is perched on a honeysuckle, variously coloured, with some oxidation. This drawing lacks the strong brown stripes on the breast and the white bars on the wing coverts, and there is little suggestion of red on the wings and tail. A poor depiction of the bird.

(b) Baltimore Oriole

Icterus galbula (Linn.), though there are inaccuracies. The bill is grey, the head and throat black, and a black band runs across the back. The nape with the breast and underparts are yellow, heightened with crimson, while the lesser coverts, mantle, rump and upper tail coverts are similarly coloured. The rest of the wings and tail is black and the legs and feet grey. The red eye-ring is fanciful, the white wing-bar and tips are lacking and the distribution of the black and orange colouring of the

wings is incorrect. Edward Topsell used another version close to this in 'The Fowles of Heauen' (Huntington Library, Ellesmere MS 1142), f. 86 *r.* with the caption, 'A Virginia bird wt.out description'.

FIGURE 82
(a) Eastern Red-Wing

Agelaius phoeniceus phoeniceus (Linn.), with some inaccuracies. The bill is silver and yellow and the plumage black, except for the scarlet shoulders and silver heightening on the crown and tail. The eye is ringed with yellow and an outer ring of yellow spots. The legs and feet are grey. In this representation the yellowish iris has been mistaken for an eye-ring and the size of the eye exaggerated. The yellowish border to the red area of the wings is absent.

Edward Topsell used a very crude version of this copy in reverse in 'The Fowles of Heauen' (Huntington Library, Ellesmere MS 1142) f. 85 *r.*

(b) Barn Swallow

Hirundo rustica erythrogaster Boddaert. The bill is black and the forehead and throat reddish-brown. Below is a broad black bar. The breast and underparts are white touched with brown. The rest of the plumage is black, heightened with silver, the shoulder touched with white and silver. The legs and feet are yellowish green. The black bar of the throat is too wide and regular, the underparts too white, and white is absent beneath the tail.

FIGURE 83
Towhee

Red-eyed Towhee, *Pipilo erythrophthalmus erythrophthalmus*. The bill is whitish-grey and the breast and underparts white. The rest of the plumage is black, picked out with white, with small white patches on the wings and a larger white patch on the lowest feathers. The legs and feet are pinkish. The size of the bill is excessive and the absence of the characteristic red eye and the sparse white of the wings and tail might suggest the southern sub-species, *Pipilo erythrophthalmus alleni* Coues, now confined to the region of Charleston, South Carolina.

Edward Topsell used another version of this copy in 'The Fowles of Heauen' (Huntington Library, Ellesmere MS 1142), f. 85 *v.*, with a note saying that he received the drawing from Richard Hakluyt. This means that the Sloane volume of copies had been made and were in circulation before 1614 (see p. 21 above).

FIGURE 84
Eastern Cardinal

Richmondena cardinalis cardinalis (Linn.), with the size of the crest and the black on the face exaggerated. The bill is red, touched with silver, the lores red, the forehead, face and chin black, touched with white. The iris is heightened with white and encircled with a ring of white dots. The rest of the plumage is red, with scarlet on the head, breast, crest and underparts, and crimson on the wings, back and tail. The legs and feet are grey.

FIGURE 85
Yellow-Shafted Flicker

Colaptes auratus (Linn.), but probably the northern race, *Colaptes auratus luteus* Bangs. The bill and molar regions are grey and black, the forehead, crown and nape greyish-blue, with a scarlet and crimson band on the nape. The face, throat and part of the chest are pink, with a band of black, heightened with white and silver, on the lower chest. The back and wings are brown, spotted with black, the upper tail coverts white with black spots, and the tail brown, touched with black and yellow. The underparts are white spotted with black and touched with grey. The iris is white and the legs and feet greenish-grey.

Edward Topsell used a crude version of this copy inscribed *Aiussaco* in 'The Fowles of Heauen' (Huntington Library, Ellesmere MS 1142), f. 31 *v.*

FIGURE 86
Blue Jay

Cyanocitta cristata (Linn.), though it is not possible to identify the race from the copy. The bill is black, heightened with white, the head and crest back, wing and tail a

strong blue. Some of the wing features are tipped with white and white tail borders are indicated. There is a black ring round the throat which extends up the head to the top of the crest. The face, chin, breast and underparts are white, picked out in grey. The legs and feet are brown, outlined in black. Though the copy undoubtedly indicates a blue jay, the black and white bars on the wings are absent, while the breast and underparts are too light and there is no hint of purple in the blue. The crest is rather crudely indicated. The inscription is confused, the imitator being the mockingbird. The Indian name, *Artamockes* has, of course, nothing to do with the habit of mocking.

Edward Topsell used a poor version of this copy inscribed *Artamokes* in 'The Fowles of Heauen' (Huntington Library, Ellesmere MS 1142), f. 32 *r.*, and repeats the fallacy about the bird as an imitator.

FIGURE 87
(a) Cuckoo (?)

Perhaps intended for the Yellow-billed Cuckoo, *Coccyzus americanus americanus* (Linn.), though the identity of the copy is in doubt. If it is a cuckoo the feet are wrong as it should have two toes pointing forwards and two backwards. The bill of this bird is yellowish, the crown, back, wings and tail brown, with yellow on the sides of the head and shoulders and white streaks on the wings. The forehead is brown, strengthened with black (white oxidized?) and the face, chin and crest are grey. The iris is yellowish and the legs and feet greyish-pink.

(b) Junco (?)

Probably the Slate-coloured Junco, *Junco hyemalis hyemalis* (Linn.), but the head is stylized, the blue colour too strong, the bird generally too slender and the tail too long. The bird has a white bill, the head, chest, back, wings and tail are blue or greyish-blue, the underparts white, touched with grey and blue. The eye-ring is white, the iris black and the legs and feet are grey.

FIGURE 88
Thrasher (?)

The bird as copied is not certainly identifiable. It may have been intended for a Brown Thrasher, *Toxostoma rufum* (Linn.)(see fig. 81[a]) but the drawing is very crude. The bird has a yellowish-grey bill, heightened with white or silver, now oxidized. The head, back, wings and tail are brown with black spots, the side of the head and neck, with the underparts, white with small black spots and touched with grey. The breast is yellow, touched with red and with small black spots, the iris is yellow, the legs and feet are yellowish-green.

For a Brown Thrasher the brown is not the correct chestnut shade and should not have cross-marks or spots on the upper parts, wings and tail, while the breast is too yellow and lacks the dark streaks. The black and white wing-bars are also absent.

FIGURE 89
Flounder

Probably the Southern Flounder, *Paralichthys lethostigmus* Jordan and Gilbert, if the colour is reliable, otherwise Summer Flounder, *Paralichthys dentatus* (Linn.). The general colour is dark brown, with darker and lighter blotches, and the dorsal, ventral and anal fins are lighter brown. The teeth are indicated in black, the eyes are outlined in black, and the eyes themselves and the inside of the mouth are bluish-grey (oxidized silver?). No pectoral fin is shown. The eyes are set side by side instead of one above the other and are too small, the dorsal and anal fins are rather shallow and extend too far back, and the edge of the caudal fin should form an obtuse angle.

FIGURE 90
Bowfin

Amia calva Linn., a freshwater fish of the North Carolina Sounds. The colour of the head is dark brown, with lighter patches, the body lighter or darker brown, with touches of blue on the side. The dorsal fin is greyish-blue, the other fins brownish, with streaks of blue and light red, while the caudal is a dark greyish-brown. The

iris is reddish-brown, the pupil black. The scales are flecked with brown to give a mottled effect. The bony plate on the head is absent and the plate on the cheek is confused by the copyist with the gill-cover. The dorsal fin is rather stylized and too low, the pectoral fin incorrectly extended and the caudal fin should be more convex.

FIGURE 91
White Perch

Roccus morone americanus (Gmelin) probably, though the identification is not certain. The snout is bluish-grey, the lower part of the head and gill-covering bluish-grey, touched with light red and brownish-yellow, while the upper part of the head is bluish-grey, darker towards the top. The eye has a brownish-yellow iris and a black pupil. The fins vary from light blue (dorsal) to bluish-grey. The scales are somewhat formalized, the dorsal fins too far apart, the anal fin much too far back, while the caudal fin is too deep.

FIGURE 92
Alewife

Alosa pseudoharengus (Wilson) probably, rather than American Shad, *Alosa sapidissima* (Wilson). The head is greenish, with touches of brown and red, the body light greyish-blue in the upper parts, pale greyish-green below, while the fins are greenish-grey, touched with pink. The iris is blue and yellow. The anterior ray of the dorsal fin, which is half the length of the second, may be the copyist's error or indicate a damaged specimen. The eye is rather small and there are other inaccuracies of detail.

FIGURE 93
Striped Bass

Roccus saxatilis (Walbaum). The head and snout are darkish-blue, the iris brown and yellow, the pupil black. The gill-coverings are light bluish-grey, spotted with brown and touched with orange and yellow. Above the lateral line the body is rather dark blue, shading to light bluish-grey and near white below it. There are horizontal

stripes, slightly darker than the background colour, running from head to tail. The fins are light blue or bluish-white, the pectoral, ventral and anal fins also touched with orange. The scales are rather unevenly drawn and formalized. The head is somewhat elongated and flattened, the snout rounded, the mouth enlarged and the position and size of the dorsal and anal fins are not accurately recorded.

FIGURE 94
Drum or Channel Bass

Sciaenops ocellata (Linn.). The front part of the head and snout are dark brownish-grey above, light bluish-grey below. In the large eye the iris is brown or reddish-brown, the pupil black. The gill-coverings are bluish-white, touched with grey, brown and orange. Above the lateral line the body is dark brown on top, shading to lighter brown with touches of yellow, and below it, yellow, shading to bluish-white touched with pink on the underparts. There are two black spots near the caudal fin, eight vertical light blue stripes across the belly and the horizontal stripes of the same colour near the tail. The dorsal fins are greyish-blue or grey touched with brown, the caudal is striped horizontally with brownish-yellow and grey, the pectoral bordered with pink and the ventral and anal fins are striped brown and light blue. The scales are formalized. The light brown of the upper body should extend further towards the belly and the brownish stripes on the lower caudal fin are exaggerated.

FIGURE 95
Sea Lamprey

Petromyzon marinus Linn. The mouth is brown, the iris of the small eye grey, the pupil black. The row of seven black spots represent circular gill openings. The body is dark grey above, whitish below, with occasional light blue ventral markings. The dorsal fins are light brown and grey, the caudal fin is dark grey.

FIGURE 96
Striped Mullet

Mugil cephalus Linn. The head and upper part of the body are dark blue and bluish-green, the underparts pale greenish-grey, touched with light brown. Of the three lateral stripes, the topmost is dark, the others light grey. The dorsal and caudal fins are bluish-grey, the other fins greenish. The pupil of the large eye is yellowish, shaded with blue and the iris black. The body in general is rather too flat, the first dorsal fin should have four spines, not five, the caudal fin should be forked and the ventral and anal fins should be further forward. The eye is too large and the head, in profile, too humped.

FIGURE 97
Needlefish or Houndfish

Either *Strongylura acus* (Lacépède) or *Strongylura raphidoma* (Ranzani). The snout is dark green above and light grey and white (oxidized) below, with touches of pink in the mouth. The iris is light blue and mauve, the pupil black. The gill plates are white and bluish-grey, touched with pink and brown. The back is a uniform green while below the lateral line the body is white, with faint blue vertical strokes. The fins are blue, sometimes touched with white.

FIGURE 98
Gar

The copy could represent the Longnose Gar, the Bony Gar or Gar Pike, *Lepisosteus osseus* (Linn.) or, since the snout is broad, one of the Shortnose Gars, *Lepisosteus platostomus* Rafinesque or *Lepisosteus platyrhincus* De Kay. The snout is multicoloured with black, green, grey, pink and white (oxidized). The lower jaw is light grey and green. The low-set eye has a blue iris and the pupil is black. The plates on top of the head are dark, the gill-covers blue, heightened with white. The body is deep greyish-blue on top, lighter along the lateral line and pinkish-brown below. The pectoral and ventral fins are pale pink. The engraving of fish cooking (fig. 18) shows a gar in the basket being carried to the barbecue.

FIGURE 99
Catfish

Possibly the White Catfish, *Ictalurus catus* (Linn.). The snout is dull grey, the lips pinkish, the barbels hanging from the jaw are also pink, but the long barbels protruding from the upper jaw are grey, touched with pink. The small eye has a red and yellow iris and a black pupil. The upper part of the body is dull grey with darker vertical bars. Beneath, the belly is pale brown, touched with white (oxidized), the underparts towards the tail very light grey to white, with light grey vertical stripes. The fins are generally grey but sometimes touched with brown and the caudal and anal fins are touched with white (oxidized). The drawing is crude, the barbels do not correspond to a single species and there are other inaccuracies. The catfish appears prominently in the fishing scene (pl. 43), in the engraving (fig. 17) and in the basket in fig. 18.

FIGURE 100
Sheepshead

Archosargus probatocephalus (Walbaum). The mouth is dark grey, the snout a dark mottled brown, the lower head light grey, touched with pink. The body is yellow and grey, brownish on the back, paler beneath, with seven broad, dark grey vertical bands. The fins are a medium grey, except for the pectoral fin which is pale brown. The iris of the eye is brown and yellow and the pupil black. The copy is fairly accurate except that the soft portion of the dorsal fin is too long and too prominent.

FIGURE 101
Skink

Perhaps a mature male specimen of the Five-lined Skink, *Eumeces fasciatus* (Linn.), but *Eumeces incypectatus* and *Eumeces laticeps* also occur in the North Carolina coastland. The head is pale, dull red, the eye bluish. The rest of the creature is yellowish-brown, darker on the back, lighter on the underparts. The scales are crudely represented by a lozenge-shaped pattern and the length, as inscribed, is rather too long.

FIGURE 102
Snake

The copy is too indefinite for precise identification but probably represents one of the non-poisonous King Snakes, genus *Lampropeltis*, possibly the Milk Snake, *Lampropeltis triangulum triangulum* (Lacépède). The main dorsal and ventral colouring is made up of blotches of dull red, black and greyish-white. A yellowish band extends from the head to the tail, there is a near white band on the upper jaw and blotches of darker colour round the eye.

FIGURE 103
Atlantic Sturgeon

Acipenser oxyrhynchus Mitchill. The snout is dark brown, the mandible and head bluish-grey, the body and fins reddish- and purplish-brown, darker above, while the shields are whitish, touched with light-brown. The solid round shape protruding from the base of the mandible could be the copyist's idea of the barbels or, conceivably, the end of a fish spear. The gill-covering is partly open showing the edges of the gill-filaments which are light red. The bony surfaces on top of the head have been exaggerated by the copyist into dark brown rounded projections. The dorsal shields have also been exaggerated. Similar ventral shields are indicated. The line of lateral shields is coloured bluish-grey, with regularly spaced dark blotches. The bony points on the skin are shown by small groups of four dots, bluish above, reddish below. The copy is crude and the shields and snout have been treated diagramatically.

FIGURE 104
Burrfish

Otherwise Spiny Box-fish, *Chilomycterus schoepfi* Walbaum. The basic colour is yellow, with black stripes extending from the snout backwards and across the underparts, and black blotches near the pectoral and caudal fins. A very crude copy of the same fish as shown in the surviving original at pl. 53, but the representation of the caudal fin is in fact more accurate.

FIGURE 105
Croaker

Probably *Micropogon undulatus* Linn. The snout is pink and green, the mouth dark grey (white oxidized?). The gill-coverings are banded vertically green and pink. The eye is ringed with blue, the iris is pink, heightened at the outer edge with silver, the pupil black. The head is pink, touched with green, the back brown, touched with pink and green, becoming light yellow near the lateral line as is the belly. The sides are pink, touched with green. The fins generally are blue, sometimes touched with pink, but the caudal is brown heightened with deep pink and grey. The copy is not convincing in detail.

FIGURE 106
End Flyleaf

A table collating some of the natural history subjects in the volume with plates in Mark Catesby's *Natural History of Carolina, Florida and the Bahama Islands* (1731–43). The words at the top, 'by White. Mr Catesbys' are in Sloane's writing. In one instance, 'The yellow Woodpecker' is collated with Sloane's *Natural History of Jamaica*. The numbering on the left refers to an early pagination (not the earliest) in the Sloane volume, that on the right to plates in Catesby's work or in one instance to Sloane's *History of Jamaica*. Clearly, Sloane, Catesby and others made much use of the volume as the only work of reference for the natural history of North America available before the publication of Catesby's own work which drew much from these copies (see pp. 22, 32).

Select Bibliography

Binyon, Laurence. 'The drawings of John White'. *The thirteenth volume of the Walpole Society, 1924–1925* (Oxford, 1925), pp. 19–24, pls. XXIV–XXX.
_____ *English water-colours*, 1st edn, London, 1933; 2nd edn, London, 1944.

Birket-Smith, Kaj. *Anthropological observations on the Central Eskimos* (Report of the fifth Thule expedition, 1921–24, III, no. 2.) Copenhagen, 1940.
_____ *The Eskimos*, London, 1936; 2nd edn, London, 1959.

Bushnell, David Ives, Jr. 'John White – the first English artist to visit America, 1585.' *Virginia Magazine of History and Biography*, XXXV (Richmond, Va., 1927), pp. 419–30.

Catesby, Mark. *The natural history of Carolina, Florida and the Bahama Islands*. 2 vols. London, 1731–43 [48].

Croft-Murray, Edward & Hulton, Paul. *Catalogue of British drawings* [British Museum] I. XVI and XVII centuries. 2 parts (text, plates). London, 1960 [1961].

Cumming, William Patterson. *The southeast in early maps*. Princeton, N.J., 1958; 2nd edn, 1962.
_____ 'Our earliest known map'. *The State*, XXV, no. 17 (Raleigh, N.C., 11 Jan. 1958), pp. 10–11, 22.

Hakluyt, Richard. *The principall navigations, voiages and discoveries of the English nation*. London, 1589.
_____ *The principal navigations, voiages, traffiques and discoveries of the English nation*. 3 vols. London, 1598–1600.
_____ *The principal navigations, voyages, traffiques and discoveries of the English nation*. 12 vols. Glasgow, 1903–5.

Harriot, Thomas. *A briefe and true report of the new found land of Virginia*, with engravings after John White. Published by Theodor de Bry. Frankfurt-am-Main, 1590.
_____ A facsimile of the above, with an introduction by Paul Hulton. Dover Publications, Inc., New York, 1972.

Harrison, Thomas P. *Edward Topsell and John White, the first water colors of North American birds*. University of Texas Press, Austin, n.d.

Hulton, Paul & Quinn, David Beers, eds. *The American drawings of John White, 1577–1590*. 2 vols. London and Chapel Hill, N.C., 1964.

Hulton, Paul, ed. *The work of Jacques Le Moyne de Morgues, a Huguenot artist in France, Florida and England*. London, 1977.
_____ 'Jacques Le Moyne de Morgues and John White'. *The westward enterprise*, K.R. Andrews, N.P. Canny and P.E.H. Hair, eds (Liverpool University Press, 1978), pp. 195–214.

Keeler, Mary Frear, ed. *Sir Francis Drake's West Indian voyage 1585–6*. London, Hakluyt Soc., 1981.

Moffet, Thomas. *Theater of insects*. London, 1658.

Morison, Samuel Eliot. *The European discovery of America*. I. *The northern voyages* (New York, 1971), pp. 617–84.

Quinn, David Beers. *Raleigh and the British Empire*. London, 1947; New York, 1949. New edns, London, 1962; New York, 1962.
_____ ed. *The Roanoke voyages 1584–1590*. London, Hakluyt Soc., 1955.
_____ *New American World*. III. *English plans for North America. The Roanoke voyages. New England ventures*. New York, 1979.

Shirley, John W. *Thomas Harriot: a biography*. Clarendon Press, Oxford, 1983.

Skelton, R.A. *Explorers' maps*. London, 1958.

Stevens, Henry. *Recollections of Mr James Lenox of New York and the formation of his library*, Henry N. Stevens, ed. London, 1886. V.H. Palsits, ed. New York, 1951.
_____ *Bibliotheca historica*. Boston, Mass., 1870.

Sturtevant, William C. 'First Visual Images of Native America'. *First images of America*, Fredi Chiappelli, ed (University of California Press, Berkeley, Los Angeles, London, 1976), pp. 417–54.

Swanton, John R. *The Indians of the southeastern United States*. Smithsonian Institution, Bureau of American Ethnology, Bulletin, no. 137. Washington, D.C., 1946.

Index